GREEK MYTHS

A Vase Painter's Notebook

He then called to the boy, 'What would you give, my lad, to know about the Argonauts?' 'Sir, (said the boy,) I would give what I have.'

Boswell's *Life of Johnson*

GREEK MYTHS

A Vase Painter's Notebook

JANE HENLE

INDIANA UNIVERSITY PRESS
Bloomington

Published in Canada by Fitzhenry & Whiteside Limited, Don Mills, Ontario
Library of Congress catalog card number: 72-75639
ISBN: 0-253-32635-4 cl. 0-253-32636-2 pa.
Manufactured in the United States of America
3 4 5 6 87 86 85 84

Contents

GREEK MYTHS

A Vase Painter's Notebook

1

Proagon

On a vase of the early classical period (FIG.1) a woman runs ahead of a young rider. She turns back as she runs: her haste and backward glance might indicate anxiety. Her gesture, too, seems uneasy. What could the scene represent? How are we to read it? How are we to identify a mythological scene?

In the fifth century B.C. the scene on the reverse of a vase is often related to the one on the obverse. Not here: on the reverse are satyrs and a maenad, followers of the wine god Dionysos, who have nothing to do with the boy and the anxious young woman. The scene stands alone on the vase.

Taken alone, the picture tells us little. But we do not have to take it alone. We know from a series that these are Troilos and Polyxena, outside the walls of Troy, fleeing from the murderous Achilles.

A woman strides forward with an ax (FIG.2). A bearded man holds her back, hand on shoulder, hand on wrist. He wears chlamys and petasos, the short mantle and sun hat of the traveler. How shall we interpret the scene? Again the scene on the reverse does not help us to identify this one: there a youth is carrying a wine skin. But we know from a similar scene on another vase that the herald Talthybios is restraining Klytaimnestra as she rushes to the defense of Aigisthos. This is an excerpt from the murder of Aigisthos.[1]

On the companion vase (FIGS.3, 4) Talthybios and Klytaimnestra are on one side, the murder on the other. The names of the figures are inscribed, and these figures enacting this scene can only represent the slaying of Aigisthos by Orestes.

An armed goddess is in combat with a hoplite (FIG.5). The inscriptions identify the figures as Athena and Enkelados, thus the scene as an excerpt from the battle of the gods and Giants. But the

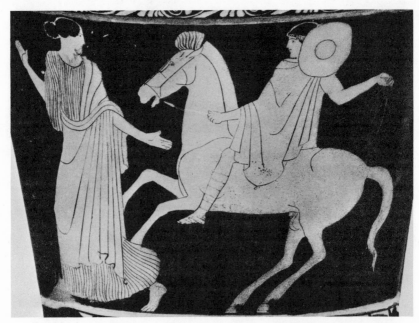

1 • Troilos and Polyxena. Villa Giulia Painter, calyx krater, Staatliche Museen zu Berlin, inv. 4497. Gottfried von Lücken, *Greek Vase-Paintings*, plate 54. The Hague: Martinus Nijhòff, 1923. (Nijhoff's Uitgevers—Mij)

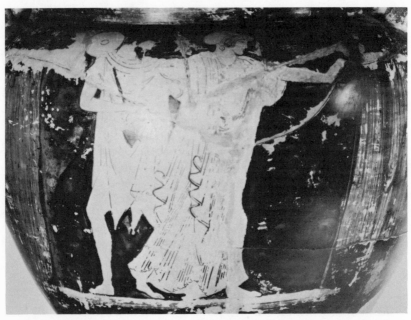

2 • Klytaimnestra and Talthybios. Harrow Painter ("probably"), column krater, Vienna 1103. (Kunsthistorisches Museum)

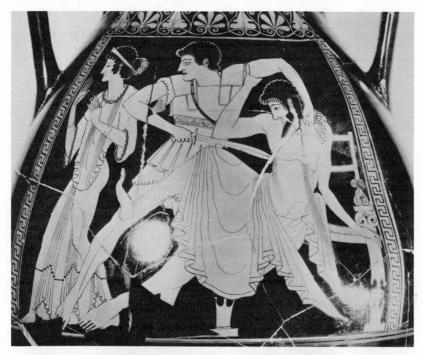

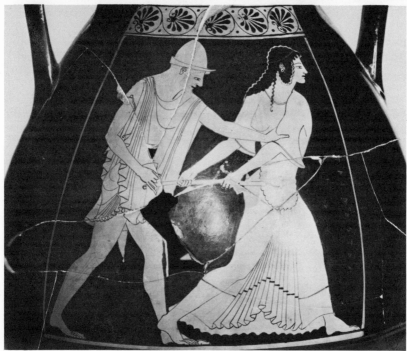

3 • 4 • A. Murder of Aigisthos; B. Klytaimnestra and Talthybios.
Berlin Painter, pelike, Vienna 3725. (Kunsthistorisches Museum)

5 • Athena and Enkelados. Attic black-figure neck amphora, Rouen. (Musée des Antiquités)

picture is decipherable without inscriptions. We recognize Athena by her helmet, aegis, and spear. Athena battling a hoplite is Athena battling a Giant.

One picture explains another; named figures identify scenes. And just as inscriptions name, attributes name. The identification of figures by their attributes is an important part of the identification of scenes.[2]

In the great days of the Athenian theater the presentation of the plays was preceded by the Proagon, the introduction of the actors—a playbill in the ancient manner. We, too, shall bring forward our actors before we come to the dramas in which they take part, the scenes of Greek mythology which are the subject of our study.

We begin with the gods.[3] Zeus, their king, has his scepter and especially his weapon and attribute, the thunderbolt (FIG. 21), and his eagle.

Hera, his queen, is recognizable chiefly by her association with Zeus, as Amphitrite by association with Poseidon.[4] On a metope

A Vase Painter's Notebook

from Selinus in the early classical period, on the Parthenon frieze in the classical, she faces Zeus, drawing aside her mantle in a gesture of modesty. In the scene of the judgment of Paris we know her sometimes by her position, sometimes by bland attributes of diadem and scepter.

Poseidon, god of the sea, has his trident (FIG.28), sometimes a dolphin, symbol of his realm.

We know Athena by her arms, helmet and spear. Sometimes she has a shield, more often the aegis, a scaly capelike covering with fringe of snakes, usually with the gorgon's head, the gorgoneion, to relieve its plainness (FIG.50) She may be accompanied by her owl or her snake.

We know her by her attributes—in later times. In early periods, the late eighth century, the seventh, and the early sixth, gods and heroes have not yet acquired the array of attributes that mark them clearly later. Athena, for example, stands between Perseus and the pursuing gorgons on a bowl of the end of the seventh century (FIG.46). She has none of her warlike attributes but an inscription to identify her. Still earlier there is no name. We know her by her role. The thin stiff figure who holds off the gorgons on a Protoattic amphora from Eleusis (FIG.44) can only be Athena, the friend and protectress of heroes. This is our earliest Attic picture of Athena,[5] and just the one we would choose, for it shows her in the role for which the Greeks held her in affection, as we do today.

We recognize Hephaistos rarely by his lameness, usually by his tools. On a vase in Boston (FIG.63) the craftsman of the gods is polishing a new shield for Achilles, which Thetis, Achilles' mother, has ordered. His mantle is tied about his waist, to free both hands for work, and he wears a woolen workman's cap. On the wall hang the finished armor and tools, the tongs and hammer of the smith and the bow to work the bow drill. In the scene of his drunken return to Olympos he carries tools not for use but as attributes (FIG.27), to tell again what the scene tells.

Apollo is a young god, beardless, beautiful, and hard. He has his laurel branch, laurel wreath, lyre or cithara, bow and arrows (FIG. 23). Artemis, his twin sister, is often beside him, and the association is one of her attributes. She has bow and arrows and sometimes the short dress and high boots of the huntress. (FIG. 14).

Aphrodite, the goddess of love, has her dove. She often wears a cap, and is distinguished from her sister goddesses by her stylishness. But her special attribute is her son Eros (FIG.59), a winged boy for earlier artists, a winged baby for later ones, a figure who grows, in time, not only younger—as many gods and heroes—but also dual and plural.

Ares, the god of war, is armed (FIG.21), a drab hoplite, indistinguishable from any other hoplite.

Dionysos is the wine god, the god of drunkenness, also divine drunkenness: "the god enters the human body."[6] We know him by his gift, the vine; his ivy crown or branch; his kantharos, the deep, high-handled drinking cup (FIG.27) or, earlier, the drinking horn. He carries the thyrsos, or his followers do, the ivy-headed stalk of giant fennel. He may wear kothornoi, the soft boots of the Athenian tragic actors. Sometimes he is accompanied by a panther, symbol of his wildness. But he also has a taste for civilized luxury; on the Parthenon frieze he sits on a cushion.

By the later fifth century he has become youthful and drunken but in the archaic period he is a dignified bearded god, often standing stiffly among the moving throng of his followers, satyrs and maenads (FIG.26). Satyrs are horse-men, horse-tailed, horse-eared, bald-headed, snub-nosed rascals with two things in mind, wine and maenads. Maenads are mad women, women maddened by the gift of the god. They carry snakes and wield their thyrsoi as weapons. Satyrs and maenads surround the god, frame his sobriety with drunkenness, his stiff xoanon-like divinity with bestiality.

Hermes is the swift messenger who travels on winged boots.

A Vase Painter's Notebook

He carries the herald's staff, the kerykeion, and is characterized as a traveler by chlamys and hat, the wide-brimmed petasos or the pointed pilos (FIG.58).

Demeter may carry her gift of grain or the torch with which she searched the earth for her daughter Persephone. She will hardly come into our story.

These are the twelve Olympians. We shall meet, too, lesser divinities. Meanwhile, let us turn to heroes. We know Herakles, the hero par excellence of the Greeks, by his club and bow and by the lionskin he wears (FIG.38). Of course, when he fights the Nemean lion, his first labor, he has not yet the lionskin, but we know him by the scene of hero wrestling with lion.

The neck picture of a great amphora in Athens, an early landmark of the Attic black-figure style (FIG.45), shows Herakles, in the early manner, without attributes. He is battling the centaur Nessos. The figures are named, Herakles, Netos,[7] but we could guess the subject without inscriptions: a scene of single combat between a hero and a centaur would most likely, though not always, represent Herakles and Nessos. In many later examples, too, we know Herakles by his deed: the antagonist takes the character of attribute.

As Herakles, Theseus, the hero of the Athenians, struggles with man and beast and monster, but the two heroes are usually distinguishable because of Herakles' attributes. Also, each has his own antagonists, as Herakles the hydra, Theseus the Minotaur—except that both fight bulls. The two are distinguished again by age. Herakles is a bearded man, Theseus a beardless youth.[8] Theseus, finally, the immigrant to Athens, is often represented as a traveler, with chlamys and petasos.

Perseus, the slayer of the gorgon, a favorite hero of the archaic period, wears winged boots and the cap of darkness. He carries the harpe, a sickle-like implement for decapitating gorgons, and

the kibisis, a special pouch for carrying gorgons' severed heads (FIG. 47).

Other heroes are recognizable by their actions or, rather, the scenes that have been devised for their actions. Bellerophon, riding the winged horse Pegasos, fights the chimaera. The goddesses are led by Hermes to Paris. Troilos, on horseback, is pursued by Achilles on foot. Odysseus rides underneath a ram, escaping from Polyphemos.

This has been our Proagon, the presentation of our actors, or some of them. The characterizations, of course, have been general. There are always exceptions and, more important, differences in different periods.[9]

Besides changes in characterization, there are changes, as time goes on, in the mode of illustration. Before we come to the scenes our characters enact, we must review the course of illustration, the changing manner of presenting these scenes.

A Vase Painter's Notebook

GREEK VASE PAINTING
PERIODS AND APPROXIMATE DATES

Eighth century *Geometric*
 Last quarter Beginning of orientalizing styles in Cor-
 (725-700) inth and Attica. Beginning of mytholog-
 ical illustration

Seventh century *Orientalizing*
 Protocorinthian, Protoattic, Cycladic,
 East Greek
 Last quarter *Archaic*
 (625-600) Early Attic black-figure, Early Corin-
 thian, others

Sixth century
 First quarter Attic black-figure, Middle Corinthian,
 (600-575) "Rhodian," Lakonian
 Second quarter Attic black-figure: Kleitias, others; Late
 (575-550) Corinthian; Lakonian
 Third quarter Attic black-figure: Exekias, others
 (550-525)
 Last quarter Attic: late black-figure, early red-figure;
 (525-500) Caeretan hydriai

Fifth century
 First quarter *Late Archaic*
 (500-475) Attic: red-figure, late black-figure
 Second quarter *Early Classical*
 (475-450) Attic red-figure
 Third quarter *Classical*
 (450-425) Attic red-figure, beginning of Early
 South Italian red-figure

9

Last quarter (425-400)	*Late fifth-century* Attic red-figure, Early South Italian red-figure
Fourth century First quarter (400-375)	Attic red-figure, Early South Italian red-figure
Second quarter (375-350)	Attic: beginning of Kerch style. South Italian: beginning of local styles: Apulian, Lucanian, Campanian, Paestan

2

Bild und Lied

Our survey of the course of illustration will take us from the late eighth century into the fourth. From the timeless and placeless "types" of the earlier periods, we shall move to the archaic and classical styles. These later styles will be seen in terms of treatment of time and place, and for this we go back to the work of Carl Robert, whose *Bild und Lied* (1881) is the foundation for the modern study of mythological illustration.

To begin at the beginning: it is in the late geometric period, in the late eighth century, that mythological scenes emerge in Greek art. The period is marked in Athens by the great vases that served as grave monuments, vases with funeral scenes painted in silhouette on the light ground of the clay. These scenes are large tableaux, enacted by small austere geometrical figures—geometrical in that they are made up of triangles, rectangles, circles, as if they have stepped out of the world of plane geometry. There is no grief at these funerals; all is patterned, abstract, impersonal. "Everyman's funeral," commented H. L. Lorimer and added, thinking of the display implied in these crowded scenes, "or at least every nobleman's."[1]

Besides funerals, another favorite subject of the Attic geometric vase painter is ships and rowers. "Rowing," as Humfry Payne beautifully remarked, "is . . . the most geometric form of exercise."[2] Now once, in the imagination of a vase painter, as the rowers sit at their long oars, ready for their geometric exercise, a man grasps a woman by the wrist and leads her aboard ship (FIG.6). Is it Theseus carrying off Ariadne? Paris and Helen?[3] We do not know; we only know that something new has come into geometric art. Two figures, geometric enough in appearance, ungeometric in intent, have burst into a conventional scene of daily life. Two figures with a tale to tell. Narrative has moved into a geometric tableau.

6 • Attic geometric bowl. British Museum 1899, 2-19, 1. (Trustees of the British Museum)

A late geometric tripod leg from Olympia has a scene in relief of two figures grasping a tripod, threatening each other with fists.[4] Two figures struggling for possession of a tripod might be Apollo and Herakles. Which is which we could not say: they are without attributes, almost exact counterparts of each other. The myth if it is told is told in the impersonal language of geometric art.

A man and a centaur, a small bronze group in New York, are locked in the embrace of combat. Herakles and Nessos? Zeus and some savage foe?[5] We cannot say. Still, the little group has taken us into the world of mythology where men and centaurs clash.

Thus mythological figures emerge in the late eighth century, almost shyly, as if reluctant to take off the geometric disguise of impersonality and anonymity. In the last years of the eighth century and in the seventh the strange bud opens to exuberant flower. This is the great period of trade with the Near East, the orientalizing period. With objects of trade come to craftsmen new ideas for decoration, new motives: fantastic monsters—winged men, sphinxes, griffins, sirens. A new world opens, the world of the *Odyssey* with its monsters and distant lands.

From the east come monsters but the Greeks add heroic antagonists: "the monsters produced their human conquerors,"[6] to kill or, being Greek, to outwit them. For the chimaera, Bellerophon; for the gorgon, Perseus; for the sphinx, Oidipus who knew her famous riddle.

A Vase Painter's Notebook

Monster and hero—it takes two to make a story. The narrative impulse, timidly, equivocally expressed in the geometric period, now with the rush of new ideas becomes bold. Besides folktales epics are illustrated. Heads are windowed in a wooden horse. Odysseus and his men drive the stake into the eye of Polyphemos or escape under his rams.

In the archaic period illustration becomes very complex and rich. Before we consider archaic illustration we should pause to recall that the ancient illustrator is not merely translating a text into pictures. No text accompanies the scenes of a sculptured frieze or of a vase, and the artist is free from literalism.[7] Indeed, sometimes he must deviate from his model if he is to be understood. For example, in a scene from the *Iliad*, the ransom of Hektor, the painter regularly places the body of Hektor under Achilles' banqueting couch, a grisly departure from the epic but one that is needed for recognition of a scene unaccompanied by text.[8]

Separation of tale and illustration, with the freedom it brings to the illustrator, does not mean that the artist is on his own. He is working in a tradition, a pictorial tradition that is close to the literary tradition but not entirely dependent on it.[9] The example just cited will serve as illustration: the body of Hektor under Achilles' couch does not belong to the literary but to the graphic tradition. This graphic tradition was first distinguished by Robert in his great work *Bild und Lied*.

The artist, then, is working in a tradition of illustrations that were developed by artists before him; he follows a type, a schema, a paradigm for his scene.[10] We have already noted the similarity of two scenes of Talthybios restraining Klytaimnestra: two painters have followed the same type. The artist is not obliged to create a new scene each time he puts brush to pot. The scene is there, before his mind's eye. He is like a rhapsode, head full of verses of epic,

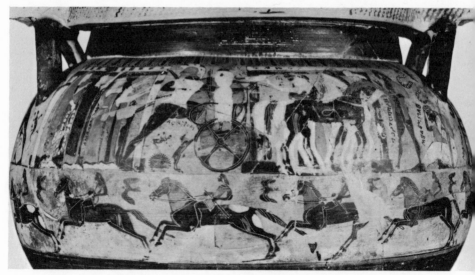

7 • Departure of Amphiaraos. Late Corinthian column krater, Staatliche Museen zu Berlin 1655 (now lost). (Staatliche Museen zu Berlin)

who begins to sing. The types, Robert says, "were bequeathed from generation to generation as a rich treasure."[11]

The advantage of the type for the spectator is recognizability, for the artist freedom for a quiet originality. He can deepen a scene with his own view of one of the actors, his own feeling about the action, his own unduplicable hand.

For archaic illustration, let us review some of Robert's examples. A well-known Corinthian vase shows the departure of Amphiaraos (FIG.7). The episode belongs to the myth of the war of the Seven against Thebes. When Adrastos was raising an army to restore Polyneikes to the Theban throne, he tried to enlist Amphiaraos. Amphiaraos, a seer, knew he would not return from the war and refused to go. But Polyneikes bribed the wife of Amphiaraos, Eriphyle, with a marvelous necklace, the work of Hephaistos. Eriphyle took the necklace and sent her husband to his death.

On the vase Amphiaraos is about to depart for the war.[12] He is mounting his chariot but turns back, with drawn sword, glaring at Eriphyle. His family stand before the house, two daughters, his son Alkmaion, a nurse carrying on her shoulder the baby Amphilochos, and Eriphyle with the necklace. The children all hold out their hands to Amphiaraos, entreating him to spare Eriphyle.

A Vase Painter's Notebook

In front, Baton, the charioteer, is standing quietly in the chariot, holding the reins and about to take a libation bowl which a woman offers him. A servant comes up to the horses. Another member of the household, Halimedes, sits on the ground, lost in dark thoughts of the future, for he knows that Amphiaraos will not return.

To the modern eye there are contradictions in the picture. Why is Eriphyle not fleeing? She stands stolidly before the house, holding out the necklace, which the archaic artist has drawn oversize to remind the viewer of the cause of all the trouble.[13] The charioteer waits in the chariot without even glancing back at the scene of threatened murder. Similarly, the servant attends to the horses and not to the glaring eye and menacing sword of Amphiaraos; and Halimedes, who is so concerned for the future, has no thought for the present crisis.

Perhaps the explanation is that Amphiaraos, as in the myth, will not kill his wife after all, but is going to the war, leaving vengeance to Alkmaion. Indeed, he is mounting his chariot to go. But why should his children appeal? If they are begging for the life of Eriphyle, it is because Amphiaraos is about to take it. The bare sword, too, tells us he will kill his wife—as his mounting the chariot tells us he will not: there is a contradiction in mounting the chariot with sword drawn. The whole painting is a web of contradictions.

Before we try to resolve these contradictions, let us follow Robert in his analysis of another example of archaic illustration. A Lakonian cup illustrates the blinding of Polyphemos by Odysseus and his men (FIG.8). Polyphemos is finishing a meal of one of the companions of Odysseus; he still holds a leg in each hand. Odysseus and the men stand before the Cyclops, the foremost man offering him a cup of wine to make him drunk. At the same time the men are driving a stake into the eye of the giant.

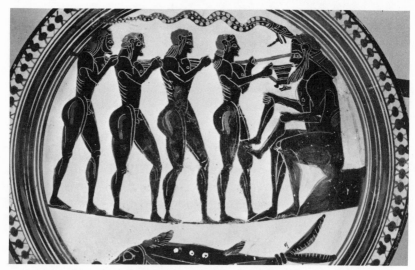

8 • Blinding of Polyphemos. Manner of the Arkesilas Painter, cup, Paris, Bibliothèque Nationale, Cabinet des Médailles 4894. (Photo. Bib. nat. Paris)

9 • Perseus and Medusa. Metope from Temple C at Selinus, Palermo, Museo Archeologico Nazionale. (Soprintendenza alle Antichità per le Provincie di Palermo e Trapani)

A Vase Painter's Notebook

Polyphemos cannot take the cup because his hands are full: there is a contradiction here, too; and a greater one in the driving in of the stake, an attack which the Cyclops would not conceivably allow when he is sitting up, wide awake and sober, eating his dinner.[14]

We leave this unlikely situation for the moment and go to another of Robert's examples, a sculptured metope from the archaic Temple C at Selinus in Sicily (FIG.9). Perseus, whom we know by his winged boots as well as by his deed, is cutting off the gorgon's head, carefully looking away from the sight that turns the viewer to stone. Athena stands beside him. Medusa is collapsing: she is shown in the "bent-knee" pose, a device of archaic art to indicate running or collapse. She holds a little horse tenderly in her arms. This is Pegasos, the winged horse, who sprang forth from her neck, with Chrysaor, her human son, when Perseus had cut off her head. But here Pegasos has sprung from her neck although a head is still upon it.[15]

The problem in all these examples is the same; it is one of time and it disappears when we ask, with Robert, what moment is represented. We must answer, not one moment but several: several moments of time have been condensed into a single scene.[16]

Amphiaraos 1) threatens his wife, then 2) changes his mind and mounts his chariot. Two moments are shown as one.

Polyphemos 1) is finishing his dinner, 2) is offered the cup, 3) is blinded by Odysseus and his men.

1) Perseus cuts off Medusa's head; 2) Pegasos springs from her neck.

This mode of narration, in which several moments are worked together, has been named by Weitzmann the "simultaneous" method.[17] It is not the usual narrative method in the archaic period; more often a simple schema is presented, with no implications of time, as two warriors dueling or a girl riding a bull. This

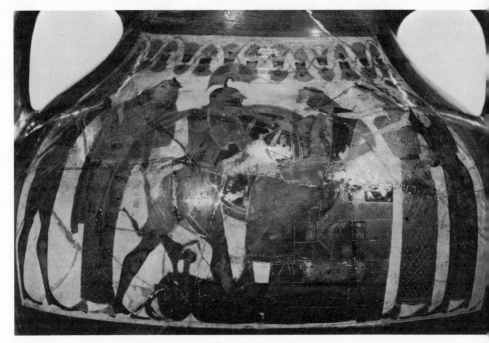

10 • Iliupersis. Lydos, amphora, Staatliche Museen zu Berlin 1685.
(Staatliche Museen zu Berlin)

simultaneous method is in no way primitive but a rich and tapestried tissue.[18]

Treatment of place is analogous to treatment of time. Actual indications of locality are very scant in Greek art. The interior of a house may be represented by a column or a chair or couch, or objects hung up on the wall. A tree may represent a garden or a forest, as fish the sea. Indications of place are few but place is implied by action: Polyphemos is blinded in his cave; Achilles feasts in his hut.

Neoptolemos is about to murder King Priam and the child Astyanax (FIG. 10): the scene is Troy. At the left of the picture a warrior has seized a woman and threatens her with his sword: Menelaos has found Helen at the sack of Troy and is about to lead her to the ships of the Achaians. The two events could not come at the same place in Troy, at least not in the same place at the same moment. As it appears to the eye, the scene is incredible: a helpless old man and a young boy are about to be murdered, and Menelaos and Helen do not even glance their way. But the scene is not to be taken literally: two places have been drawn into one.

A Vase Painter's Notebook

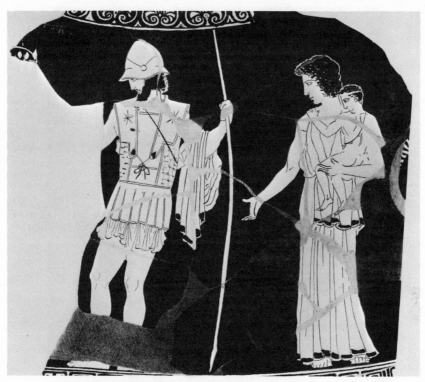

11 • Departure of Amphiaraos. Dwarf Painter, hydria, Boston 03.798.
(Courtesy Museum of Fine Arts, Boston)

The archaic fullness of the narrative art disappears in the
fifth century; now comes the dramatic moment, as Robert calls it.[19]
Let us set beside the archaic Corinthian departure of Amphiaraos a
classical Athenian version of the same scene (FIG.11) Amphiaraos
is armed and ready to go. He has turned away from the nurse who
is carrying his son and holds out his hand to Eriphyle, of whom
only the top of the head is preserved. They were probably clasping
hands, as in another example of the scene.[20] Amphiaraos is going
through the gesture of leave-taking but cannot look at his wife.
The nurse holds out her hand in a gesture of hopelessness, and the
child clings to her in fear. All look down. It is a moment of bitter
silence and eyes cannot meet.

Oidipus faces the sphinx who is posing her riddle. The excite-
ment of the moment is given by the intense stares, the almost
trembling hand of Oidipus. A moment, again, single, dramatic,
clarified.[21]

Bild und Lied

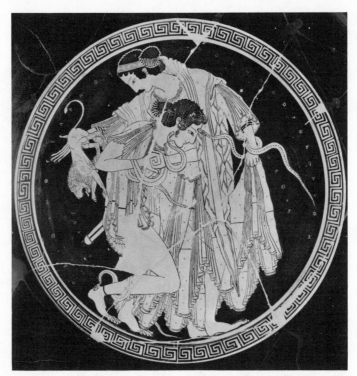

12 • Peleus and Thetis. Peithinos, cup, Staatliche Museen Preussischer Kulturbesitz, Berlin 2279. (Staatliche Museen Preussischer Kulturbesitz, Antikenabteilung)

Necessarily with this sharpening of the moment, this new unity of time, comes unity of place.

Thus the distinctive narrative method of the archaic period is the simultaneous method, the condensing of several moments into one without repeating the figures. The fifth century presents the dramatic moment. For the fourth century there may be said to be two specialties. One is the mythological scene that has lost its action: toward the end of the fifth century and in the fourth, mythological pictures slip into genre.[22]

A fourth-century illustration of the courtship of Peleus and Thetis has so little of the old type, the traditional scene, as to be at first view unrecognizable. Thetis, a sea nymph, could assume any form. To win her Peleus had to capture her. He seized her but she kept changing her form, transforming herself, one after another, into ferocious or slithering creatures. On a cup of the

A Vase Painter's Notebook

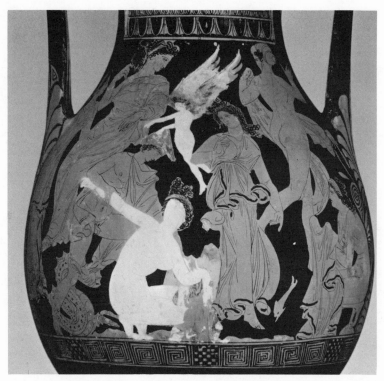

13 • Peleus and Thetis. Marsyas Painter, pelike, British Museum
E 424. (Trustees of the British Museum)

archaic period (FIG.12) Thetis is trying to get free as Peleus holds
on. A little lion attacks him, and snakes. We translate: Thetis
turns into a lion, then a snake.[23] In the fourth century a woman is
bathing at the seashore (FIG.13). A youth approaches and grasps
her arm. A sea monster is coiled about his leg: the youth is
Peleus, struggling to hold Thetis. Nereids, Thetis' sisters, flee. Here
are some of the elements of the old scene but the scene is new, a
picture of a bather surprised, a picture that is almost genre.[24]

Again, Poseidon runs after the fleeing Amymone, a daughter
of Danaos, in one of those pursuit scenes loved by the fifth century.
In the fourth century he holds her hand, looks into her eyes, and
whispers persuasive words.[25] Herakles in the archaic period battles
the dragon that guards the tree of the Hesperides. In the later fifth
and in the fourth century he stands or sits in quiet conversation

Bild und Lied

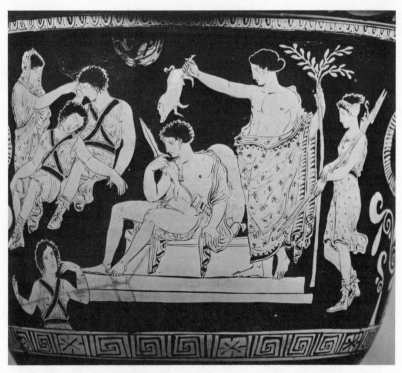

14 • *Eumenides*. Eumenides Painter, bell krater, Louvre K 710. (Musée National du Louvre)

with the nymphs in their garden.[26] Mythological figures, who emerged in the geometric period from tableaux of daily life, sink back into tableaux, now quiet idealized scenes, essentially without story, that is, without myth.

This mythological sunset of the fourth century is balanced by a sunrise. The other distinctive type of illustration is of the drama. For this we turn to South Italian vase painting.[27] Revivals of the great old Athenian tragedies must have been popular in Greek South Italy for many vase paintings seem to reflect performances of tragedy. They may be recognized as illustrations of the theater by the costume of the actors or indications of a scene building, or by a distinctive scene. For example, the ghost of Klytaimnestra is waking the Furies (FIG.14), as she does in the prologue of the *Eumenides* of Aischylos. In the center of the picture Orestes sits beside the omphalos, the navel of earth, the symbol of Delphi: the action takes place at Delphi. Apollo stands behind Orestes, purifying the murderer by sprinkling over him the blood of a pig. This

A Vase Painter's Notebook

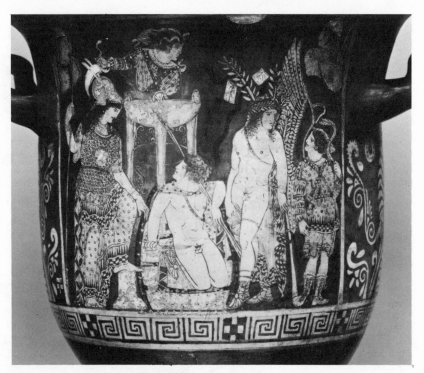

15 • *Eumenides.* Python, bell krater, British Museum 1917, 12-10, 1.
(Trustees of the British Museum)

is a scene we do not know. It could have been written into a fourth-century "improvement" of the play.[28] But it could not come at the same moment that Klytaimnestra is rousing the Furies. This is no still of a scene, rather a combination of moments of the play or of a performance.

Another fourth-century illustration of the *Eumenides* will clarify the method of the illustrator (FIG.15). Orestes is kneeling before the omphalos: the scene again is Delphi. Here are Apollo and the Furies: the moment, again, is early in the play. At the left Athena stands gazing upon Orestes—but she comes into the action after a year has passed and in another place, Athens. Moments and places are combined, without repetition of figures, in fourth-century illustration of tragedy as in archaic narrative illustration.[29]

As the mythological picture changes, so does its "frame." In the archaic period mythological scenes frequently include onlookers, "complementary figures," Robert calls them,[30] figures who do

Bild und Lied 23

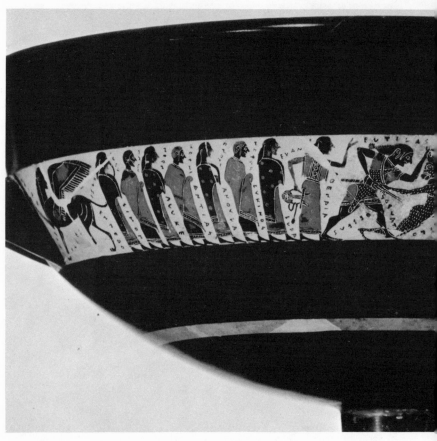

16 • Theseus and the Minotaur. Archikles and Glaukytes, cup, Munich 2243. (Staatliche Antikensammlungen und Glyptothek)

A Vase Painter's Notebook

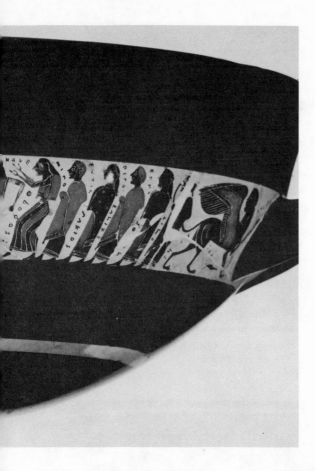

not belong to the action, figures, that is, whose function is decorative. On a black-figure cup (FIG.16) Theseus is killing the Minotaur to a packed house. Again, Aias the Less seizes Kassandra at the sack of Troy (FIG.17), attempts to tear her from the image of Athena to which she has fled, threatens her with his sword. A woman and a boy look on impassively. This is how black-figure spectators watch, a "do-nothing" chorus. In time the onlookers thaw. In the late sixth century Herakles wrestles with the Giant Antaios (FIG.18). On either side are screaming little figures who form a backdrop of panic and by their size make the heroic figures bigger. Now the frame is beginning to be part of the picture: the terror of the spectators is a comment on the action. Next, the frame disappears. In the bright light of the fifth century, with its dramatic focus, its single moment, the galleries are empty, and any onlookers who remain, remain because they have a part to play in the action.

Bild und Lied

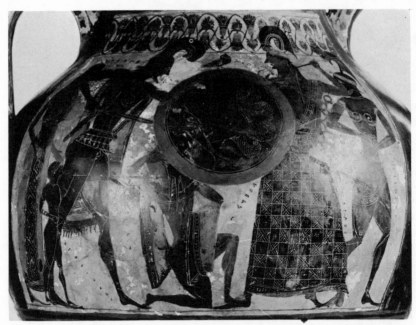

17 • Aias and Kassandra. Group E, amphora, Staatliche Museen zu Berlin 1698. (Staatliche Museen zu Berlin)

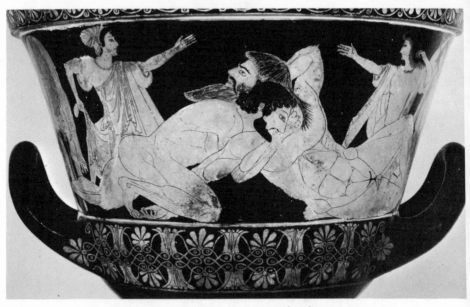

18 • Herakles and Antaios. Euphronios, calyx krater, Louvre G 103. (Musée National du Louvre)

A Vase Painter's Notebook

3

Zeus and
His Loves

Zeus is a weather god, the bringer of rain, "cloud gatherer" Homer calls him, hurler of the thunderbolt. He is a venerable god, as old as the Greeks in Greece.[1] But his myths show a lighter side; they are almost all about his love affairs, extramarital and triangular.

One of Zeus' loves was Io, daughter of the river god Inachos. Zeus suspected that Hera knew what was going on—as she always did—so he transformed Io into a heifer. Hera admired the heifer, asked for it as a gift, and Zeus could not refuse. Hera posted Argos to guard the heifer, Argos of a thousand eyes, the sleepless watchman. Zeus at last sent Hermes to kill Argos and rescue Io, and the death of Argos is a theme of vase painters. Hermes advances with drawn sword.* Argos, full of eyes, wounded, sinks to the ground, pleads. His beard is straggly, his many eyes bleary. Io the cow quietly walks away. Sometimes Argos is Janus-faced, a two-faced villain apparently; actually the painter wishes to show eyes in the back of the head.

Io transformed by Zeus is also transformed in the pictorial tradition. A heifer at first, she sheds her cow form and becomes a horned maiden, perhaps under the influence of Io in the *Prometheus*:[2] Aischylos presents Io in human form because a cow speaking lines could not possibly be a tragic figure, only a ridiculous one; and illustrators take up the concept of the horned maiden, the maiden touched by bovinity.

Europa was a Phoenician princess whom Zeus loved. He took the form of a gentle bull and carried her off to Crete. In the illustra-

* An asterisk here and throughout the book refers to the Index of Types.

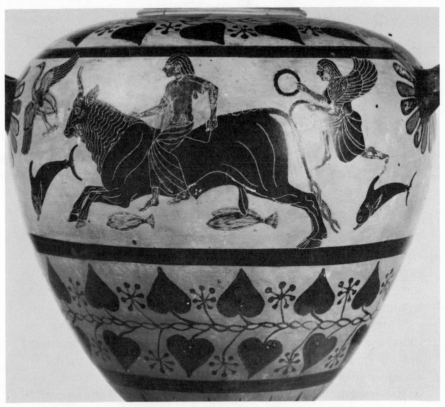

19 • Europa and the bull. Caeretan hydria, Villa Giulia 50.643. (Soprintendenza alle Antichità dell'Etruria Meridionale)

tions the bull bounds along, with Europa on his back. But—a woman riding a bull need not be Europa. We have criteria: (1) the bull must be running; (2) the girl must grasp the bull's neck or horn; (3) the sea should be indicated—by dolphins or other creatures.[3] Otherwise, unless an inscription names her as Europa, the woman riding a bull might be a goddess or, in a Dionysiac surround, a maenad.[4] We must therefore cross-examine ladies on bull-back, at least in the archaic period. Then we shall find, for example, Europa in FIG.19 but a maenad in FIG.20.

In the fourth century there is no problem of identification. On Attic vases there is an escort: Eros or a Triton or Nereids riding sea monsters.[5] Or, on South Italian vases, the action may take place on shore, the flowery meadow where Europa is among her friends, and the bull bursts in. Such elaboration is the pattern of many mythological scenes of the late fifth and the fourth century, those that

A Vase Painter's Notebook

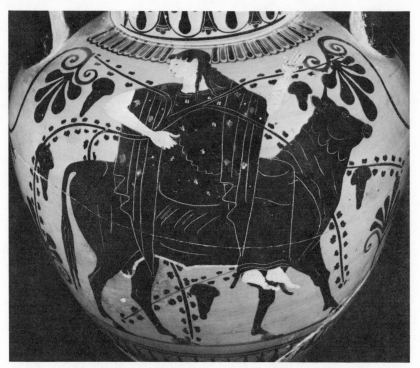

20 • Maenad riding bull. Leagros Group, neck amphora, Berkeley 8.3852. (Lowie Museum of Anthropology, University of California, Berkeley)

remain mythological. The old severe type is transformed into a scattered and populous scene.

Ganymede was a young Trojan prince whose beauty caught the fancy of Zeus, and Zeus took him among the Olympians to be his cupbearer. Ganymede first appears on Greek vases at the end of the sixth century, but it is not until the fifth that the myth finds a type. This is the pursuit, a favorite schema for love affairs of gods and mortals, a flexible type that can be accommodated to any tale of love.[6] One figure pursues another: the scene is characterized by attributes of one or the other runner. Thus Zeus runs after a woman, a bearded sceptered god in pursuit of a woman who might be Aigina if she is without attributes, or Thetis if she has a dolphin in her hand.[7] The god takes a trident, the woman a water jar: it is Poseidon pursuing Amymone—he met her at a spring.[8] Again, the god changes his mask for one with wind-bristled hair and beard; he takes wings and winged boots; the

Zeus and His Loves 29

woman puts attributes aside: Boreas, the North Wind, is rushing after the Athenian princess Oreithyia. Or a goddess may assume the role of pursuer: a winged woman runs after a boy who is sometimes characterized by his lyre as a schoolboy: the story is that of the love of Eos, the Dawn, for the young Tithonos.[9]

The pursuit of Ganymede by Zeus follows this pattern. The sceptered god runs after Ganymede, who is characterized as a young boy by hoop and hoop stick,* attributes adopted for him from daily life. Another attribute of Ganymede is the cock, a favorite love gift of men to boys, prized by young fans of the cock fight.[10]

It is not in vase painting but in sculpture that the myth finally finds a form of its own. This is the group of Ganymede and the eagle, the messenger of Zeus carrying the boy to Olympos. The invention of the type is attributed to the fourth-century sculptor Leochares. A single Roman copy may go back to the lost work, and there are many reflections in the minor arts.[11] A myth of a class least likely to find individual expression, the love of a god for a mortal, has at last found a type. This is independent of the literary tradition, for the original myth knows nothing of the eagle.[12]

A Vase Painter's Notebook

4

Old Midwives' Tales

Athena sprang from the head of Zeus and the gods looked on in awe.[1] This is just the picture we see on a number of black-figure vases and a few in red-figure. A lively little figure, full-armed, climbs out of the head. The gods look on, displaying their attributes with archaic care: Apollo plays the cithara, Poseidon holds his trident, Ares glowers behind his shield (FIG.21). Sometimes the surgeon Hephaistos leaves the scene. He has split the skull with an ax and hastens away as if in fear of his own bold stroke. As he departs he looks back toward the miraculous birth, his hand raised in astonishment. A birth goddess, an Eileithyia, stands before Zeus, sometimes another behind him, hands raised to Zeus' head in the gestures of the midwives' trade.[2]

Other vase paintings represent a moment before the birth. An Eileithyia stands before the seated Zeus, another usually behind, hands busy about the head. Gods may attend the labor. A third scene depicts a moment soon after the birth when a small armed Athena stands on the lap of her parent and the gods look on.

The birth is essentially a black-figure scene, though a trickle of its torrent survives into red-figure times.[3] It had dried up in the graphic tradition by the time Pheidias made his sketches for the east pediment of the Parthenon. But even if the tradition had continued, Pheidias must have stood outside it:[4] the lost central group of his composition cannot have resembled any of the lively archaic scenes we know but must have risen to a dignity proper to Athena's splendid dwelling on the Athenian Acropolis.

Another divine birth that made mytho-medical history was the

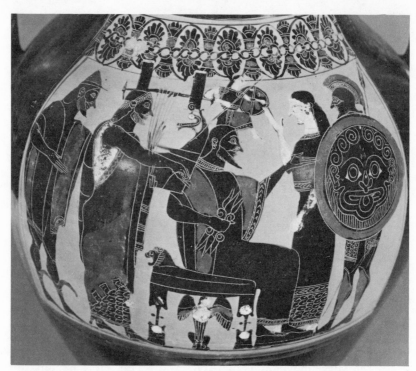

21 • Birth of Athena. Group E, amphora, Boston 00.330. (Courtesy Museum of Fine Arts, Boston)

birth of Dionysos. One of Zeus' loves was Semele, daughter of the Theban king Kadmos. Hera the jealous, Hera the wily, tricked Semele into asking Zeus to come to her as he had come to Hera. Semele had won a promise from him that he would fulfill any wish—that blank check of folktale—and Zeus could not refuse. He came to her in a flash of lightning and the mortal Semele was burnt to a crisp. Zeus rescued her unborn son Dionysos and sewed him in his thigh. When the time came Dionysos, the twice-born, was born from the thigh of Zeus.

A few vase paintings tell the story. Zeus is seated, sometimes among gods, giving birth. Once a little head is seen pushing through the thigh.[5] Or the child, half-emerged from the thigh, holds out his hands to an Eileithyia who comes to take him in her arms.*

Aphrodite was born from the sea. We feel the magic of a goddess rising on the great Ludovisi relief in Rome.[6] On vases we

A Vase Painter's Notebook

recognize the theme if rarely the wonder. Aphrodite is rising, half-visible. Eros, like Strephon older than his mother, stands on the shore, bends down to welcome her as she ascends.* A woman may approach, bringing a mantle for the newborn goddess, perhaps Charis, Grace, as she is once named.[7]

Once on a vase as on the Ludovisi relief the scene is set by pebbles, but usually there is no indication of sea or shore.[8] In an art that scarcely indicates locale, sea blends into land and a goddess rising from the sea is indistinguishable from a goddess rising from the depths of the earth.[9] And other goddesses than Aphrodite rise up from "deep places." Ge, the earth goddess, appears out of the earth; Pandora rises.[10]

Persephone, too, emerges from the ground. On an inscribed krater in New York she is stepping out of a cleft in the earth. She raises her hand in astonishment at the bright world of the living. Hekate, an underworld goddess, lights the way with torches; and Hermes stands behind her, conductor of the dead, guide in the underworld, a ghostly frontal figure. Demeter stands waiting, expressing by her whelmed quiet the wonder of the return, the return of the earth to life.[11]

Persephone rises on another inscribed vase, a krater in Dresden.[12] Hermes stands before her and Pans dance about her, goatmen, woodland spirits, wild with joy. And on an inscribed pelike in Rhodes, a goddess is ascending.[13] Hermes stands on one side, a single excited Pan on the other. The name of the goddess is not Persephone but Aphrodite: the rising, or anodos, of Persephone differs from the anodos of Aphrodite only in the inscription. But this is not Aphrodite rising from the sea but a nature goddess, the chthonian Aphrodite rising out of the earth.

There are other vase paintings, uninscribed, in which a goddess rises in the presence of Pan or Pans. On a skyphos in Boston a goddess ascends, serene amidst a wild dance of two Pans.[14] Is she

Persephone or Aphrodite? We cannot say.[15] Is she either? The rising goddess may be the center of a scene that is not narrative, not mythological, and in such a scene she will not be named. Call her Persephone, call her Pandora, call her chthonian Aphrodite—she is the great goddess of the powers of the earth.[16] The scene may be one of magical evocation or one of greeting:[17] the goddess rises from the earth in the spring, and the woodland spirits hop for joy.

Helen of Troy, in one version of the story of her birth, was the daughter of Zeus and Nemesis, goddess of retribution. Zeus loved the angry lady and wooed her, Nemesis fled, Zeus pursued, Nemesis changed herself into a goose, and Zeus took the form of a swan. And so it was that Nemesis laid an egg, the egg that was to hatch Helen. Zeus sent Hermes to bring the egg to Leda, wife of the Spartan king Tyndareos, to keep it safe until it hatched.

It is not until fairly late in the fifth century that the story wins a modicum of popularity among vase painters.[18] In the usual scene a small group of people, the family of Tyndareos, stand about an altar.* On the altar is a large egg: Hermes has brought the egg to the sanctuary of Zeus. At the sight of it Leda throws up her hands in astonishment. Tyndareos stands by, a bearded elder, sceptered, mantle-enfolded. One or both of the Dioscuri look on, Polydeukes and Kastor, twin sons of Zeus or, in another tradition, Polydeukes son of Zeus and Kastor son of Tyndareos. Hermes may be present, the egg man. Sometimes an eagle flies toward the altar, a sign from Zeus.[19] On a cup in Boston the eagle has alighted on the altar and studies the egg.[20] "Some egg!" it seems to say, "Some chicken!"

A Vase Painter's Notebook

5

A Comedy
of Arrows

No god seems more Greek than Apollo, with his beauty, his youth, his music. Seems—there is a harsh and cruel core. When we meet him first, in the *Iliad*,[1] he is striding along the peaks of Olympos, drawing his silver bow against the Greeks—an exercise that came to be a very bad habit. Witness the Niobids.

His father was Zeus, his mother Leto, one of the race of Titans, those old pre-Olympian divinities almost forgotten but for Prometheus, the fire giver, and Kronos and Rhea, parents of Zeus.

Father: Zeus; mother: Leto; twin sister: Artemis. Artemis the chaste and lovely huntress, the Euripidean, Praxitelean huntress. So she seems. But there is always something of the old Artemis: originally she is a mighty goddess of nature. *Potnia theron*, Homer calls her, mistress of wild animals, and early monuments show her in this primitive role.[2] On a well-known "Melian" amphora Apollo is arriving somewhere in a chariot, a figure bearded in the early manner, recognizable by his cithara.[3] He is accompanied by two women whom we cannot name and is greeted by a third woman, whom we know by her quiver and bow. It is Artemis, mistress of wild animals, grasping a stag by the antlers, to show her power over it and her intimacy.

Apollo and Artemis often appear together on the monuments. Sometimes Leto is with them, and we know her by the association: her children are her attributes.

Apollo went to Delphi, slew Python, the mighty dragon that guarded the oracle, and took over the oracle. When his mother came to join him she was set upon by Tityos, son of Earth, who carried her off with intent to rape. She cried for help and her chil-

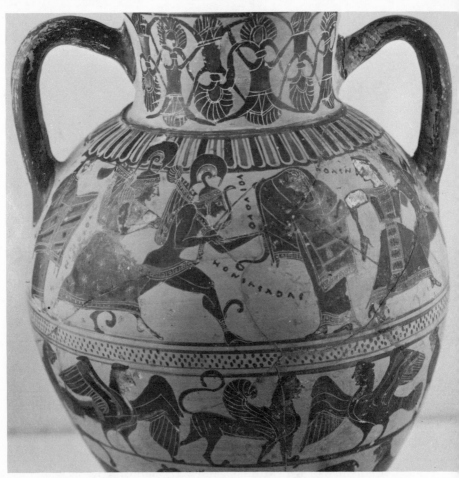

22 • Apollo and Tityos. Tyrrhenian neck amphora, Tarquinia T 2.
(Soprintendenza alle Antichità dell'Etruria Meridionale)

dren heard. In the archaic type the abduction is combined with the punishment.[4] Tityos is running off with Leto: exit pursued by the Letoids, who loose a rain of arrows as they come (FIG.22). Sometimes a female figure stands in the path of the arrows, Ge, Earth. She has come to protect her son or appeal for his life.[5]

In the fifth century, with its single moment, painters no longer combine two scenes but represent the moment of Tityos' collapse. The twins attack or, more often, only Apollo—so lean the type has become. Tityos, wounded by arrows, is sinking. He may hold out a hand to Apollo in entreaty, with the other hand clinging feebly to

A Vase Painter's Notebook

a goddess who is at his side; but she slips from his grasp and turns to flee, drawing aside her veil (FIGS.23, 24).

Who is the goddess? Is it Ge, to whom Tityos turns for help? Or Leto, escaping as her captor falls and his hold slackens? Nineteenth-century scholars identified her as Leto. The veil is the clue: Apollonios Rhodios describes a scene woven into Jason's mantle, in which Apollo shoots Tityos as he is dragging Leto by her veil.[6] Toward the end of the nineteenth century it was seen that the goddess is fleeing from Apollo, not toward him as Leto would. It must be Ge, who is still appealing for the life of her son even as she flees from the angry god.[7] And by the mid-twentieth century the argument had run full circle: the lady must be Leto. The veil is the clue: Apollonios Rhodios describes a scene woven into Jason's mantle. . . .[8]

The goddess does not always wear a veil, and the veil is probably irrelevant to an interpretation. But it is significant that the veiled goddess belongs to the fifth century, when the scene has become spare, bare, and dramatic, a scene now usually stripped even of Artemis. In a drama played by three actors, Apollo, Tityos, and another, the third actor should be Leto because she is needed to identify Apollo's victim.[9]

In black-figure times an archer might brush with his bow the victim of his arrows, but now artists recognize the problem of distance that the bow brings to a scene. In our example the painter has given distance to the field by placing Apollo on one side of the vase, Tityos on the other.[10] Another solution is for Apollo, having shot, to move in with a sword for the kill.[11] He still holds his bow as he swings his sword. Tityos cringes. And the mysterious goddess lifts her veil and flees.

Tityos' act would have been acceptable in a god—but he was not a god. He was guilty of hubris, arrogant pride, assuming a role

23 • 24 • A. Apollo. B. Tityos. Eucharides Painter, neck amphora, British Museum E 278. (Trustees of the British Museum)

above his station. Hubris, again, was Niobe's fault. Niobe was daughter to Tantalos, ancestor of the house of Atreus, himself guilty of hubris for which he suffered punishment in the underworld so cruel that we describe it by his name.

Niobe married Amphion, a king of Thebes, and had six daughters and six radiant sons,[12] her great pride. Her great pride and her fall, for she boasted that she was better than Leto: she had borne many children, Leto only two. Whereupon the two destroyed the many: the Letoids shot down the Niobids. The theme is important in Greek sculpture, rare in vase painting, and typeless.[13] On a celebrated krater in the Louvre Apollo and Artemis are shooting Niobids in a bleak Polygnotan landscape.[14] On a cup in the British Museum Apollo shoots on one side, Artemis on the other.[15] Our few other examples, those that are more than fragments, show little resemblance to either of these.

Another creature who felt the edge of Apollo's fury was the satyr Marsyas. It all began when Athena threw away the double flute. She had invented that instrument and played for the gods but—they laughed when she sat down to play. A look in the mirror told her why: she puffed out her cheeks and spoilt her pretty face. She turned against the flutes, flung them away, and Marsyas picked them up. We know the next moment in copies of Myron's bronze group that stood on the Acropolis at Athens: Athena returns to the scene and Marsyas starts back, clutched by fear.

Still, he mastered the instrument and, compounding hubris, dared to challenge Apollo to a contest: he would play the flutes, Apollo the cithara, and the winner could do what he pleased to the loser. The subject of the contest begins to be popular among vase painters only in the later fifth century.[16]

Marsyas sits on a rock playing the flutes.[17] Apollo stands before him, laurel-wreathed, holding the laurel branch, superior.*

A Comedy of Arrows

Muses frame the scene or other listeners: Artemis; Athena, who had set the action moving; Hermes, inventor of the lyre; a brother satyr; maenads.

Now it is Apollo's turn. He sits down to play or, in a small group of fourth-century vase paintings, stands, clad in the rich, long-sleeved robe of the kitharodos.[18] He moves downstage center, he dominates the scene. Marsyas sits listening, rapt or dejected. Others listen: muses; Artemis; Olympos the flute player, Marsyas' pupil, a Phrygian youth, recognizable by his soft pointed cap.

After the contest came the reckoning. The preparation for the flaying of Marsyas is depicted on vases,[19] but we know it best in sculpture, in the Hellenistic group of Marsyas bound and hanging by the wrists, in naked agony; Apollo's Scythian slave sharpening his knife and looking up dumbly at Marsyas, a Hellenistic Man with the Hoe; and perhaps Apollo, a serene spectator. waiting for the performance to begin.

A victim of Apollo's twin was the hunter Aktaion. He was punished by Artemis, in the story we know, when he came upon her bathing:

> And, as he thought to scape,
> Changed was Acteons shape;
> Such was unluckie fate
> yeelded to him.

Artemis changed him into a stag, and he was torn to pieces by his own hounds. The transformation and the tearing are old, but the story of the bath is Hellenistic, is not the version the vase painters knew.[20] Let us turn to the vase paintings for the older myth.

In the black-figure type Aktaion is trying to escape from a pack of hounds who swarm over him, sinking in their teeth. Blood flows. The type is a tangle of man and tiny dogs. There is as yet no trans-

A Vase Painter's Notebook

25 • Death of Aktaion. Lykaon Painter, detail of a bell krater, Boston
00.346. (Courtesy Museum of Fine Arts, Boston)

formation.*²¹ In late black-figure the running man tries to defend
himself. Sometimes the scene is framed by women, and then one
of them takes bow and quiver and becomes Artemis—fully clothed,
by the way.²²

Other changes come with red-figure. The running man stops—
is stopped: he sinks to one knee, still defending himself with stick
or spears, forming a triangle with the dogs, dogs now fewer and
larger than before. Artemis stands quietly, inciting the hounds.²³

Sometimes Aktaion wears an animal skin: Artemis does not ac-
tually transform him but throws about him the skin of a stag and so
deceives the hounds.²⁴ In the classical period we see the transfor-
mation. On a krater in Boston (FIG.25) Aktaion, half-fallen, fight-
ing off the hounds, is already part stag. He has antlers and ears of
a deer and fur upon his face. Artemis stands in the wings as a figure
new to the scene runs in. This newcomer wears a short chiton,
long-sleeved Persian jacket, hunting boots, and—strange huntress
—a dog's head atop her own. It is Lyssa, the inscription tells us,
Madness, and the dog's head alludes to a special meaning of the
word, madness in dogs, rabies. She comes in a gliding run, in full
cry, as hounds follow the huntsman.²⁵

A Comedy of Arrows

This Lyssa is a well-known personification of tragedy, so that the vase painting has been seen as a reflection of a lost tragedy.[26] Such personifications—Madness, Frenzy, Deceit—appear on South Italian vases that reflect performances of Athenian tragedy, and sometimes they carry torches, the torch of madness.[27] There is a torch in our Attic picture, too, but it is carried by Artemis, not Lyssa. Is Artemis holding Lyssa's attribute while Lyssa maddens the hounds?[28] She may be doing that, for Lyssa has taken the role that Artemis plays elsewhere.

There is another new figure in the picture, an absorbed spectator, bearded, carrying scepter and flaming thunderbolt, and named: Zeus is watching his commands obeyed. Aktaion was Zeus' rival for the love of Semele and Zeus ordered Artemis to slay him.[29] This picture explains the others: Artemis is only the executioner in the older myth.[30]

A Vase Painter's Notebook

6

A Happy Return

Hera in a rage flung Hephaistos from lofty Olympos. He found refuge in an ocean cave with the sea nymphs Thetis and Eurynome, and here he set up his smithy. One day he sent his mother a gift, a dazzling golden throne. Hera sat down and, when she tried to rise, found herself held by invisible chains. Only Hephaistos could release her and he would not come. Ares went out to capture him but Hephaistos drove off the war god with firebrands from his furnace. Then Dionysos made Hephaistos drunk and brought him back to Olympos.

Kleitias tells the story on the François vase.[1] The gods wait on Olympos. Zeus is throned; Hera, throned perforce, scolds with chirping hands. Athena pours scorn upon Ares, who sits in armor, head bowed, the god of war humbled by the lame craftsman— worse, robbed of his beloved Aphrodite, who was, it seems, to be given to Hephaistos as payment for freeing Hera.[2] Aphrodite stands at the edge of Olympos, dismayed at the sight of the revelers approaching with her husband-to-be. Dionysos leads; Hephaistos follows on muleback, riding because of his lameness, which is indicated again by a twisted foot. Then come the thiasos of Dionysos, his band of followers, satyrs and maenads, or silenoi and nymphs, as Kleitias names them. Satyrs here are more equine than later satyrs, with horses' legs, besides tails and ears, the slender, elegant, nervous legs of Kleitian horses.

Lameness is depicted only here in Attic illustrations of the return of Hephaistos.[3] Non-Attic painters delight in exaggerating lameness to deformity, but Athenians after Kleitias suggest it only, by the riding.

No other illustration of the return is so full as Kleitias'.[4] In Attic as in non-Attic black-figure the usual schema is that of the komos, the throng of revelers, the Dionysiac rout. On Attic vases

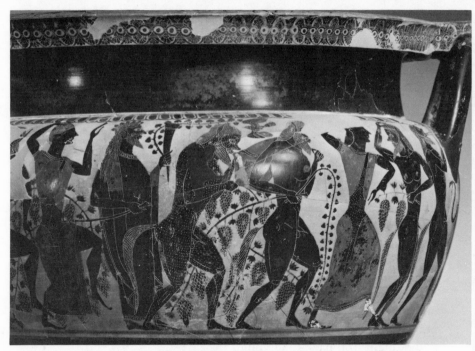

26 • Return of Hephaistos. Lydos, column krater, New York 31.11.11.
(The Metropolitan Museum of Art, Fletcher Fund, 1931)

Dionysos may walk ahead, turning to look back at his prize,
Hephaistos riding the mule; all about are dancing satyrs and
maenads. Or the frieze may run round the whole vase, with Diony-
sos on one side, Hephaistos on the other. Dionysos stands stiff and
stately among his rout: drunken satyrs, maenads who lift their long
thin feet and hands in angular fierce motions of the dance (FIG.26).
Hephaistos on the other side rides his mule amidst the dancing
throng. It is a picture of simple and glorious drunkenness and, ap-
propriately, the scene was painted on many drinking cups and on
kraters, mixing bowls for wine and water.

Hephaistos, at first without attributes, acquires a hammer, tool
of the metal worker.[5] In red-figure he also carries tongs, whose jaws
bite a lump of metal still smoking from his forge.

With red-figure changes come to the schema. The komos con-
tinues but Hephaistos may go on foot: the painter is able to sug-
gest either lameness (Hephaistos rides) or intoxication (Hephaistos
staggers). Not only he but even Dionysos may be drunk. The two

A Vase Painter's Notebook

gods may stumble along together, Hephaistos with hammer or tongs, Dionysos with thyrsos and kantharos.

In the classical period the komos is usually reduced to a few figures: perhaps only Dionysos; Hephaistos riding, youthful or bearded; and a single satyr.[6] The period has set its mark upon the scene: the old drunken revel has become sober, dignified, noble. On a krater in Munich (FIG.27) is a little procession of three. At the head is a satyr playing not the double flute, the instrument of excitement, but the gentle lyre. A youthful Hephaistos rides his mule, as Furtwängler remarked, with the ease and dignity of the youths of the Parthenon frieze.[7] Dionysos strides before him, a tall, commanding, irresistible figure. He turns back to Hephaistos, compelling him with his glance, no longer by the happy persuasion of the vine.[8]

The scene hardly outlives the classical period. In the later fifth century a few painters return to the theme of drunkenness.[9] On a krater of this period, when mythological pictures are fading into genre, two drinkers recline on a couch. One is recognizable as Dionysos; the other is named in an inscription, Hephaistos.[10] The old komos is no more; the revelers have gone inside an Athenian dining room.

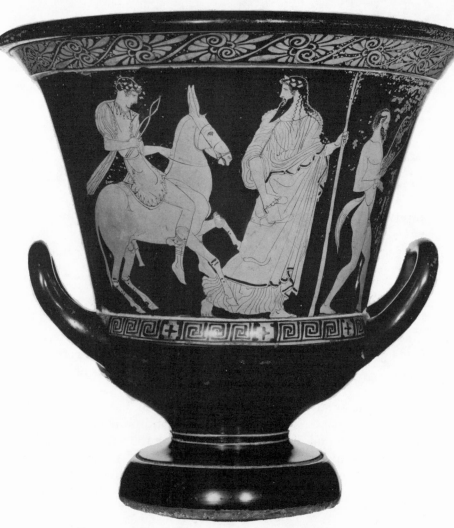

27 • Return of Hephaistos. Group of Polygnotos, calyx krater,
Munich 2384. (Staatliche Antikensammlungen und Glyptothek)

A Vase Painter's Notebook

7

The Giants
are Coming!

The Gigantomachy, the battle of the gods and the Giants who rebelled against them, is vastly popular in Greek art. Beginning in the sixth century it is the subject of sculptured pediments and friezes and, among the minor arts, hundreds of vase paintings.[1] It comes, in time, to symbolize the struggle that civilization and reason have to wage against the forces of darkness, this battle as well as battles of Greeks against centaurs, Amazons, and Trojans.

To the archaic artist a battle is a series of single combats.[2] Beneath the rush is always the duel. The archaic Gigantomachy, then, is a succession of single combats, enlargeable to many, abridgeable to a few or to a single duel between a god and a Giant; and this form continues beyond the archaic period. In the full Gigantomachy the duels are arranged about a center, a triad of Zeus, Athena, and Herakles.[3] Why Herakles, who is not a god? Because an oracle had revealed that the gods could not win without the help of a mortal, and the mortal in the story is Herakles.

The gods come against the attackers, recognizable and fierce. Zeus hurls his thunderbolt; Herakles draws his bow; and Athena, a raging warrioress, fights with her spear and defends herself with her snake-ringed aegis.[4] Ares is always the hoplite.[5] Poseidon uses his trident, his fish spear, to spear Giants. Sometimes he shoulders a huge rock, the island of Nisyros, a piece of Kos, which he broke off with his trident and hurled at the Giant Polybotes (FIG.28).[6] Artemis draws her bow but Apollo fights at closer quarters with sword or spear.[7] Hermes, too, takes arms.[8] Dionysos fights with spear at first, later the thyrsos. He may be helped by his wild beasts —lion, panther, snake; and in the fifth century he comes at the

47

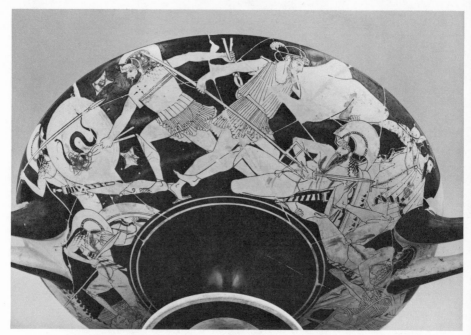

28 • Gigantomachy. Brygos Painter, cup, Staatliche Museen Preussischer Kulturbesitz, Berlin 2293. (Staatliche Museen Preussischer Kulturbesitz, Antikenabteilung)

head of a company of satyrs and maenads.[9] Hephaistos may wield his tongs, loaded with red-hot metal (FIG.28).[10] Other gods play minor roles.

The Giants in the sixth century appear as Greek hoplites, full-covered by their Corinthian helmets and great round shields. Later they push back the Corinthian helmet or exchange it for one that shows the face. They fight with sword or spear or occasionally throw stones, the weaponry of the savage.[11]

In the course of the fifth century a remarkable change comes over the Giants.[12] An amphora in the Louvre, of about 400 B.C.

A Vase Painter's Notebook

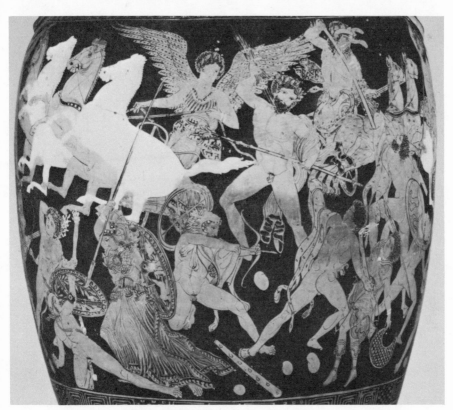

29 • Gigantomachy. Suessula Painter, neck amphora, Louvre S 1677. (Musée National du Louvre)

(FIG.29) tells the story.[13] Some of the Giants have shields and helmets, but others are clad in animal skins: they are barbarians, cave men, and they fight with clubs and stones and, as Apollodoros says, "burning trees."[14]

The battle centers about Zeus. He has leaped down from his chariot and hurls his thunderbolt at a Giant whom we may name Porphyrion, the traditional antagonist of Zeus, one of the new savage breed. Porphyrion faces Zeus, shielding his arm with an animal skin and aiming a burning tree. Beside him a woman is fighting on the side of the Giants. She is trying to throw her spear at Zeus, but her arm has lost its strength. She is falling back and as she falls, the shield slips from her arm, the crescent shield of the

The Giants are Coming! 49

Amazon. We know of no woman who fought on the side of the Giants and we cannot name her.[15]

Porphyrion and his strange companion form one arm of a triangle whose apex is Zeus and whose other arm completes the central triad: below Zeus Herakles kneels and draws his bow; below Herakles Athena lunges at a fallen Giant, Enkelados, we may name him.[16]

In the upper row, again, Dionysos aims his thyrsos from his panther-drawn chariot. Poseidon, patron of horsemen, fights on horseback, trident poised. Below him is Hermes, with chlamys and winged hat. He has seized a fallen Giant by the hair and is ready to plunge his sword. And so the battle rages.[17] And beneath the fury and the confusion is the old schema of the dual, two tiers of duels now instead of one as earlier.[18] The duels are sometimes fought on a single level, as those of Athena and Hermes; but sometimes one figure is on a higher level than the other—always a god, who aims his weapon downward at a Giant fighting upward.

The Giants are storming the citadel of the gods. They are scaling Olympos. This is a new idea that comes into the Gigantomachy at the end of the fifth century.[19]

The most-discussed of the turn-of-the-century Gigantomachy vases is a fragmentary krater in Naples (FIG.30).[20] A youthful Giant is laboring to lift a huge rock, perhaps to crush a god as Poseidon crushes Polybotes.[21] To his right is a Giant seen from behind. An animal skin is thrown over his shield arm; he is hurling a missile upward. A fragmentary inscription names him as Porphyrion. He is the very twin of Porphyrion on the amphora in Paris. Above him Giants climb, an army advancing, scaling the heights of the gods.[22] To the right of Porphyrion a Giant staggers under the weight of a great rock. Farther to the right Ge, Earth, rises up out of the ground to plead for her sons the Giants, Ge,

A Vase Painter's Notebook

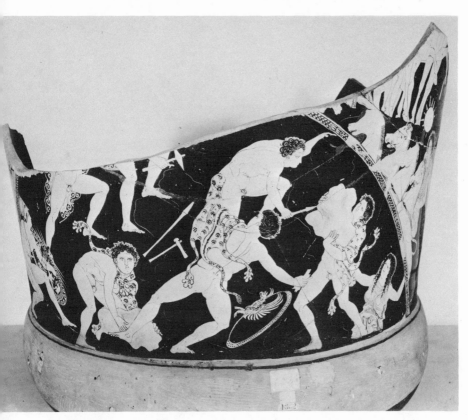

30 • Gigantomachy. Near the Pronomos Painter, calyx krater, Naples 2883, Museo Archeologico Nazionale. (Fotografia della Soprintendenza alle Antichità delle Province di Napoli e Caserta—Napoli)

who appears in a few archaic Gigantomachies, then not again before the end of the fifth century.[23]

At the left is a Giant of the old tradition, with helmet and sword. He is named in an inscription, Enkelados. He sits leaning against the arc of a circle. The circle is broken at the top; the arc at the left was originally continued by the one at the right: both are arcs of the same circle, or semicircle, rather, since it stops at the foot of the vase.

At the right, identified by the sun above him, Helios drives his horses up over the arc, and at the left a woman on muleback is descending. It is Selene, the moon goddess, setting as the sun god rises. The sun rises and the moon sets about this arc: it is the vault of heaven.[24] In the sky is a team of horses: here was the four-horse chariot of a god fighting from the heights, as Zeus on the Paris amphora, a defender of the lofty citadel.

The arc contains the army of Giants, the cave men with their animal skins and their rocks, and the old-fashioned warrior Enkelados. Enkelados sits resting, holding his shield, which is elaborately decorated with a sculptured blazon and a painting inside. We know other paintings on the interiors of shields, and these have been explained by Cecil Smith: they probably represent painted or woven designs on textile linings, linings that served as cushions for the shield arm.[25]

Enkelados' shield painting represents a battle, indeed a Gigantomachy, a Gigantomachy within a Gigantomachy.[26] A warrior strides forward, aiming his spear downward, a god defending the citadel. At his feet is a fallen Giant; two Giants oppose him. Of one only the head can be seen above Enkelados' arm. The other is seen from behind, his right arm raised to throw a stone, his left arm shielded by an animal skin.[27]

We know this figure. He is Porphyrion of the Naples Gigantomachy itself, the figure seen from behind, throwing a missile, with an animal skin on his shield arm. He is Porphyrion of the Paris Gigantomachy. And he comes into other Gigantomachies of about 400 B.C.[28]

These figures of Porphyrion are remarkably alike yet they occur in compositions that are unlike. We are not dealing with a vase painters' type, repeated from hand to hand with little varia-

tion. We have come, rather, upon a problem of archaeological detection. As a detective, when a pattern recurs, seeks a single criminal, so the archaeological detective, when a figure recurs on a series of monuments, seeks a single source. He looks in ancient literature, the archaeological police records, for mention of a work from which the extant figures could have been taken. Our vase painters are not copying but recalling and, occasionally, quoting.

We are looking for a work, most likely a painting, since painting is the natural model of the vase painter.[29] A lost painting, since Greek painting is lost, a celebrated painting of a Giganto-machy. And since the recurring figure, the Giant Porphyrion, appears on vases with Giants fighting for the first time uphill, we may suppose that this lost painting was the one that introduced the idea of the Giants scaling the heights and the gods defending their lofty fastness.

The archaeological detective is on the trail. He is Cecil Smith, at the time our story opens, in 1896, Assistant Keeper of the Department of Greek and Roman Antiquities of the British Museum.[30] He recalls Pliny's mention of a Gigantomachy of the fifth century, probably a painting, the Gigantomachy that decorated the concave interior of the shield of the Athena Parthenos of Pheidias, the great gold and ivory statue that stood in the Parthenon.[31] We have many Roman copies of the Parthenos, all different, all reduced free copies. The main lines of the original are most accurately reproduced in a small figure in Athens, the Varvakeion statuette, the main lines but nothing of the greatness. Athena stands holding a Nike in one hand; the other hand rests on her shield. Inside the shield her great snake is coiled.

We possess a number of copies of the shield as well as of the Athena, copies not of the Gigantomachy inside but of the sculptured Amazonomachy on the outside. One of these copies is the

Strangford shield in the British Museum, long known for its Pheidian Amazonomachy. Cecil Smith was the first to wonder whether the Gigantomachy inside the shield had been copied as well as the Amazonomachy of the outside. He was the first to look inside and he found traces of a painted figure "so distinct that one can only marvel that it has hitherto escaped notice."[32] He describes a bearded figure bending and lifting a rock, a Giant who is "almost identical" with the youthful figure of the Naples Gigantomachy who stoops to lift a rock.[33] Thus Smith had linked the Naples vase to a lost work, the Gigantomachy of the shield of Athena Parthenos.

Some forty years later the Strangford Gigantomachy was studied again by Arnold von Salis, who made out a second painted figure, a second Giant, on the interior of the shield.[34] He confirmed the relation of the Strangford and Naples Gigantomachies and brought other vase paintings into the picture.

To summarize: the stooping Giant appears on the Strangford shield and on the Naples krater; the fighting Giant Porphyrion appears on the Naples krater and in several other Gigantomachies. The former figure relates the Naples vase to the shield of Athena Parthenos; the latter relates the whole group of turn-of-the-century Gigantomachies to the Naples vase, which is related, in turn, to the shield painting. All reflect, more or less dimly, the lost shield painting.[35]

The evidence points to Pheidias. But we should like more evidence. There is also the compositional requirement: we are looking for the painting that introduced the idea of a battle up the heights, that freed the Gigantomachy from the old pattern, the chain of single combats. Of Pheidias' composition we have only two sketchy figures, dim remains of a copy that was never more than a reduced, free, and hasty excerpt. Still, we know something

A Vase Painter's Notebook

of the composition of the outside, and this helps us to imagine that of the inside: the Amazonomachy is a battle up and down the rocky slope of the Athenian Acropolis—a new idea, as far as we know, of Pheidias.[36]

In the Naples Gigantomachy, more than any of the others, the single combat is given up for an irregular uphill battle, so that this has seemed the closest of all the Gigantomachies to the lost painting of Pheidias.[37] And it has another connection with Pheidias: it is marked by the Pheidian idea of a frame of rising sun and setting moon.[38]

Before he painted the shield Pheidias had tried this frame, sun rising, moon setting, on the north metopes of the Parthenon. He used it also for three birth scenes, two of them sculptured on the bases of the great cult statues, the birth of Pandora on the base of the Athena Parthenos, the birth of Aphrodite on the base of the Zeus at Olympia. And in the east pediment of the Parthenon the birth of Athena is set in the vast and joyous frame of sunrise and moonset. Helios drives his horses out of the sea, his arms and head emerging in the left angle; Selene guides her team under the waves, and as the horses descend their heads fill the right angle.

Perhaps we can arrange these framed scenes in a meaningful sequence. Pheidias has devised the frame of Helios and Selene for the north metopes. Now—we imagine—he is painting the sun god on the shield. The designs for the pediments are always on his mind: how right for the birth of Athena! Perhaps he recalls Aias greeting the charioteer Helios for the last time and never again.[39] Athena would greet this bright charioteer—in joy as she springs to the light. He tries his frame for a birth scene, the birth of Pandora on the base of the Parthenos. And after the model, the east pediment.

What of the birth of Aphrodite sculptured on the base of the Olympian Zeus, framed again by Helios and Selene? A signature, perhaps, of the exile, remembering glorious Athens.

8

The Life
of Labors

Herakles is the hero of the Greeks most loved and most portrayed. His appeal is that of the strong man, the helper of mankind who rids the world of dangerous beasts.[1] He has faults as large as his virtues and they, too, appeal: no high and remote tragic flaws, rather comic flaws, as gluttony and boasting, which give him a very long life as a stock character of low comedy.[2] He holds a magnifying mirror to nature.

But there is more than strength and goodness and gluttony: his story is the story of mankind, the life of labors that come to an end only with death. Herakles is Everyman. More, he expresses the hope of Everyman when, after his death, he is taken into the circle of the gods.

During his lifetime, too, he carries the battle against death. He wrestles with Death in the *Alkestis* of Euripides, and the later labors express in symbols the same struggle. In the far west, where the sun sets, he battles the triple-bodied Geryon, double of Hades, lord of the underworld. He descends into the underworld itself to capture the fierce watchdog Kerberos. And he journeys to the garden of the Hesperides to bring back the apples of immortality.[3]

Another hero who won a victory over death was Tithonos, whom Eos loved. She asked Zeus to make him immortal but forgot to ask for eternal youth as well, and he all but withered away, a loathsome husk about an incessant whispered complaint. But Herakles gained youth with immortality. After his apotheosis he married Hebe, Youth. There is a commentary on the marriage to Hebe, a companion story, lost in literature and known only in a few vase paintings. Herakles is pursuing an old man or threaten-

ing him with his club.* The victim is a nude beardling with wrin-
kled brow, shrunken limbs, and large misshapen genitals.[4] On
two vases he is named: Geras, Old Age. Herakles, the slayer of
Death, to whom Youth has been given, is thrashing Old Age.[5]

Herakles was the son of Zeus and Alkmene, a mortal woman,
wife of Amphitryon. Zeus came to Alkmene in the guise of Am-
phitryon, and she bore twin sons, Zeus' son Herakles and Amphi-
tryon's son Iphikles. Hera in her untiring fury at Zeus' infidelity,
sent a welcoming committee, a pair of deadly serpents, which the
infant Herakles strangled, a prelude to his labors.[6]

Herakles grew to manhood, married, was visited with mad-
ness by his patient enemy Hera, and slew his wife and children.
After the murders he consulted the priestess of Apollo, who sent
him into bondage for twelve years to Eurystheus, king of Myce-
nae. Each year Eurystheus set for him an impossible task, hoping
he would not come back, and these tasks in time become the cycle
of the twelve labors.[7]

1. The first of the labors was the slaying of the Nemean lion,
a beast sent by the gentle Hera to harass the herdsmen of Nemea,
a valley in Argolis. This is the most popular of all the adventures:
hundreds of illustrations are known from the archaic period.[8]
The lion was invulnerable to metal and Herakles had to strangle
him. There are illustrations in which he swings his club or
plunges the ineffective sword, but the most frequent form of the
struggle is the wrestling match. The two figures form a tall trian-
gle, Herakles the left arm, the lion the right.*[9] The lion supports
himself on one hind leg, claws at Herakles' thigh with the other.
He attacks with teeth as well, to break Herakles' neckhold,
but Herakles forces the great jaws open and makes them help-
less.[10]

Sometimes there are onlookers, most often Athena and the

mortal Iolaos, Iphikles' son, Herakles' nephew and faithful friend. Even as a black-figure spectator Iolaos helps, holding Herakles' club and bow while the hero is in action. Hermes, too, may watch or, having escorted Herakles to Nemea, turn to go.

In the later sixth century, perhaps about 530, a "low" or "horizontal" type appears and this type prevails in late black-figure and archaic red-figure. Herakles has thrown the lion and the struggle continues on the ground (FIG.31). The lion strikes Herakles' head with a hind paw as Herakles seizes him or is already strangling him. There may be the usual spectators—Athena often on the right, like the central figure of a pediment whose left wing is filled by the wrestlers. The theory of influence of an archaic pediment accounts not only for the form of the new schema but for its sudden popularity.[11]

Herakles skinned the lion and after the first labor wears the lionskin, except, of course, in the early period when heroes are naked of attributes.[12] The front paws are knotted over his chest, the hind ones hang down; the tail may float gaily behind him or be tucked up under his belt; and the head covers his, the white teeth framing his face.

2. Next he confronted the Lernaean hydra, a serpentine monster, many-headed, that lived in the swamps of Lerna, in Argolis, and ravaged the land. More than invulnerable, it thrived on decapitation: whenever a head was cut off, two would grow in its place. For this labor even Herakles needed help and his friend Iolaos was on hand.

The scene is one of the oldest in Greek art. It occurs, fully formed, on Boeotian fibulae of the end of the eighth century or the early seventh.[13] On one of these the monster is in the center of the picture, pouring heads like a malignant fountain. Herakles attacks from one side with sword, Iolaos from the other with harpe, a sickle or scimitar specialized in Greek mythology to cutting off

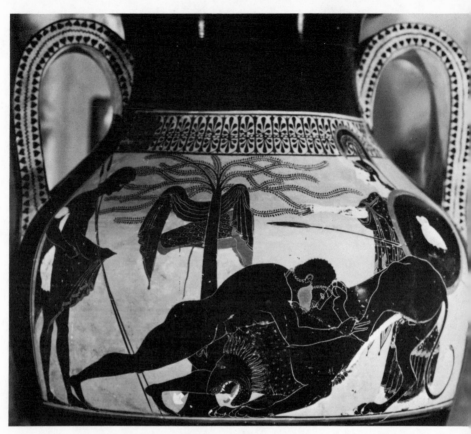

31 • Herakles and the lion. Psiax, amphora, Brescia. (Per concessione della Direzione dei Civici Musei di Brescia)

A Vase Painter's Notebook

monsters' heads. Below, ready to pinch, is a mighty crab, an ally of the hydra—courtesy of Hera.[14]

The series continues on Corinthian vases. The hydra becomes a many-coiled thing, rearing its heads against the heroes, Herakles with sword, Iolaos with harpe. The crab may be on duty. The Corinthian painters add a chariot to bring the heroes to Lerna and they add Athena, the helper of heroes.[15]

From Corinth the scene travels to Athens, where the hydra undergoes changes.* It gradually loses its sinuousness until, in the fifth century, it is a lumbering scaly monster with cloven tail and a tuft of snake heads. The stouthearted Iolaos, too, suffers diminution. If he is present at all, he may wait in the chariot. Or he may take part, searing the necks with torches to prevent new heads from growing, as Herakles, who has appropriated the harpe, cuts.[16]

3. The third labor was to bring the Erymanthian boar, alive, to Eurystheus, a ferocious boar that lived on Mount Erymanthos in the northwest Peloponnesos. Herakles pursued the boar through the woods and during the chase stopped to visit the centaur Pholos. Pholos entertained him in his cave with meat and drink. In the scene of the visit Herakles and Pholos stand, one on either side of a pithos, a large storage jar, which is sunk into the ground. Herakles lifts the lid or dips jug or kantharos, drawing wine; and Pholos may invite with a gesture.* The wine was fine and fragrant and the smell of it brought thirsty centaurs at a gallop, armed with branches and rocks. A battle followed, the battle of the pithos, and a rout of the centaurs.[17]

A pithos comes again into the scene in which Herakles brings the boar to Eurystheus.[18] When Eurystheus saw Herakles coming with the boar on his shoulder, he jumped into a pithos to hide.* The huge jar is sunk into the ground and only Eurystheus' head can be seen and his frantic, entreating arms and hands. Herakles

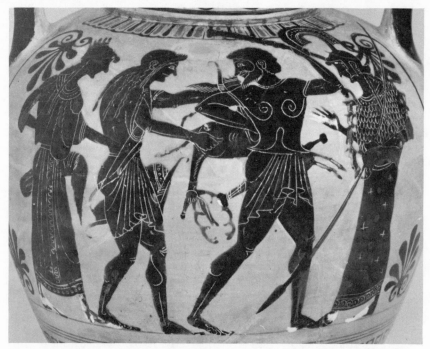

32 • Herakles and Apollo: struggle for the hind. Group of Würzburg 199, neck amphora, Würzburg 199. (Martin von Wagner–Museum der Universität Würzburg)

bends menacingly over the pithos, resting one foot on its rim or shoulder, about to hurl the boar at Eurystheus and joyously complete his assignment.

Onlookers are most often the faithful little band of well-wishers: Athena, Iolaos, Hermes.

4. After his experience with the boar Eurystheus chose next a gentler beastie, the hind of Keryneia, the hind with golden antlers.[19] Herakles had to bring her back alive and, as she was sacred to Artemis, unwounded. He pursued her for a year before he caught her. On vases we see him seizing her;* once or twice breaking off the golden antlers—a version of the myth we do not know in literature. We do know a story that, when Herakles had captured the hind, Apollo and Artemis appeared and demanded her return. Herakles explained his position and they allowed him to complete the labor. The opening of this myth may be illustrated in a small group of vase paintings in which Herakles is carrying off the hind and Apollo is trying to rescue her (FIG.32). The scene

A Vase Painter's Notebook

is cast in the type of the struggle of Herakles and Apollo for the Delphic tripod—as if to say that even the capture of a defenseless deer may be heroic if it is a struggle with a god.[20]

5. The fifth labor was to drive away the Stymphalian birds, a flock of birds that haunted Lake Stymphalos in Arcadia, man-eaters or pests according to the mythological authority. Herakles scared them off with a bronze rattle or shot them. In the vase paintings, which are few and unheroic, he shoots them with a sling* or bow, or attacks them with his club.

6. The sixth labor was to clean, in a single day, the stables of King Augeias of Elis. He did it by diverting the course of a river to run through the stables. This is a local Elian myth, of little interest elsewhere in Greece; it comes into the cycle only because of its inclusion in the frieze of the celebrated Elian temple, the temple of Zeus at Olympia. We know no vase paintings that tell the story.[21]

7. Another beast to be brought back alive was the Cretan bull, and now Herakles journeyed to Crete. The scene of the first six labors is the Peloponnesos; the second six will take the hero afield: at first out of the Mainland, then out of Greek lands, finally out of the land of the living.[22]

He caught the bull, brought it to Eurystheus, and let it go. In one tradition it ranged about the Greek mainland until it came to Marathon, where Theseus later fought it. On vases, mostly black-figured, Herakles is pursuing and just catching the bull; or wrestling it to the ground; or he has brought it to its front knees and is roping it.* Often he has stripped and hung up mantle, bow, and quiver on a late-black-figure tree or on the wall of the vase. The archer's attributes in the background help us distinguish Herakles' from Theseus' tauromachy.[23]

Perhaps you are thinking that this mighty hero, who wrestled with the Nemean lion and cut off the hydra's heads, is shooting

birds like any duck hunter and roping bulls like an old cowhand. We can only reply with Pausanias, "Long ago, it seems, beasts were more formidable to men."[24]

8. Herakles' experience as a cowboy served him for the eighth labor, the taming of the man-eating horses of the Thracian king Diomedes. Artists were simply unable to evoke the image of those formidable beasts of long ago, and there are few illustrations.

9. The ninth labor was to bring back the belt of Andromache, queen of the Amazons. These were a race of warlike women who lived somewhere in Asia, "where geography begins to melt."[25] Eurystheus wanted the belt for his daughter, says Apollodoros, lamely explaining an errand that is apparently only an impossible task of folktale.[26]

Herakles collected a small army and sailed to Themiskyra, the city of the Amazons. He was received by Andromache who promised him the belt. And that would have been all, had not Hera entered the picture. She felt that this labor was too easy and she disguised herself as an Amazon and spread the rumor that the strangers were carrying off the queen. The Amazons sprang to arms, and the battle is a great favorite of black-figure painters— with never a suggestion of its improbable cause, the belt of contention.[27]

In the second quarter of the sixth century, when the scene comes into Attic vase painting, the battle, as most archaic battles, is a series of single combats; frequently three, with Herakles' duel as the center.[28] After the middle of the century, as fields of decoration grow shorter, the scene may be reduced to a single duel within a thin frame of battle, perhaps an Amazon on either side advancing or fleeing.[29] Herakles seizes the collapsing Andromache by the crest of her helmet or by her hair or arm, and threatens her with sword or club.*

This scene, so popular in black-figure, dwindles in red-figure;

A Vase Painter's Notebook

by the middle of the fifth century it has disappeared from the repertory of the Athenian vase painters.[30]

10. Next Herakles had to bring to Eurystheus the cattle of Geryon. Geryon was a triple-bodied monster who lived on the island of Erytheia in the far west—the farthest west—beyond Ocean. Here he lived with his cattle, his herdsman Eurytion, and his dog Orthos. Orthos was brother to Kerberos and, like him, two-headed and snake-tailed. By his likeness to Kerberos, Orthos strips off the mask of Geryon: as Orthos is the double of Kerberos, his master is the double of Kerberos' master, Hades. The victory over Geryon is a victory over death.[31]

Herakles crossed Europe on his way to Geryon's island and came to Libya. When he could no longer endure the heat of the sun, he drew his bow against Helios, and the sun god wondered at his spirit and lent him the golden bowl in which he himself journeys at night. Herakles sailed toward the west, in the path of the setting sun, to the land of Hades' double. But he looks very cheerful in the illustrations, dipping his toes in the water or sitting inside the wave-lapped bowl.*

The battle with Geryon is popular among black-figure painters, who solve the problem of embodying the folktale monster in one of two ways. On a pair of Chalcidian vases Geryon is a winged warrior, three-bodied above, single-bodied below. In Attic vase painting he is more truly triple: three hoplites marching side by side, phalanxed. Herakles has already shot the herdsman and the dog and now comes against Geryon with sword or club. One of Geryon's bodies sinks wounded, the other two fight on. Herakles moves rightward, Geryon faces him, and between them Eurytion—or occasionally Orthos—lies dying.*

In red-figure the theme is rare but one of our few examples is of special interest, a cup of Euphronios, who followed the old type with a new elan and found in it a model for an Amazonomachy

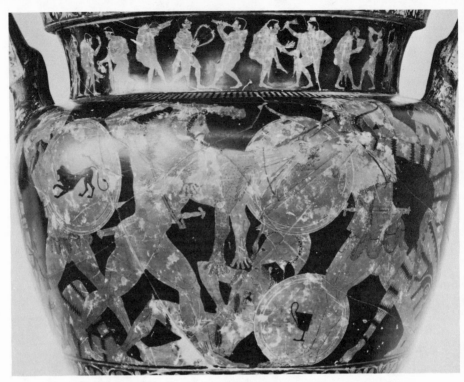

33 • Herakles and the Amazons. Euphronios, volute krater, Arezzo 1465. (Soprintendenza alle Antichità dell'Etruria, Firenze)

(FIG.33).[32] You will recognize Herakles' furious advance; two Amazons fighting, Geryon-like, the third falling back; and a wounded Amazon lying in Eurytion's place.

11. After the battle with Geryon–Hades Herakles had to confront Hades in his own person. The eleventh labor was to descend into the underworld and bring back the ferocious watchdog Kerberos. Eurystheus must have chuckled as he sent Herakles to that bourn from which no traveler returns. But Herakles had, to be his guides, the maiden with gleaming eyes and the conductor of souls. He captured Kerberos, brought him to Eurystheus, then, courteously, returned him to Hades.

In Attic literature Kerberos is three-headed, on Attic vases almost always two-headed. He is, there, a garland of the attributes of fierceness, a snake-tailed monster with lion feet and a great shaggy mane along his back. But in Attic vase painting, too, he shares the ambition of many large dogs to become a lap dog. He

A Vase Painter's Notebook

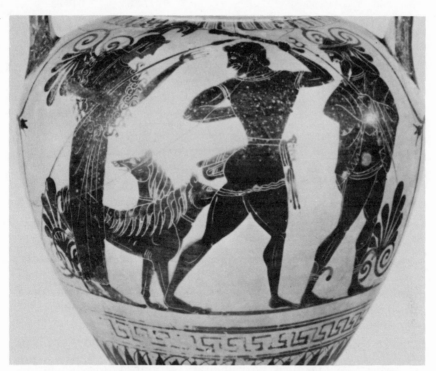

34 • Herakles and Kerberos. Antimenes Painter, neck amphora, Tarquinia RC 976. (Soprintendenza alle Antichità dell'Etruria Meridionale)

does not resist. Herakles drives or drags him or, more often, has only to lead him, and the diplocephalus follows tamely. Hermes leads the little procession or brings up the rear. Athena stands by, hand raised in a gesture of encouragement (FIG.34).

Occasionally Hades is present, unprotesting as his dog; more often Persephone sits or stands in Hades' palace. Hermes may turn to greet her: the underworld is his beat, and they are old friends. Or he may hold out a hand, explaining, persuading, soothing bruised feelings.

A scene even less effortful than the leading up of Kerberos is the enticement of that unfierce watchdog. Herakles stoops down, holding out a hand that promises to caress; a chain is ready in the other hand.[33]

Outside of Athens Kerberos is three-headed. On a pair of Caeretan hydrias Herakles brings him to Eurystheus, really fierce with his great toothy jaws and snakes growing from heads and

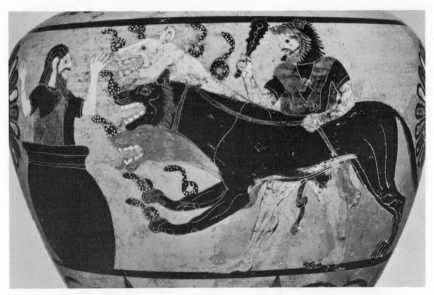

35 • Herakles and Kerberos. Caeretan hydria, Louvre E 701. (Musée National du Louvre)

forepaws. The terrified Eurystheus has jumped into his pithos (FIG.35): the painter has used the type of the bringing of the boar to give à hilarious twist to his scene.[34]

12. The last of the labors was to bring back the golden apples of the Hesperides. The Hesperides, daughters of Night, dwelt at the end of the earth, in the farthest west. Their garden is a Garden of the Blessed, an Elysian field, and the apples are apples of immortality.[35]

The tree with the golden apples had been a wedding present from Ge to Hera. Hera had it planted in the garden and she posted a mighty serpent to guard it, the sleepless Ladon.

The tree was well-guarded and the garden well-hidden. Only from Nereus could Herakles learn where it was, but the old sea god was unwilling to give up his secret. Only force would convince him and he was hard to lay hands on. Inconstant as the sea, he could assume what form he wished. In a small group of early black-figure paintings Herakles is struggling to keep his hold on Nereus, a great dragon-bodied fish-tailed elder, who is hardly aware of his little assailant.* Herakles clings and looks back at Nereus' latest transformation, serpent or lion or flame.[36]

A battle not to be confused with Herakles' struggle with Tri-

A Vase Painter's Notebook

ton, another dragon-bodied, fish-tailed sea monster but no poly-morph so that Herakles does not look back.[37] He demonstrates, rather, a hold of the palaestra, the "ladder," in which one climbs on the back of his opponent and seizes him from behind.[38] The type is a tangle of arms and legs and scaly coils.*

We do not know why Herakles fought Triton, only that this battle succeeds the battle with Nereus in the repertory of black-figure vase painters, becomes, indeed, a favorite theme.[39] A favor-ite of Nereus, too, for he frequently watches, human now, white-haired, solemn, and gentle.[40]

The human form likes Nereus well. A few vase-painters, late black-figure and red-figure, return to the old subject of his struggle with Herakles and picture him as an old man, seized in black-figure, fleeing in red-figure.

On his way to the garden of the Hesperides—now he knew the way—Herakles came to Libya, where the Giant Antaios forced strangers to wrestle with him, then slew them. Until he met Herakles. The scene of hero and Giant wrestling comes late into the pictorial tradition and, perhaps for this reason, has no type. It is simply a scene of wrestling, varied as different holds and throws are used.[41] Herakles' attributes often hang on the wall of the vase or lean against it, but the scene is essentially a slice of the life of the palaestra (FIG.18).

Herakles slew Antaios and journeyed on. He came to Egypt, to the court of King Busiris. Egypt had been plagued by drought and Busiris had consulted a Cyprian seer, Phrasios. The seer had ad-vised him to sacrifice a stranger to Zeus, showing himself more skilled in reading Egypt's future than his own, for he was a stranger at the court. The remedy was so effective that Busiris sacrificed every traveler who came to Egypt. Until Herakles came.

The graphic tradition is dominated by a great guffawing Caere-tan hydria in Vienna.[42] A gigantic nude Herakles is romping over

a field of puny, white-clad Egyptians, trampling, throttling, hurling—six at a time. Others cower at the altar at which Herakles was to have been offered. Busiris himself lies twisted in death.

In Athens it is not until red-figure times that we can follow the tradition. Herakles attacks Busiris at the altar, which is streaked with the blood of victims. On either side Egyptians flee, dropping the implements of sacrifice,* knives, hydria, sacrificial basket, spits. There is no longer the loud laughter of the Caeretan hydria, but the scene is still lighthearted, a ballet of attack and fear.[43]

Herakles came at last to the garden of the Hesperides. Two versions of the myth are illustrated in Greek art. In one, Herakles slays the dragon and makes off with the apples. In the other, on the advice of Prometheus, he sends Atlas, the Endurer, who stands at the end of the earth, before the garden of the Hesperides, and holds the sky on his shoulders. Herakles takes the sky and Atlas goes for the apples.

The latter version is almost never pictured on Attic vases, the former only rarely.[44] Herakles approaches the tree, round which the serpent is coiled; or approaches and starts back at the sight of the formidable guardian.

It is not until the late fifth century and in the fourth, when the other adventures are fading from the vase painters' stock of scenes, that this one comes into its own, but not in its old form.[45] Quiet figures sit or stand about a tree: we recognize the scene because a serpent is coiled about the tree (FIG.36).[46] There is no struggle to mar the quiet of the garden. A Hesperid may pick apples or offer them to Herakles; or an Eros may pluck them, that ubiquitous little intruder into fourth-century scenes. A sunlit afternoon in a garden, a garden party in Paradise.

A Vase Painter's Notebook

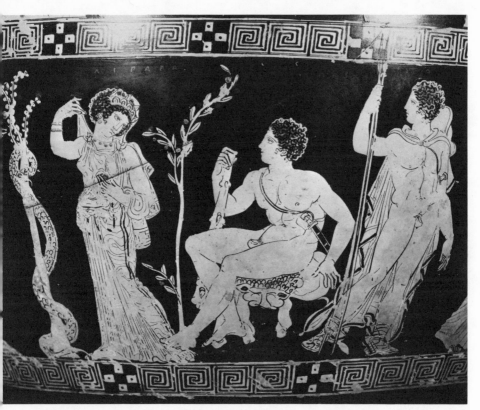

36 • Herakles in the garden of the Hesperides. Meidias Painter, hydria, British Museum E 224. (Trustees of the British Museum)

9

A Little Dictionary of
Deeds: Herakles and . . .

ALKYONEUS. On the return journey from Trojan War I, Herakles and his companions were attacked by Alkyoneus, a herdsman "mountain-tall."[1] In a tradition lost in literature but known to us in vase paintings, Herakles surprises the giant in sleep.[2] Alkyoneus lies upon the rocks, his club at his side, as Herakles steals up, ready with sword or club or bow. Often sleep, the distinctive feature of the scene, is twice indicated: not only by the closed eye, the relaxed form, but by the presence of a little winged figure flying over the giant or perched upon him, Hypnos.*[3]

Herakles drove off Alkyoneus' cattle, which are sometimes represented.

KERKOPES. Herakles captured the Kerkopes, a pair of merry thieves, when they tried to steal his weapons. In a black-figure scene he carries them on a pole, trussed, as booty from the hunt, heads down.*[4] From their disvantage point they could see the "black bottom," the hairy buttocks, a mark of manliness for the Greeks. They traded jokes about it and so amused Herakles that he let them go.

KYKNOS. He slew Kyknos, son of Ares, highwayman and builder—he used the skulls of his victims as blocks. In the battle Herakles attacks, Kyknos often falls or retreats. Ares hastens up to aid his son, lance poised; Athena seconds Herakles. Zeus occupies the center of the scene. He has come to part the fighters and flings up both hands like a frantic umpire, signaling them to "break it up." Chariots may frame the scene, the taxis of epic heroes.[5]

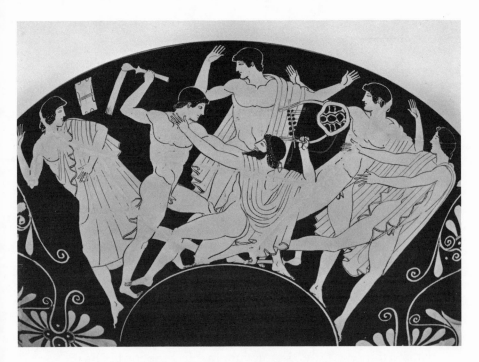

37 • Herakles and Linos. Douris, cup, Munich 2646. (Staatliche Anti-
kensammlungen und Glyptothek)

The supporting figures may withdraw: Zeus, even Athena and
Ares, and the combat becomes, simply, a duel between Herakles
and a hoplite.*6

LINOS. As a boy Herakles hated his music lessons and he
hated his teacher, Linos, and one day killed him. On a few red-
figure vases Herakles stands over his teacher threatening him: in
a version known to vase painters he breaks a stool over Linos'
head. Linos is fallen, pleading or feebly trying to defend himself
(FIG.37). A writing tablet, hanging on the wall, indicates the
schoolroom; or a stalk of narthex, the rod that raps young
knuckles. Or a frightened schoolboy scuttles away.

PROMETHEUS. Herakles shot the eagle sent by Zeus to de-
vour the liver of Prometheus. Prometheus, a Titan, had stolen fire
from the gods to give to men, and Zeus sent the eagle against him.
Each day the eagle feasted, each night the liver grew whole again,
and in the morning the eagle returned.

A Little Dictionary of Deeds: Herakles and . . . 73

On a few black-figure vases the pyroklept squats on the ground, bound to a post. The eagle approaches. Herakles kneels and draws his bow. Arrows fly.*7

SYLEUS. In a myth known to us in bits and fragments Herakles was forced to labor in Syleus' vineyard. He set to work with industry and concentration—uprooting the vines, then killed Syleus. There are a few red-figure vase paintings in which Herakles confronts Syleus or digs up a vine with his pickax.*8 Syleus may rush up, fuming, armed with staff or double ax. He is too late to prevent the destruction, just in time for his own.

10

A Sophoklean
Detective Story

The story of Herakles' death is a murder story told by the mystery writer Sophokles.[1] It begins when Herakles married Deianeira, daughter of King Oineus of Kalydon, sister of the hero Meleager. Herakles had to fight for her, for she had a suitor, the river god Acheloos. Acheloos could change his form; he is represented as a monster tauromorphic: bull below, man above but horned, or as a bull with human face.[2] Herakles wrestles with him and breaks off one of his horns.*

Herakles took his bride home. On the way they came to the river Euenos, where the centaur Nessos ferried travelers across for a fee. He took Deianeira on his back and safely in midstream, made advances. In the myth Herakles shoots him, but the illustrations, mostly black-figured, indicate neither distance nor water.[3] Herakles pursues the centaur or seizes him and attacks with sword or club. Nessos, fleeing to the right or foundering, turns back, pleads, despairs. Often he is still carrying Deianeira, who holds out her hands to Herakles.* Or she has escaped and fled the scene and Herakles battles a centaur (FIG.45).

Before Nessos died he gave Deianeira a vial of his blood, poisoned by Herakles' arrows. It would be a love charm, he told her, for the heart of Herakles, so that he would never look at a woman and love her more than Deianeira.[4]

Time passed. Herakles fell in love with Iole, daughter of King Eurytos of Oichalia in Euboia, but she rejected him. Later, in a seizure of madness he killed her brother Iphitos, and was visited as punishment by a terrible disease.[5] He went for advice to the

75

priestess of Apollo, but she turned him away, and the impetuous Herakles replied by carrying off Apollo's tripod. The theft of the tripod—dispute or pursuit—is a favorite subject of archaic art. In the struggle the tripod is in the center; Apollo and Herakles face each other, threaten or tug. In the pursuit Herakles makes off with the tripod and Apollo gives chase, reaching out or seizing it.* Athena often backs Herakles and Artemis, drawn by symmetry and twinly feeling, stands behind Apollo.[6]

Zeus intervened with a thunderbolt. The tripod was restored. Herakles served a term of slavery for the murder of Iphitos. Then he gathered an army and marched on Oichalia. He took the city, killed Eurytos, and sent Iole to Deianeira with other captive women. Deianeira learned of Herakles' love for Iole and remembered the philter of Nessos. She anointed a robe and sent it as a gift to Herakles. Nessos had spoken truly: the potion was a deadly poison, and Herakles never again looked at a woman and loved her more than Deianeira.

And the murderer was beyond suspicion, for he was long dead when he committed the crime.

After his death Herakles was taken to Olympos to be a god. In the sixth century the journey to Olympos is cast in the form of a popular black-figure type, a scene from life, the departure of a warrior in his chariot.[7] Instead of charioteer and warrior, Athena and Herakles may stand in the chariot, Athena holding the reins; or Athena may climb aboard while Herakles waits in the car or beside it.[8] Gods on foot escort the chariot: Apollo playing the cithara; Dionysos, ivy-crowned; others. Hermes may lead the procession or turn round to the horses. It is a thronged and solemn departure for Olympos.

On vases classical and later we see the ascent. The horses race through the air.[9] Athena holds the reins at first, then almost al-

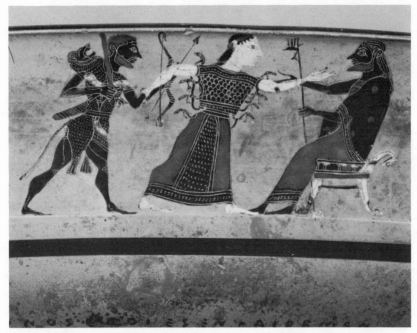

38 • Introduction of Herakles. Phrynos Painter, cup, British Museum
B 424. (Trustees of the British Museum)

ways Nike.[10] The herald Hermes may run ahead. Herakles,
bearded or youthful, stands beside his charioteer, wreathed,
chlamys floating in the breeze.

After the journey the new god is presented to Zeus in the scene
known as the introduction of Herakles to Olympos.[11] The scene
takes the form of a procession to Zeus: Hermes leads, Athena and
Herakles follow. Other gods may take part. Or the cast is reduced
to the three essential actors, and Athena alone makes the presen-
tation (FIG.38). She may seize the hero by the arm or even drag
him, for Herakles the fearless is clutched by fear. He may try to
escape or raise a hand in wonder at the splendor about him. Once
he blurts out, "Good Lord!"[12] It is too fine for me, he seems to say,
this very appealing hero, this hero of many faults, none of them
pride.

It is not until the late fifth century that Herakles loses his re-
luctance. At the same time the procession, as other formal pro-
cessional types, dissolves, and Herakles stands before Zeus, circled
by Olympians, confident and statuesque.

11

Hero of
the Athenians

Theseus is an old hero who takes a new image, a figure at first frozen in a single role, later alive and glorious. This "other Herakles" is also another Dionysos, for he is in a sense twice-born.

As slayer of the Minotaur Theseus is known as early as the mid-seventh century in Peloponnesian art.[1] The scene passes to Athens, and the Athenians make it their own and make the myth their own: the tale we know is the one the Athenians told. King Minos of Crete exacted tribute of the Athenians, seven youths and seven maidens to be delivered every nine years to the Minotaur, a monstrous anthropophagous bull-man. The victims were shut up in the Labyrinth, the lair of the Minotaur, to lose their way in its windings and starve to death or to find the way to the Minotaur and be devoured. Theseus killed the Minotaur, then escaped from the Labyrinth with the help of a ball of thread given him by Ariadne, Minos' daughter, for love of the hero.

On black-figure vases Theseus seizes the Minotaur, a bull-headed man, and threatens him with his sword or is already running him through. The Minotaur sometimes flees, most often kneels, that is, collapses. Sometimes he clutches a stone as a weapon but he shows little fight.[2] The scene may be watched by the Athenian boys and girls, turned black-figure spectators (FIG.16).

It is in this stereotyped scene that Theseus plays his principal role in Athenian art during a good part of the sixth century. Toward the end of the century he is given a new image. Was the P. R. man an employee of the Peisistratids? Or of the opposition?[3]

A Vase Painter's Notebook

We do not know. We only know that in the last years of the tyranny Theseus becomes alive. He is now a radiant figure, shining with youth. A cycle of adventures is invented to correspond to Herakles' cycle. He becomes "another Herakles," a national hero of the Athenians to stand beside the Panhellenic hero.[4] The Peisistratids fall; Theseus continues to prosper, a symbol of the democracy now, its protector.[5] On an amphora of the last decade of the sixth century Theseus is carrying off a woman, his favorite diversion. A bearded man looks on.[6] He calls out, "Welcome, Theseus!" It is the Athenian citizen greeting the hero of the young Athenian democracy.

Theseus was the son of Aigeus, king of Athens. Aigeus had consulted the oracle of Apollo at Delphi about his childlessness. The oracle replied in a transparent enigma that Aigeus should have relations with no woman before his return to Athens. Transparent but not transparent enough, and poor old Aigeus went to Troizen in Argolis to seek advice of the wise King Pittheus. Pittheus understood the oracle but he also desired an alliance with the Athenian royal house and he arranged for Aigeus to meet his daughter Aithra.

Before Aigeus returned to Athens he hid his sword and sandals under a huge rock and instructed Aithra to send their son to Athens when he could move the rock and take the tokens. Theseus grew up, easily rolled away the great stone, and set out on the journey to Athens that is the frame of the cycle, for the road to Athens was made for adventure. It was infested with highwaymen who had methods of their own of disposing of their victims.

At Epidauros he encountered Periphetes, the "club man," as he was called, for it was his practice to kill travelers with his club. Theseus slew him and took the club. The myth is a late addition

to the cycle, perhaps invented to account for the club sometimes carried by this "second Herakles."[7] Illustrations are very rare.

The real cycle begins at the Isthmus of Corinth. Here Sinis, the "pine bender," had his station. When a traveler passed, Sinis would require his help in bending down a pine, then, suddenly, would let go so that the tree flew up and hurled the victim to his death. Theseus dealt with the brigands he met on his journey by turning their own weapons against them—this is our clue for recognizing a scene. He killed Sinis by bending a pine and letting it fly.

The scene is marked by the tree. There are a few illustrations of the meeting, the early classical "moment before" the action, when Sinis sits quietly under the tree as Theseus approaches, wearing the chlamys and petasos of the traveler. Most frequently Theseus bends the tree and drags Sinis to it or seizes Sinis, who clings desperately to the trunk (FIG.40). He will send the bandit flying, his object all sublime . . . to let the punishment fit the crime. . . .

Sinis, as the other brigands, is a rough-looking character, nude, with wild hair and ragged beard.

Theseus journeyed on and killed the murderous sow of Krommyon. Often, in the illustrations, there is a bent old woman beside the sow, Phaia (FIG.39). Phaia is the name of both, the old woman and the sow: either the sow was named for her owner or the owner for the sow—because of her character and her life, Plutarch quaintly remarks.[8] Phaia clutches her staff with one hand, holds out the other in vain entreaty for the life of her porcine namesake.

Near Megara Skiron sat at the edge of a cliff, with a basin beside him, and would force the traveler to wash his feet. While the victim was stooped over, he would kick him—over the cliff and into the sea. In the sea Skiron's partner waited, a great turtle, a xenophagist, to dine upon the traveler.

A Vase Painter's Notebook

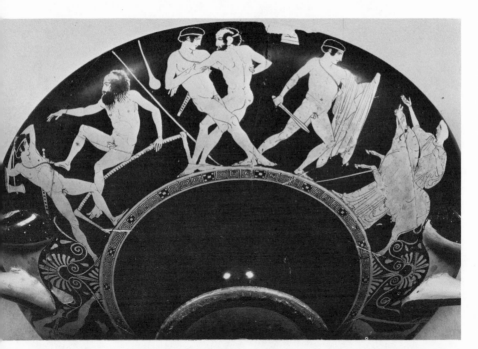

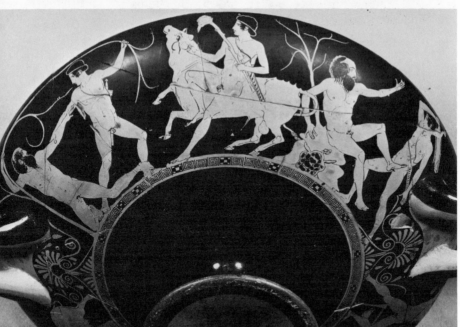

39 • 40 • Deeds of Theseus. A. Prokrustes, Kerkyon, sow; B. Sinis, bull, Skiron. Codrus Painter, cup, British Museum E 84. (Trustees of the British Museum)

There are several types for this scene. There is the "moment before," when Theseus approaches, garbed as a traveler. Skiron sits on his rock, studying him or insolently dangling a foot over the basin. Most often Theseus hurls Skiron over the cliff. The turtle may be there as attribute of the scene, or the basin,* but we know the scene without them: a young hero topples a nude uncouth bearded man. There are, finally, a few examples of a later type, in which Theseus uses the basin as a weapon (FIG.40).

At Eleusis he came upon Kerkyon, a great wrestler, who would force the traveler to a match, throw him, and kill him. He wrestles with Theseus in a scene that comes from the palaestra, illustrates body holds and neck holds (FIG.39). Theseus has Kerkyon round the middle and will lift him, or is lifting him, to throw him.[9]

He killed Kerkyon and went on until he met Prokrustes, the "stretcher." Prokrustes had a bed on which he would force travelers to lie, and if they did not fit it, would flatten them with hammer blows until they did. Now the brigand has run to his bed, fallen upon it, and holds out a hand in appeal as Theseus comes with the hammer (FIG.39). Sometimes the Procrustean bed is a bed of rock. Prokrustes has fled to the rock, clings, pleads. Where there is no indication of setting, the hammer identifies the scene.[10]

Theseus arrived in Athens, was recognized by his father Aigeus, later went forth to fight the Marathonian bull.[11] This bull is sometimes identified with the Cretan bull, which Herakles had captured, brought to Eurystheus, then turned loose. Theseus pursues, attacks, or ropes the bull. Most often he has roped it, has forced down its head and foreparts, and is pulling the ropes to make the collapse complete.*[12] This is the type of Herakles' tauromachy, and the two scenes may be indistinguishable in careless work. Attributes are very welcome: the bow and quiver of Herakles or the traveler's hat of the immigrant Theseus.[13]

After Theseus had mastered the bull he drove it to Athens and

sacrificed it to Apollo. A scene of driving the bull finds a type shortly before the middle of the fifth century. In the struggle the figures are confronted; here they move in one direction. Theseus grasps a horn of the bull and threatens the beast with his club (FIG.40).[14]

The struggle with the bull is a theme older than the cycle. As red-figure painters return to it, they return also to the battle with the Minotaur, and the old scene takes new freedom and variety.[15] Theseus pursues the bull-man or seizes or kills him, occasionally disposes of the body. The Minotaur, no longer resigned, appeals or fights back. As spectators, instead of the old silent black-figure chorus, Minos may look on, characterized by scepter or staff, and Ariadne, expressing love or wonder by her gesture. The Labyrinth may be indicated by a column or by the traveler's hat hanging on its wall.[16]

All these deeds—the adventures along the road, the tauromachy, the Minotauromachy—provide subject matter for the "cyclic" or "Theseus" cups. These constitute a new genre, a vehicle devised for the adventures of Theseus in the period of his rise to popularity.[17] Theseus moves from one deed to another in an order that is not chronological; there is no idea of time, only of a series.[18] On the exterior of the cup is a selection of adventures (FIGS.39, 40); inside, as the tondo, most often the Minotauromachy.

One of these cyclic cups was published in 1881 by Cecil Smith, who noted that in one episode Theseus resembles the Tyrannicide Harmodios, in another his companion Aristogeiton of Kritios' bronze group that stood in the market place at Athens after the Persian Wars (FIGS.39, 40).[19] Other examples are now known.[20] As Tyrannicide Theseus becomes the explicit symbol of the Athenian democracy. It is only an occasional role but one that is very striking and significant.

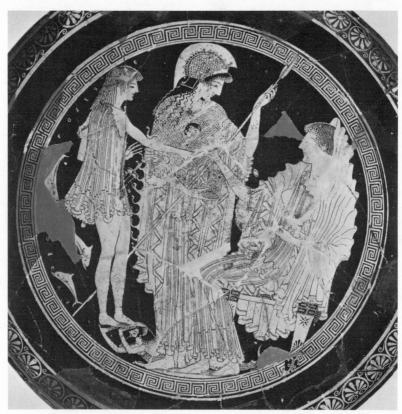

41 • Theseus and Amphitrite. Panaitios Painter, cup, Louvre G 104. (Musée National du Louvre)

Besides the tradition that Theseus was the son of Aigeus, there is another that he was Poseidon's son. On the journey to Crete King Minos challenged Theseus' claim of being descended from the god. He tossed a ring into the sea and called on Theseus to retrieve it. The Athenian hero dived from the ship and was carried by dolphins to his father's undersea palace. There are a few red-figure illustrations of the meeting, a scene sometimes characterized by the handclasp.*21 Nereids may watch, or Amphitrite, herself a Nereid, Poseidon's gracious queen. On a beautiful cup in the Louvre (FIG.41) Theseus is received not by Poseidon but by Amphitrite, who has as a gift for him a shining wreath to light the Labyrinth.

Theseus came to Crete, slew the Minotaur, sailed homeward with the young Athenians and with the princess Ariadne. He

A Vase Painter's Notebook

abandoned Ariadne on the island of Naxos as she slept. The fifth-century Athenians, unhappy about Theseus' fickleness and ingratitude, invented a story that he deserted Ariadne by the will of the gods.[22] He leaves her in a scene in which the intervention of the gods is sometimes indicated. Athena may be ordering Theseus back to the ship as Dionysos appears to Ariadne, her future husband. Once Theseus steals away, shepherded by the wily and light-footed Hermes.[23] Ariadne lies asleep. The pathetic figure of the sleeping Ariadne, rare in classical art, wins great and long popularity in Hellenistic and Roman times.[24]

Dionysos found Ariadne on Naxos, carried her away, and married her. And they lived happily ever after.

Another abductee of Theseus was Helen of Troy, when she was very young. In Attic vase painting the scene—if the few examples have been rightly interpreted—differs from other scenes of abduction in that the woman is seized by two young men instead of one, Theseus and his friend Perithoos. In the earlier type they grasp her arms or wrists.*[25] Later, Theseus lifts Helen to put her in his chariot, where Perithoos waits, ready for the getaway.[26]

The venture failed. The Dioscuri, Helen's brothers, rescued her and carried Theseus' mother, Aithra, into slavery to Helen.

With the help of Perithoos, again, Theseus carried off Antiope, the Amazon queen.* She is usually characterized as an oriental by trousers, sleeved jacket, and the stiff, lappeted Scythian cap. She may carry bow and quiver and battle-ax. Greeks may follow, Amazons pursue. Sometimes Poseidon stands by, looking with a benevolent eye upon his son's youthful prank.

The harvest of this adventure was an invasion of Athens by an army of Amazons. The Athenian Amazonomachy comes into the pictorial tradition in a surge of pride after the Persian Wars: the Amazons, as the Persians, had invaded Attica and had been

hurled back.[27] Athenian pride included pride in Theseus, leader in the first battle and ally in the second: he had risen up from his grave to help his people at Marathon.[28] In 475 the Athenian general Kimon had found the bones of Theseus (or a political facsimile of those) on the island of Skyros and brought them back to Athens. On the walls of Theseus' sanctuary, where the bones reposed, was painted, with other exploits, the Amazonomachy.[29] There was another painted Amazonomachy at Athens,[30] and it is under the influence of one and then perhaps the other of these paintings—under the direct influence of the great painting of the early classical period—that the battle comes into Attic vase painting.[31]

There are great battles, set in a bare Polygnotan landscape, and smaller ones. In a type of the classical period a mounted Amazon battles a Greek on foot. The Greek, occasionally inscribed Theseus, may set one foot on a little rise of ground, a reminiscence of the landscapes of the big battles.* He is sometimes backed by a comrade.[32] The Amazon may wear Greek battle dress, or oriental: trousers, sleeved jacket, and, now, a soft cap, the Persian tiara.

In this battle, the battle that saved Athens, Theseus had his finest hour and, had he fallen, he might have been happy as Tellos. But he came to an evil end. In one version of his myth he whiled away eternity in the underworld, seated beside his friend Perithoos. They had descended together to abduct Persephone, whom Perithoos coveted, and they never came back. In another version Theseus was rescued by Herakles, when he went below to capture Kerberos.[33] Theseus returned to Athens only to be exiled by the usurper Menestheus. He died on Skyros, pushed from a cliff by a treacherous hand. This radiant symbol of glorious Athens, this second Herakles, died the death of a second Skiron.[34]

12

Perseus
Gorgonslayer

The story of the Argive hero Perseus is pure folktale. As an infant he is sent floating out to sea in a chest. As a young man he slays a hideous monster and rescues a beautiful princess from gruesome death. And yet these adventures center about the legendary founder of Mycenae, a figure if not historical, at least emanated from a historical background.[1] The real biography is lost but the imaginary one was popular through antiquity and is still familiar.

Akrisios, king of Argos, had a daughter Danae but wished for sons. He consulted the Delphic oracle and learned that he would have no sons but a grandson—who would kill him. As other foolish old men of mythology, Akrisios tried to outwit fate. He locked Danae in an underground chamber, a brazen dungeon, but Zeus came to her as a golden rain and Perseus was born.[2]

When Perseus was three or four years old his grandfather heard his voice and knew that Apollo had prophesied well. But he tried again to evade his destiny; he shut mother and son in a chest and sent them floating out to sea.

Red-figure vase paintings show Danae and Perseus in the chest, about to set out on their doomful journey. Akrisios stands before them, commanding or lecturing by his gesture.* There may be others in the scene: Perseus' nurse, the carpenter who has just finished or is finishing the chest. Two pictures show the carpenter using a bow drill, working a bow back and forth to revolve the drill. In one of these (FIG.42) Danae stands behind the chest expressing horror and disbelief, and Akrisios replies with a gesture of indifference. Little Perseus, in the nurse's arms, watches the

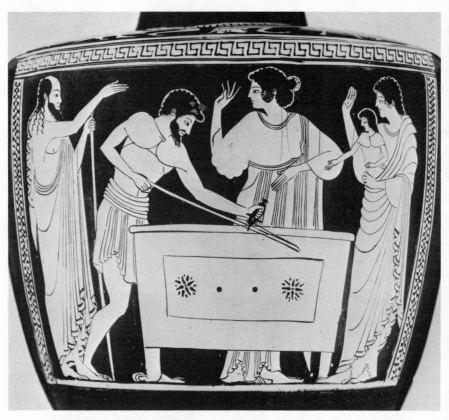

42 • Danae. Gallatin Painter, hydria, Boston 13.200. (Courtesy
Museum of Fine Arts, Boston)

drilling, fascinated as little boys are with mechanical devices. It is
a cheerful scene of a craftsman at work, one that has almost for-
gotten to be mythological.

The chest floated to the island of Seriphos, a rocky little Cy-
cladic isle. It was pulled ashore by a fisherman, Diktys, who res-
cued Danae and Perseus and took them in.[3]

As the folktale has it,[4] the simple fisherman was brother to
the king, Polydektes; and Polydektes fell in love with Danae.
Perseus was now grown and stood in the way of the wicked king.
Luckily for Polydektes—as it seemed—Perseus had made an un-
thinking promise to fetch the gorgon's head.

A wild and foolish promise. A gorgon is a thing of terror, a
shriek personified: the word is related to our tamed words gargle,
gurgle, gargoyle—once frightening noises and creatures who
make them.[5]

A Vase Painter's Notebook

In the archaic period, her floruit, the gorgon has great orientalizing "sickle" wings, one or two pairs, or sickle wings and bird wings both. Later she will be bird-winged only. She may have snakes about her head or in her hair and snakes about her waist. She wears a short chiton for easy flying and is shod in winged boots.

The striking feature is the grotesque head, the gorgoneion. It is round, frontal, masklike, characterized by a huge grinning toothy mouth, ferociously tusked, with tongue protruding. Sometimes it is bearded.[6]

In the myth there are three gorgons, of whom two are immortal, Sthenno, the "strong," and Euryale, the "wide leaping." The third sister is mortal, Medusa, the "ruler," the "queen."[7] And her head, the head that Polydektes required, the shriek made visible, had the power to turn the beholder to stone.

Perseus returned to his senses, too late: Polydektes would not release him from his word.

Hermes to the rescue. He found the despondent Perseus and brought him to the Graiai, the "old women." These three had been old from birth and so nearly blind and toothless as to possess among them but a single eye and a single tooth. They shared these by passing them from one to another, and Perseus sneaked up and reached for the eye and the tooth while they were going round.[8] He held them until the Graiai revealed the way to the Naiads, river nymphs who would give him his equipment. He receives it on a Chalcidian amphora:[9] winged boots for swift escape, the cap of Hades to make him invisible,[10] and the kibisis, a wallet for carrying the gorgon's head. A folktale 007 is being issued the latest in gadgetry before he sets out on his dangerous assignment. Athena stands behind him, the early unwarlike Athena. She will be at his side in the scenes that follow, the slaying of the gorgon and the flight from the vengeful sisters.

The slaying of Medusa is a rather infrequent subject of Greek art. There are a few archaic reliefs and some vase paintings. In the reliefs Perseus turns toward the viewer as he cuts off the head, that is, avoids the lithopoeic sight (FIG.9); on vases he almost always looks back, pivots his head so that his feet are turned to the right, the usual direction of the scene, his head to the left.*[11] At first his weapon is a sword; later he will use the harpe.

Even in the archaic period Perseus is youthful in this scene. It was long ago observed that in scenes of the slaying Perseus is usually beardless, in archaic scenes of the flight, bearded.[12] As if the wild deed belongs to youth, the better part of valor to later years.

On a metope from the archaic Temple C at Selinus (FIG.9) Perseus faces the viewer, a youthful figure, wearing cap and winged boots. Athena is at his side, a pillarlike source of strength. Medusa collapses in the bent-knee pose, holding in her arms a little winged horse. It is her son Pegasos, who sprang forth from her neck after the slaying, with her human son Chrysaor. Speaking the rich language of the archaic period, the sculptor has combined two moments and has made a scene of decapitation tender and attractive.

Beginning in the early classical period artists prefer to depict the moment just before the slaying.[13] Perseus has come upon the gorgons sleeping. Now he steals up, harpe in hand, head averted, hat winged. An example from the classical period (FIG.43) shows this schema with Medusa remarkably changed. During the fifth century she has been losing her grotesqueness, becoming a graceful and at last a beautiful winged figure. "Fair-cheeked Medusa," Pindar calls her.[14] Now only the wings and short chiton recall the gorgonian race. She lies upon a grassy hillside, a beautiful dreamer, the harpe at her neck.

A Vase Painter's Notebook

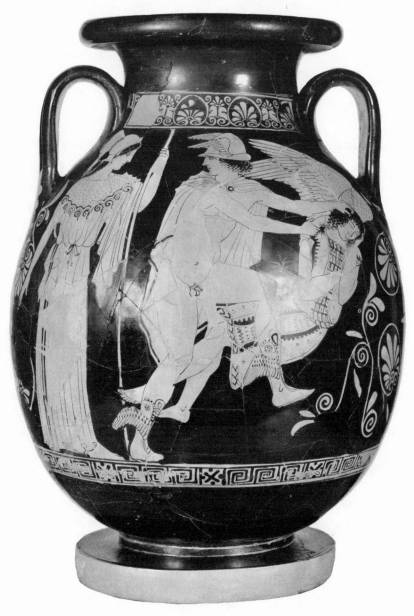

43 • Perseus and Medusa. Polygnotos, pelike, New York 45.11.1. (The Metropolitan Museum of Art, Rogers Fund, 1945)

Perseus put the head into the kibisis and took to his winged heels. Unlike the scene of the beheading, the pursuit prospered in Greek art. The history of Attic vase painting could almost be written in terms of the pursuit. We begin with the magnificent Protoattic amphora found by Mylonas at Eleusis in 1954 (FIG.44). Medusa lies headless in a field of loopy Protoattic flowers. Her sisters pursue or rather step gracefully, in unison, a chorus of Protoattic Rockettes. Their course is stopped by a thin and stately figure holding a spear: Athena has made her debut in Attic art, already in the role of her greatest success, the protectress of heroes.[15] She has come between the gorgons and Perseus, of whom only the lower part is preserved, with winged boots turned to flight.

In the late seventh century the Nessos Painter continues the tradition (FIG.45). Dolphins set the scene: the gorgons dwelt at the edge of Ocean. The headless Medusa collapses, wings sadly folded, the purple blood streaming from her neck. Her sisters pursue. They have great sickle wings, fierce tusked mouths, beards like flame. And Perseus wears the cap of darkness and is nowhere to be seen.

In another work of the same painter, a fragmentary bowl (FIG. 46), Perseus is visible but the gorgons are lost. The hero flies through the air, his flight made swifter by the quiet of Athena, who stands behind him, unwarlike, unmoving, reassuring. At the left, part of a leg is preserved to tell us that Hermes has come into the scene and is holding off the gorgons.[16]

In the early sixth century the Gorgon Painter gives the full scene: Medusa collapses, gorgons pursue, Perseus flees, Athena and Hermes stand by to protect.[17] From the second quarter of the century we have a fragment of Kleitias, the great painter of the François krater: an elegant Perseus flies on winged boots and Athena follows on foot.[18]

A Vase Painter's Notebook

44 • Blinding of Polyphemos; Perseus and the gorgons. Polyphemos
Painter, neck amphora, Eleusis. (Eleusis Museum, T. A. P. Service)

Perseus Gorgonslayer

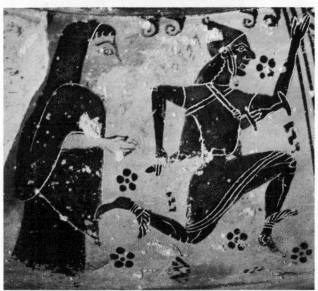

45 • Herakles and Nessos; the gorgons. Nessos Painter, neck amphora, Athens 1002. (National Archaeological Museum of Athens, T. A. P. Service)

46 • Perseus fleeing. Nessos Painter, krater, Staatliche Museen zu Berlin 1682. (Staatliche Museen zu Berlin)

On a cup of a contemporary of Kleitias, the C Painter, Athena may well be wishing for winged boots of her own.[19] This is one of a few examples where the helping gods think of their own skins and flee with their protégé. Perseus rushes off with Hermes at his heels. Both look back to see if Athena will make it to safety. She comes puffing up, arms pumping desperately, aegis flapping, but she is slowed by her heavy shield and her tight skirt.[20] Will Athena escape? Will the gorgons overtake her?

As the gorgons pursue, Medusa collapses, a fantastic figure, apparently hippocephalic, actually giving birth to Pegasos. Chrysaor is in the picture, too,[21] Medusa's human son, a figure who rarely comes into the scene, so colorless he is beside his celebrated and decorative brother.

In the third quarter of the sixth century, when Attic black-figure is at its height, Perseus experiences an eclipse but he returns to flee in late black-figure and in red-figure. In red-figure the scene, as others, is thinned, reduced to a few figures.[22] On an amphora of the Berlin Painter, in the late archaic period, a single gorgon chases Perseus—round and round the vase forever.[23] The Pan Painter tells the story, in the early classical period, with three figures (FIG.47). Headless Medusa collapses, a graceful figure, a dancer dying a ballet death.[24] Perseus skips off, harpe in hand, wearing winged boots and winged pilos. Athena follows trippingly. The scene has become as lighthearted as any of the fifth-century pursuits.

The head in the kibisis is already becoming beautiful. But there is another princess, more beautiful than Medusa, who comes into the myth of Perseus.

Andromeda was the daughter of Kepheus, king of Ethiopia, and of Kassiepeia, a vain and foolish woman who boasted that she was more beautiful than the Nereids. Poseidon was offended at

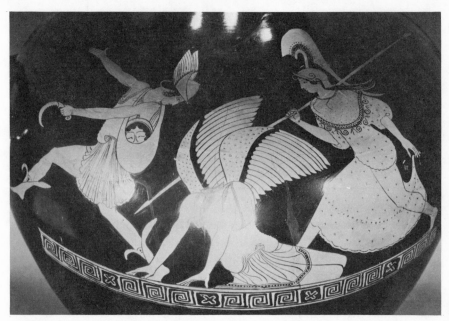

47 • Perseus pursued. Pan Painter, hydria, British Museum E 181.
(Trustees of the British Museum)

this insult to the lovely sea ladies and he sent a sea monster to
ravage the land. It would be appeased only when it had feasted
upon the daughter of the king.

As Perseus was flying out of reach of the pursuing gorgons, he
passed over the coast of Ethiopia. He looked down and saw An-
dromeda bound to a rock, a banquet set out for the monster. He
fell in love, battled the monster, and rescued the princess. He
married her—and should have lived happily ever after.

A Corinthian vase painting tells us that the story was known
at least as early as the middle of the sixth century.[25] Perseus is
hurling stones at a gigantic animal head that rises out of the
waves. Andromeda stands behind him, no helpless beauty bound
to a cliff but a vigorous young girl who praises the gods and passes
the ammunition.

The archiac picture of Andromeda is not our picture. The
myth was worked by Euripides, whose *Andromeda* came out in

A Vase Painter's Notebook

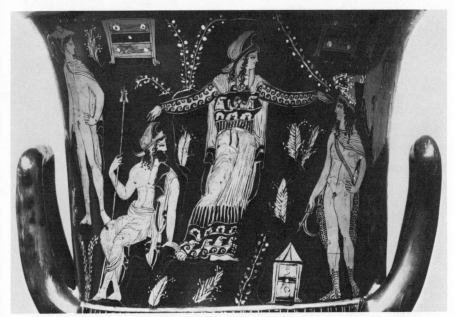

48 • *Andromeda.* Attic red-figure calyx krater, Staatliche Museen zu Berlin, inv. 3237. (Staatliche Museen zu Berlin)

412, a romantic play now lost save for fragments. It was all the rage in its time, and later, and centuries later, and it has so left its stamp on the myth that we can picture no other Andromeda than Euripides'.[26]

On an Attic krater of the early fourth century (FIG.48) the Euripidean Andromeda stands against a cliff, arms outspread, wrists bound, as she speaks the prologue. She wears the rich dress of the tragic actor, a long, long-sleeved robe with elaborate patterns inwoven.[27] Not all the actors wear the tragic dress.[28] The artist is not reproducing but recalling, and in his memory performance and story blend into one.

The play opens with Andromeda's lament, which we know in part from Aristophanes' parody in the *Thesmophoriazousai.* She stands alone in the lonely landscape. Then the chorus enter, Ethiopian girls, friends of Andromeda, to weep with her. The vase

presents one of the chorus, a figure characterized as an actor by the rich dress and as an oriental by the trousers.[29]

First episode: enter Perseus on the flying machine. He has seen the princess standing against the bleak cliff like a "marble statue worked by a skillful hand." He will fight the monster in return for the hand of the maiden. On this vase and a few others he negotiates with Kepheus.[30] This is a scene that could not come in the prologue, where Andromeda is alone: two moments are combined without repetition of the actors—a characteristic method of tragic illustration and one that recalls the simultaneous method of the archaic period.

The bargain is sealed and the scene ends with Perseus' famous prayer to Eros for help, "Eros, tyrant over gods and men. . . ." What a different Perseus from the one shepherded by the stalwart Athena and faithful Hermes!

To the next episode belong fragments of a messenger's speech describing the battle and reporting Perseus' victory. On some fourth-century South Italian vases the messenger's speech is represented by the battle it reports, a battle sometimes watched by Nereids riding dolphins or other sea steeds.

After the victory and the freeing of Andromeda, we can no longer trace the action of the play.[31] Neither fragments nor vase paintings guide us. We return to the myth.

Perseus took Andromeda home to Seriphos. There he found his mother in the clutches of King Polydektes. He had a new weapon now, and a few vase paintings show him using it. He holds up the gorgon's head and turns Polydektes to stone. On an Attic krater the wicked king is seated on a rock—no, he is turning to stone.[32] Athena looks on pensively, perhaps picturing the gorgoneion on her aegis.

A Vase Painter's Notebook

Perseus gave it to her, and on a little group of South Italian vases the hero and the goddess study its reflection in a pool of water or on Athena's shield.[33] She must have found it pleasing for she wore it ever after.

Perseus brought his mother and his wife to Argos, hoping to make peace with his grandfather Akrisios. But Akrisios feared the oracle and fled to Thessaly. Perseus found him, won him over, and they set out together for Argos. On the way Perseus took part in an athletic contest and was throwing the diskos when it slipped out of his hand and rolled into the crowd of bystanders, hitting Akrisios. Akrisios died of the blow, and the oracle of Apollo was fulfilled.

As for Perseus he could not bear to rule on his grandfather's throne and he traded realms with the king of Tiryns. He undoubtedly ruled wisely and well. And he founded golden Mycenae.

13

Bellerophon and the Chimaera

Chrysaor, son of Poseidon and Medusa, has left little mark on Greek mythology. But his brother Pegasos, the winged horse, plays a distinguished role. He was the swift steed of Bellerophon when the hero rode forth to slay the chimaera.

Bellerophon is a Corinthian hero, in one tradition son of Glaukos and grandson of Sisyphos, in another a son of Poseidon. For a reason that is not clear—blood guilt, late writers explain—he had to take refuge with the king of Tiryns, Proitos. Proitos' wife —Anteia in Homer, Stheneboia in tragedy—fell in love with the young hero, but he rejected her advances. She told her husband of the affair, with the roles—familiar story—reversed.

Proitos wished to keep his own hands clean: foul play was indicated and he assigned it to his father-in-law Iobates, king of Lycia. He sent Bellerophon to Iobates with a letter, a request to get rid of the bearer. Iobates sent Bellerophon to fight the chimaera, a terrible fire-breathing monster, a lion with snake tail and with a goat's head rising from the back.[1]

The myth is known very early in Greek art.[2] In the seventh century illustrations are few but impressive. The chimaera is a mighty daemonic beast. She may stride heavily, relentlessly toward Bellerophon, who flies on Pegasos to meet her, lance aimed. But orientalizing monsters lose their magic, the spell is dispelled, and the chimaera appears as she actually is, an awkward synthetic creature.[3] The chimaera is diminished and the battle diminished. There are a few examples in Attic black-figure, a few in Attic red-figure. In the later fifth century the schema of the confrontation is replaced by one in which Bellerophon rides above the chi-

A Vase Painter's Notebook

maera.[4] He aims his spear downward at the beast who faces him or flees, snarls or skulks, below. The gallant rider on the rearing horse, aiming downward, the "victorious horseman," is a type that is coming into favor at this time for many other riders besides Bellerophon.[5] It is popular in the fourth century, continues through the Hellenistic and Roman and Byzantine periods and survives into the Renaissance as the type for Saint George and the dragon.[6]

On Attic vases of the late fifth century, again, reinforcements appear on the scene, foot soldiers, Lycians, with the sleeved tunics, trousers, and tiaras of orientals. Not that Bellerophon needs more help than a winged horse gives, not that he gets it in any literary account, but because the taste of the time favors rich and populous scenes.[7]

And so the myth clings to a slender thread of illustration until, in the fourth century, in South Italy, almost suddenly the scene becomes popular.[8] Bellerophon rides the rearing Pegasos, spear aimed downward at the chimaera. He wears the traveler's hat and his chlamys floats behind him in the breeze of wing-swift flight. Lycian foot may populate the field, sending spears or arrows or hurling rocks at the miserable hybrid. There may be a gallery of divine spectators—Athena, Poseidon, and others. Nike may fly to crown the victor (FIG.49). All form an elaborate frame for the "victorious horseman" on his spirited steed.

Bellerophon rides again.[9] Why? Why should he grow popular so long after the day of monsters and monster slayers? Probably because Euripides' plays, *Stheneboia* and *Bellerophon* had revived interest in the myth.[10] The story of Bellerophon and Stheneboia now comes into South Italian vase painting. Bellerophon is sent off by Proitos, who hands him the letter. Pegasos stands behind his master, impatient for the sky-road. Or the scene is Lycia and the hero delivers the letter to Iobates.[11]

Bellerophon and the Chimaera

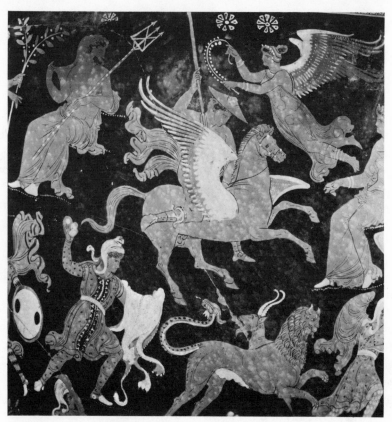

49 • Bellerophon and the chimaera. Apulian volute krater, Naples H 3253, Museo Archeologico Nazionale. (Fotografia della Soprintendenza alle Antichità delle Province di Napoli e Caserta—Napoli)

When Bellerophon returned from killing the chimaera, Iobates sent him against the Solymoi, neighbors of the Lycians; then against the Amazons; finally he set an ambush of chosen Lycians and Bellerophon slew them all. Iobates realized at last that the hero must be descended from a god and gave him his daughter in marriage and half his kingdom.

But, as so many Greek heroes, Bellerophon came upon bitter days. Remember Herakles in his burning robe, Theseus pushed from a cliff of Skyros, Perseus throwing the diskos, . . . Bellerophon after his fall. He mounted his winged horse to fly to heaven and the homes of the gods, but Pegasos threw him. And he wandered about the Aleian plain, hated by all the gods, avoiding the paths of men.[12]

A Vase Painter's Notebook

14

Argonautica

The story of the Argonauts is poor in illustrations but its poverty is of a particular richness: several vase paintings indicate versions of myths that are lost or almost lost in literature. The illustrations become part of the literary tradition.

King Pelias ruled in Iolkos in Thessaly. As the story opens an oracle is being fulfilled. Pelias has been warned to beware of the man wearing a single sandal. Now Jason comes to Iolkos, with the long locks and radiant air of another Apollo. He has lost a sandal in the mud and stands before Pelias, the man with a single sandal.

Pelias had reason to fear Jason: he had usurped the kingdom of Jason's father Aison. Good reason to fear, and he sent him on an unfulfillable errand, to bring back the golden fleece.

Athamas was a king of Boeotia. His queen was a minor goddess, Nephele, Cloud. They had two children, a son Phrixos and a daughter Helle. Athamas tired of Nephele and married Ino, daughter of Kadmos, sister of Semele, and, for the purpose of the myth, a wicked stepmother to the children. A drought fell upon the land and Athamas sent to Delphi for advice. Ino had the messengers intercepted on the way home and bribed them to report the oracle that Phrixos must be sacrificed.

Phrixos and Helle had to escape and Nephele provided means, a wonderful ram, a ram with golden fleece and human speech. It carried them over the sea. Helle fell and was drowned and the sea was named for her, Hellespont.

Phrixos hung on. We know him on a small group of red-figure vases, Attic and South Italian, none much earlier than the middle of the fifth century.[1] He grasps the ram's horns and on Attic vases usually swims along with the ram: he is pictured in a diagonal position, a swimming-floating-trailing position beside the ram.*[2] On

South Italian vases he rides. The sea may be indicated: on Attic vases by wavy lines, on South Italian luxuriantly by fish and other sea creatures.[3]

The ram carried Phrixos to Kolchis in the dim and distant east —on the eastern shore of Pontos, the Black Sea. He was welcomed by King Aietes, a son of Helios and brother of the enchantress Circe. Phrixos settled in Kolchis and married the king's daughter, Chalkiope. . . . Aietes had another daughter, Medea, like her aunt a sorceress.

Phrixos sacrificed the ram to Zeus and presented the fleece to Aietes. Aietes had it hung on an oak in the grove of Ares and there it was guarded by a sleepless dragon.

This was the fleece that Jason had to fetch. Athena helped to build a ship, famous Argo with human voice. Jason sent out heralds calling on heroes to join him. They came from all of Greece: Orpheus of the magic lyre; Mopsos the seer; Telamon, father of Aias; Peleus, father of Achilles. Herakles came but was left behind in Mysia and returned to his labors. Kastor and Polydeukes came, the Dioscuri, sons of Zeus; Meleager, who was to call upon some of the same heroes to join in the hunt of the Kalydonian boar; Ankaios, the Arcadian, who was to die in that hunt; Zetes and Kalais, sons of Boreas, the North Wind; and many others. They set out from Thessaly and sailed eastward, meeting adventures on the way.

They left Herakles in Mysia, came to the land of the Bebrykes. Here Amykos was king, a brutish and insolent man. He would force strangers to box with him and would kill them in the fight. Polydeukes leapt from the ship to accept his challenge, and they fought until Amykos fell dead. Illustrations, mostly Etruscan, show Polydeukes not knocking out Amykos but binding him to a tree, a variant of the myth all but lost in literature.[4]

They sailed through the Bosporos, the strait leading to Pontos, and came to Bithynia on the Pontic coast. Phineus was king, a seer blinded by Zeus for revealing too much to men. Zeus had blinded him and sent the Harpies against him, Snatchers, winged female figures, two in number, addicted to snatching. These loathly ladies stole the food from his table as soon as it was set before him. They left him enough to prolong his miserable life but left it befouled and so bestenched that his halls were empty. The old man welcomed the Argonauts joyfully for he knew that the sons of Boreas would drive off the Harpies. So they do in a few vase paintings. The old blind king is at table, blindness indicated by the closed eye. He gropes about the empty table or throws out a hand in despair as the Harpies fly off with his dinner. Wind-swift Boreads pursue, and the air is filled with wings.

Phineus feasted with the Argonauts, greedily, and gave them advice for the journey. They sailed on and after many adventures put in at last at Kolchis.

When Jason requested the fleece the crafty Aietes agreed to give it to him if Jason would perform certain tasks, tasks, of course, impossible to fulfill. He had to yoke Aietes' oxen, brazen-footed, fire-breathing bulls; to plough the field of Ares and sow it with dragon's teeth; and to dispose of the armed men who would spring up from the teeth. Tasks impossible without the aid of magic, but magic was at hand. There was a sorceress on the scene, Aietes' daughter, Medea. Jason's patron goddess Hera made arrangements with Aphrodite, and Medea burned with passion for Jason. She provided a magic ointment that would make him both invincible and invulnerable. He had only to promise marriage, a small return for such labors made possible, made safe. Jason yoked the oxen, sowed the dragon's teeth, destroyed the warriors who rose up in the furrows. But Aietes would not give up the

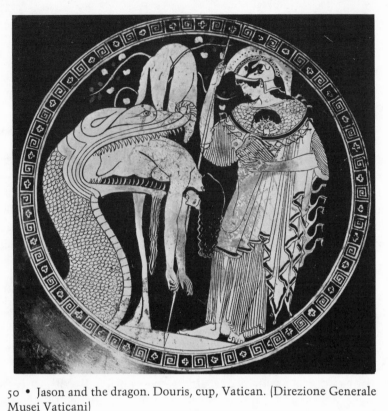

50 • Jason and the dragon. Douris, cup, Vatican. (Direzione Generale Musei Vaticani)

fleece. Medea with her potions put to sleep the sleepless dragon and Jason snatched away the golden fleece.

A few vase paintings show Jason's encounter with the dragon. On South Italian vases he does not steal the fleece but fights for it. Medea stands by, ready with her box of magic herbs or, once, holding out a bowl with a sleeping potion for the serpent.[5]

On an Athenian vase in New York Jason snatches the fleece.[6] Behind him stands not Medea but Athena. Athena appears again on a cup in the Vatican (FIG.50). The scene is set in the grove: the fleece hangs on a tree in the background. The dragon has swallowed Jason but is disgorging him now; the great toothed jaws swing open and the limp figure emerges. Athena looks on with sympathetic interest. The dragon is awake, the whale has swal-

A Vase Painter's Notebook

lowed Jonah,[7] Athena—not Medea—is the rescuer. We know no such myth in literature.[8]

The journey home provides another scene that has not come to us in literature. The Argonauts fled, pursued by the Kolchians, with the golden fleece and with Medea. After many dangers and hardships they came to Crete and attempted to land. The island was guarded by a bronze giant, Talos. A great runner, he would circle the island three times each day and if any ship approached would drive it off by throwing rocks. Being of bronze, Talos was heir to certain ills that flesh is not. The blood, or ichor, coursed through a single vein and the vein was closed at the ankle by a thin skin. Medea cast a spell upon him to drive him mad, he stumbled against a jagged rock and broke the skin, and the life blood flowed out.[9]

A well-known Attic vase of the late fifth century (FIG.51) presents a prelude to Medea's magic.[10] The figures are named in inscriptions: Talos is falling back, white-painted to distinguish him from the human actors. He is hemmed by two youths, the Dioscuri: Kastor is still on horseback, blocking escape; Polydeukes has leaped to earth and seized Talos. They have pursued him on horseback, have caught him, hold him for Medea. Medea stands behind, in oriental dress, with her basket of magic, muttering incantations.[11] At the left, Argonauts watch from the ship; at the right Poseidon, provider of sea storms, looks on, with his queen Amphitrite.

When Jason returned to Iolkos with the golden fleece, he learned that Pelias had murdered his parents and he begged Medea to take revenge. Medea approached Pelias' daughters with a remarkable remedy for rejuvenating their aged father, and she persuaded them of its efficacy by a demonstration. She chopped up an old ram, put it into a cauldron, added magic herbs, stirred well,

51 • Death of Talos. Talos Painter, volute krater, Ruvo, Museo Jatta
1501. (Dr. Giovanni Jatta)

52 • Daughters of Pelias. Villa Giulia Painter, hydria, Cambridge 12.17. (Reproduced by permission of the Syndics of the Fitzwilliam Museum Cambridge)

boiled, and lo! a young ram sprang up. So it does on a number of late black-figure vases* and a few in red-figure, in a symmetrical scene centered about the cauldron. Occasionally Pelias sits watching, a frail old man, bald, white-haired, less enthusiastic than his daughters, who exclaim with delighted hands.

The test was a spectacular success, and now it was Pelias' turn for the cauldron. He walks the long path in a small group of vase paintings of the early classical and classical periods, a bent old man. He may be helped to the cauldron by a loving daughter or she may point the way. Another daughter holds a sword in one hand, expresses determination with the other. The third misgives. Once Pelias is missing: the interest of the painter is in ethos, character (FIG.52).[12] Too probing for the decoration of a pot? For this reason and because figures are repeated from vase to vase in this small group—the sword holder, the doubter—and even details recur, it seems that the vase paintings may reflect another painting, perhaps a wall painting done shortly before the middle of the fifth century.[13]

This time Medea forgot to add the magic herbs. Pelias was

chopped up and boiled but he never sprang out of the cauldron rejuvenated.

After the murder of Pelias Medea and Jason fled to Corinth and lived there with their two young sons until Jason, the "non-hero,"[14] saw a way to the throne. King Kreon had a daughter and Jason put aside Medea to marry the princess. The story of Medea's revenge finds its final form in Euripides' tragedy, a reworking of the myth so compelling that it could be changed, after 431, only in details.[15] Medea sent as a wedding gift to the princess a poisoned robe and crown, murdered her own children, then made her escape to Athens, air-borne in a chariot lent her by Grandfather Helios.

On an Early Lucanian hydria in Policoro (FIG.53) Medea, wearing sleeved robe and oriental headdress, rides off in the dragon chariot. The children lie below, as if in sleep; a servant mourns beside them. At the right Jason rushes in, sword drawn, too late to save his children. Above left, a woman sits admiring herself in a mirror, perhaps the princess.[16] If so, two moments are combined, as often in illustration of tragedy. In Euripides' play the murder of the children comes after the death of the princess. Here the princess has just put on the magic robe but the poison has not yet had time to work, the children are already dead, and Medea is on her way to Athens.

On an Apulian krater in Munich, the most famous of the "Medea vases" (FIG.54), another combination of moments is chosen. Below the Apulian gallery of divine spectators the drama unrolls.[17] A little Ionic building represents the palace. Within, the princess collapses on the throne. Poor old Kreon rushes to her, wearing the sleeved rich robe of tragedy. At the right, a youth runs to the palace and tries to take the fatal crown from the princess' head. His name, as those of other actors on the vase, is inscribed: he is Hippotes. We know Hippotes as a son of Kreon—but he does

A Vase Painter's Notebook

53 • *Medea*. Policoro Painter, hydria, Policoro, Museo Nazionale della Siritide. (Soprintendenza alle Antichità della Basilicata)

not appear in Euripides' tragedy.[18] Below, Jason rushes up, too late to prevent Medea from murdering her son. This murder seems to come at the same time as the death of the princess—two moments, again, woven together.[19]

Behind Medea, a young retainer rescues the other son—a second departure from Euripides' action. Another striking disagreement is the presence of the shade of Aietes, Medea's father. As Medea, he wears the tragic robe and oriental headdress. Finally, to enumerate only major divergencies, Oistros—Gadfly, Sting, Madness —waits for Medea in the dragon chariot, the charioteer who will drive her to Athens.[20]

So many changes add up to more than the free associations of a vase painter. The picture seems to reflect a production of a later *Medea*, an "improvement" on Euripides by some poetaster of the fourth century B.C.[21]

And Jason? He came into our story looking like a young god and leaves it, the Euripidean Jason, a psychopath, ambitious, unfeeling, perfidious. His death in one tradition was by his own hand after his hopes collapsed in Corinth. In another tradition he was killed by a beam which fell from Argo, long beached and rotting.

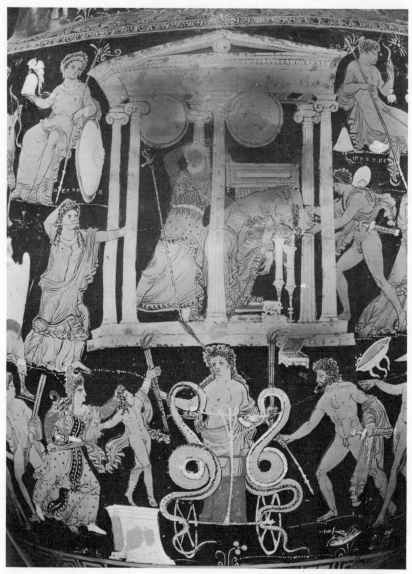

54 • *Medea*. Apulian volute krater, Munich 3296. (Staatliche Antikensammlungen und Glyptothek)

A Vase Painter's Notebook

15

Broken Strings

Another Argonaut who came to a violent end was the Thracian Orpheus, the poet who could hold men and beasts in spell by the magic of his song. Fifth-century Attic vases show him seated on a rock, singing and playing the lyre to the Thracians.[1] He wears Greek dress, but his listeners are characterized as Thracians by their foxskin caps, patterned cloaks, and high boots, fur-flapped.[2]

Into a few such pictures come armed Thracian women. Quietly, chillingly, they announce the ensuing scene, the death of Orpheus.[3] For some reason—various explanations are offered —Orpheus could enchant the Thracians but only infuriated their wives. The women set upon him and tore him to pieces. In the illustrations they attack with weapons—whatever came to hand: stones, spits, pestles, sickles, axes; or spears and swords—their own or their husbands' tools.[4] They wear Greek dress but are marked as Thracian by tattooed arms, occasionally also tattooed feet. There may be an army of women or only one or two. Orpheus flees with his lyre or, in the usual type, sinks to the ground, wounded, bleeding, feebly trying to defend himself as he raises above his head his only weapon, the unavailing lyre.[*5]

On an amphora in Brooklyn (FIG. 55) a Thracian woman rushes at Orpheus with her spit. The poet sits on a rocky slope, flinging out both hands in despair, casting away his lyre, and breaking the crossbar. Why does he not try to escape, clutching his lyre as he flees? Or defend himself with his lyre, raising it above his head?

Diodoros names as Linos' most famous pupils Orpheus, Thamyras, and Herakles.[6] It is from his schoolmate Thamyras that Orpheus takes this lyre, the lyre with broken strings. Thamyras, another Thracian singer, dared to challenge the muses to a con-

113

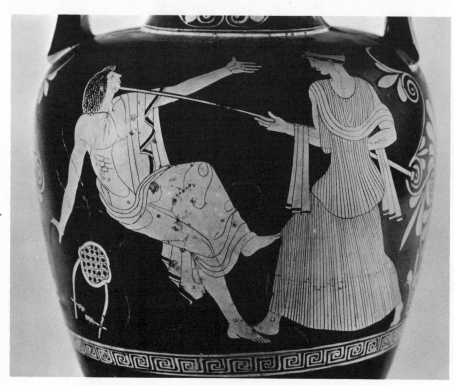

55 • Death of Orpheus. Niobid Painter, neck amphora, Brooklyn
59.34. (Courtesy of The Brooklyn Museum)

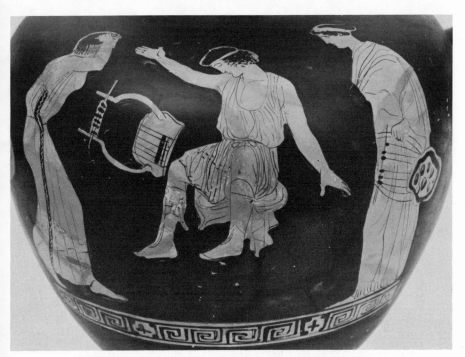

56 • Thamyras. Group of Polygnotos, hydria, Oxford 530. (Ashmolean Museum)

test and for his hubris lost his song and his sight. He is pictured on a hydria in Oxford with closed eye, throwing away his useless lyre (FIG.56). So the great mural painter Polygnotos must have painted Thamyras, blind, hopeless, his lyre at his feet, a shattered lyre with broken strings.[7] And so perhaps the youthful Sophokles presented him.[8] Something of that other Thracian bard, something of his blind despair, has come into the Brooklyn picture of Orpheus.

As Orpheus borrows Thamyras' lyre, so their teacher borrows Orpheus' when he is attacked by the third of his famous pupils, Herakles. On a cup in Munich (FIG.37) Herakles has broken a stool over Linos' head and brandishes part of it as a club for another blow.[9] The master has fallen to one knee but still tries to defend himself, raising his lyre as a weapon above his head. A humorous twist to the scene: the dull old schoolmaster strikes as his last pose one that borrows something from the type for the death of Orpheus.

Broken Strings 115

16

The Hunt of the Kalydonian Boar

Oineus, king of Kalydon in Aitolia, has come into our story as father of Herakles' wife Deianeira. Althaia was Oineus' queen and one of their sons was the hero Meleager.

When Meleager was born, the Moirai came to his mother, pointed to a firebrand on the hearth, and foretold that Meleager would die when it was consumed. Althaia snatched it from the fire and put out the flames. She kept it safe in a chest and Meleager grew to manhood.

One day Oineus was making a sacrifice to the gods and forgot Artemis. The goddess was ready with a mnemonic device: she sent a wild boar to ravage the land, a great wild boar with gleaming tusks.[1]

Meleager brought together a mighty band of heroes to hunt the boar. Many had been Argonauts: Jason, the Dioscuri, Peleus, Telamon, Ankaios, and others. Ankaios, an Arcadian hero, was to die in the hunt. From Arcadia, too, came the heroine Atalanta, a famous huntress, the first to wound the boar.

The type for the hunt of the Kalydonian boar is established by the seventies of the sixth century.[2] In the familiar Attic type the boar is surrounded and attempts to escape, usually to the left. It is still dangerous, a gigantic beast held at bay by a throng of little men coming up from front and back. They attack with spears and tridents. Hounds rush up with the hunters, snapping at the haunches of the boar. One has jumped up on the boar's back and sinks in its teeth.[3] This dog is often white or white-spotted, once is named in an inscription, Whitey.[4] Under the boar lies a wounded man, occasionally named Ankaios (FIG.57).

A Vase Painter's Notebook

57 • Hunt of the Kalydonian boar; funeral games for Patroklos; wedding of Peleus and Thetis; Achilles and Troilos. Kleitias, volute krater, Florence 4209. (Soprintendenza alle Antichità dell'Etruria, Firenze)

Sometimes there are archers among the spearmen, or a single one, and the archer may be Atalanta.[5] She need not, of course, be named to be recognizable: a white-painted figure in Attic black-figure, that is, a woman at the hunt, can only be Atalanta, and the hunt can only be the Kalydonian. But she comes into few boar hunts of the archaic period.[6] Without Atalanta, without inscriptions, when is a boar hunt the Kalydonian hunt? There is only the type to tell: the hunters come from both sides, Ankaios is lying under the boar, Whitey the dog is on the boar's back.

Of course, every mighty boar hunt is a Kalydonian hunt.[7] Every dangered hunter is a Kalydonian hunter as every sailor is an Argonaut. It is a question of how specific the reference is.

In red-figure, Attic and South Italian, there are few certain illustrations of the Kalydonian hunt.[8] Few and late, and the old symmetrical frieze has given way to a tiered and populous composition. Atalanta the archer is prominent. Ankaios has lost his place under the boar. The boar is no longer big and dangerous,[9] a mighty beast with gleaming tusks, but is reduced—the fate of "Gorgons, and Hydras, and Chimaeras dire,"[10] of monsters and monstrous creatures in the late fifth and the fourth century.

Atalanta had been the first to hit the boar. Meleager dealt the fatal blow. He loved Atalanta—but not before Euripides put his hand to the myth[11]—and presented to her the skin of the boar as a trophy of the hunt. His uncles, Althaia's brothers, enraged that a woman should have the prize, took it from her by force. In the quarrel that followed Meleager killed his uncles. Althaia, grieving to madness, found the old piece of firewood and flung it into the fire. Another Greek hero met a bitter death.

A Vase Painter's Notebook

17

Tragic Thebes

When Zeus carried off Europa her father Agenor, the Phoenician king, sent his three sons to search for her. He commanded them to search until they found her, to come home with her but not without her. Whom Zeus conceals is not to be found, and they never returned. Kadmos, one of the three, came at last to Greece. He consulted the oracle at Delphi and was instructed to give up the search and to follow a cow he would meet. He was to follow until she lay down and there was to found a city. He followed the cow to Boeotia, Cowland, to the spot where Thebes would be built, and there she lay down. He prepared to sacrifice the cow and sent his companions for water. The fountain of Ares, to which they came, was guarded by a serpent. The serpent killed some of the men, the others fled, and Kadmos himself set out for the fountain.

The scene is painted on a small number of vases, mostly Attic and South Italian red-figure. In a reedy landscape enter Kadmos. He is usually youthful, has the traveler's garb of chlamys and hat. He is holding the water jar or has just let it fall as a huge snake rises up before him. He has a stone in his hand, ready to fling at the serpent or, exceptionally, uses a sword. A woman may be seated beside the serpent, detached and serene, probably the goddess of the new town, Thebe.[*1]

Kadmos killed the serpent and on the advice of Athena sowed its teeth. Armed men sprang up from the soil, the Spartoi, Sown Men. They fell to fighting among themselves until all were dead but five. These five helped to found the new city and became the ancestors of the Theban noble families.

Kadmos married Ares' daughter Harmonia.[2] The wedding was one of the most splendid in Greek mythology. The gods came,

bringing gifts. Kadmos' own gift to his bride was a wonderful necklace, wrought by the smith Hephaistos.

Kadmos and Harmonia had four daughters: Semele, mother of Dionysos; Autonoe, mother of Aktaion; Ino, wife of Athamas; and Agave. Agave married Echion, one of the Spartoi, and their son was Pentheus, whose story we know from the *Bacchae* of Euripides.

When Kadmos was an old man he turned over the rule of Thebes to his grandson, and so it was that Pentheus represented the forces of order when Dionysos came rampaging out of Asia at the head of an army of maenads. He came to introduce his cult in the land of his birth and found he was unwelcome. Angered, he drove the women mad, clad them in fawnskins, wreathed them with ivy, and gave them the thyrsoi of maenads. And he sent them dancing and raving along the woods of Mount Kithairon. Among the new-made Bacchae were Pentheus' mother Agave and his aunts Ino and Autonoe.

Pentheus hunted down the maddened women of Thebes and made war upon the god, Pentheus, a theater tyrant, harsh, unimaginative, self-righteous. Dionysos cast a spell on him and led him to Kithairon. There the maenads fell upon him and tore him to pieces with their hands.

In our earliest illustration of the death, painted a century before the production of the *Bacchae,* raging women are tearing the already torn body.[3] In later paintings they dance, flourishing thyrsoi and severed limbs. Then, beginning in the later fifth century, an earlier moment is presented.[4] Pentheus is alive and whole, seized by maenads or falling back under their attack. Now they have weapons, swords and thyrsoi, no longer only hands of inspired strength.[5] These are not illustrations of the theater: there is never an indication of a dramatic production. The myth was there

A Vase Painter's Notebook

to be worked by painter as well as poet, a thin vein for the vase painter, a mighty mine for the poet.

After the Kadmeans Labdakos ruled in Thebes, then his son Laios. Laios had been warned by an oracle that his son would slay him. Like Mrs. Slipslop he made a small slip and, when his wife Iokasta gave birth to a boy, he exposed the infant on Mount Kithairon. As all exposed children in Greek mythology, the child was rescued. This was Oidipus, who knew the famous riddle and was the mightiest of men.[6] It is his moment of victory over the sphinx that vase painters choose to depict, omitting the rest of his bitter and triumphant story.

The sphinx is a monster of checkered history. One of the exotic creatures that came to the Greeks in the orientalizing period, she is a winged lion with human head. In archaic sculpture she is a chaste and friendly guardian of tombstones but in black-figure vase painting, a snatcher of young men—whether for sexual use or for death, or both, is never clear.[7] In red-figure she is chiefly the riddler, the Theban strangler who posed her question and punished failure with death, until she was defeated by Oidipus.[8]

In the red-figure paintings the sphinx is seated upon a rock or column, the latter perch taken from the daily scene where sculptured sphinxes were mounted on columns.[9] Oidipus faces her, usually youthful, dressed as a traveler in chlamys and petasos, carrying spears. He stands or sits in an attitude of thought or tense expectation.* The scene becomes something of a favorite in the classical period, a quiet two-figure scene dominated by vertical and horizontal lines.

When Oidipus had saved Thebes from the sphinx he was made king of the city, married the widowed queen Iokasta, later learned

who he was and what. In the passion of discovery he blinded himself. He lived on in Thebes, was mistreated by his sons, and called upon them the curse that they divide their inheritance by the sword. The fulfillment of the curse was the War of the Seven against Thebes.

Oidipus' sons tried to escape the curse: they agreed to rule alternately in Thebes. Eteokles, the elder, would rule for a year, and Polyneikes left Thebes and went to Argos. There he married the daughter of King Adrastos. At the end of the year it was Polyneikes' turn but Eteokles would not give up the throne. Adrastos promised to bring his son-in-law back to Thebes and set about raising an army of Argives.

One of the chiefs whom Adrastos approached was the seer Amphiaraos. In the past these two had been deadly enemies but they had made peace and to seal the pact Amphiaraos had married Adrastos' sister Eriphyle. And they had agreed that in the event of any future difference between them, Eriphyle would be the judge.

Amphiaraos refused to take part in the war against Thebes because he foreknew that it would end in disaster and that of the chiefs only Adrastos would return. But Eriphyle had the power of decision and she sent her husband to his death. She was bribed by Polyneikes, who offered the golden necklace of Harmonia, now an heirloom of the Theban royal family.

The bribing of Eriphyle is depicted on a few red-figure vases, a picture of greed in a guise of innocence. Polyneikes, the foreigner in Argos, wears the traveler's dress. He leans on his staff in an attitude of easy conversation, takes the necklace out of a box, and holds it up before Eriphyle. Eriphyle stands or sits, looking graceful, guileless, demure—and holds out a hand in a gesture of astonishment or greed.*

She traded her husband for the necklace and he went to the war. A famous scene of the departure of Amphiaraos, painted on

A Vase Painter's Notebook

a Corinthian krater (FIG.7), has been studied as an example of archaic narrative illustration. Amphiaraos is seen at two moments. He has drawn his sword and is about to kill his wife, then decides to entrust vengeance to his son Alkmaion and steps upon the chariot. The two moments are closely woven to a rich fabric.

The picture is remarkable in another connection also. We leave the sixth century B.C. and turn to the second century A.D. Pausanias is on his travels. At Olympia he sees among the votive gifts the "chest of Kypselos," tyrant of Corinth in the later seventh century. The chest is probably to be connected not with Kypselos but with his family; it may have been dedicated shortly before the middle of the sixth century.[10] It is known to us only from Pausanias' description, a chest of cedar, decorated with narrative friezes in ivory, gold, and cedar.

Pausanias' description of the scene of the departure of Amphiaraos reads, as Hauser observed, like a text for the Corinthian vase painting:[11]

> Next is wrought the house of Amphiaraos, and baby Amphilochos is being carried by some old woman or other. In front of the house stands Eriphyle with the necklace, and by her are her daughters Eurydike and Demonassa, and the boy Alkmaion naked. . . . Baton is driving the chariot of Amphiaraos, holding the reins in one hand and a spear in the other. Amphiaraos already has one foot on the chariot and his sword drawn; he is turned toward Eriphyle in such a transport of anger that he can scarcely refrain from striking her.

The resemblance between the lost frieze and the extant vase painting does not stop here.[12] Pausanias goes on:

> After the house of Amphiaraos come the games at the funeral of Pelias. . . .

This is just the subject of the painting on the reverse of the Corinthian vase. Here the agreement with Pausanias' description is not

really close, but the combination of these two unconnected subjects on the two monuments is very striking.[13] It lifts the curtain on a moment of the sixth century. The chest is to be sent to Olympia but is displayed now at Corinth.[14] A vase painter is walking round it as Pausanias will do centuries later. He returns to the shop; on the pot he is painting he quotes from the chest, and his quotation translates Pausanias' account into the language of black-figure and makes it live for us.

Attic black-figure, as Corinthian, depicts the scene in the type of the departure of a warrior, a scene of contemporary life.[15] It is a formal, many-figured scene where the actors have their assigned places: the warrior steps upon the chariot; the charioteer stands in the car, holding the reins; a woman stands in the background; a man sits in front of the horses; women and departing warriors may surround the chariot.[16]

There are a few fifth-century red-figure examples of the scene, and these, too, take the form of the departure of a warrior.[17] But the type has changed: now the scene is played indoors by a few actors only. Twice, Amphiaraos clasps Eriphyle's hand, not in reconciliation but because the handclasp is sometimes part of the scene of departure.[18] In one of these pictures (FIG.11) he holds out his hand but lowers his eyes—will not meet the eyes of his wife. The form is that of the departure, the hatred and bitterness belong to the myth. In a third example, Amphiaraos hands a sword to young Alkmaion, who advances with reluctant step and holds out a timid hand to take it.[19]

The timid hand struck at last. Amphiaraos, Eriphyle, and later Alkmaion died for the sake of the necklace.

A Vase Painter's Notebook

18

A Wedding
and a War

It may be that real wars bloom, evil flowers, from economic roots, but mythological wars have other causes. Consider the Trojan War. It all began with one of Zeus' love affairs. The lady was the sea nymph Thetis, daughter of old Nereus. Unfortunately, it was revealed that Thetis would bear a son mightier than his father. Zeus had toppled his own father and meant to keep the usurped throne. He gave Thetis to a mortal, the Thessalian hero Peleus. Thetis was unwilling to marry a mortal and Peleus had to capture her. He lay in wait, sprang out, and seized her. A creature of the changeful sea, the goddess could assume any form—a wild beast, fire, water—and did, as she tried to escape his grasp.

The scene is popular in late black-figure and in red-figure vase painting. Peleus has seized Thetis and holds her round the waist. She struggles to escape, looking back and holding out a hand in appeal, or flings up both hands in a gesture of despair. A transformation may be indicated, or successive metamorphoses depicted simultaneously in the archaic manner. A lion, a snake attack Peleus (FIG.12) and we read: Thetis became a lion, then a snake. Or a panther or sea lion. Or flames shoot up from Thetis' shoulders.[1]

Frightened Nereids may flee, looking back toward the scene as they run from it.* Chiron, too, may watch, the wise old centaur, friend of Peleus, who had advised him to hold on, no matter what form the pantomorphic goddess might assume.[2]

In the early classical period the theme is occasionally translated into a pursuit, that favorite type of the fifth century. Another fashion of the fifth century is for continuing the scene. On the obverse of a vase Peleus struggles to hold Thetis and Nereids

flee in panic. On the reverse other Nereids run to their father Nereus, bringing the fearsome news.

Peleus won his bride, and the wedding was most splendid. The gods attended, Apollo played the lyre, the muses sang. An illustration is as celebrated as the event, the principal frieze of the great François krater, the work of Kleitias (FIG.57). A procession of gods is coming to the house of Peleus. Thetis sits inside and Peleus stands before the house to greet the guests. They are led by Chiron and the herald Iris, then the goddesses who bless the house, and others, on foot. Then come chariots, drawn by elegant horses with slender legs. Zeus and Hera lead, others follow. The procession circles the whole mighty vase, a file of many little figures, formal and lively, with their rich robes and their language of angular animated gestures.

Most often the scene is taken from weddings of real life. In black-figure the wedding procession is depicted, a chariot scene in which the young couple ride to the house of the groom, accompanied by gods on foot. In red-figure the groom, on foot, may lead the bride, walking ahead and grasping her wrist in the ritual gesture of the wedding ceremony.[3]

After the birth of Achilles, the son stronger than his father, there was a quarrel and Thetis left Peleus and returned to the depths of the sea. Peleus brought Achilles to the old schoolmaster Chiron to raise and educate. He brings him in a series of illustrations that begin as early as the middle of the seventh century.[4] Achilles is a child in arms in the earlier type;* in the later, an older boy, old enough to be enrolled in Chiron's spelaean school.[5]

But we are ahead of our story. At the wedding there had been an incident, a disturbance, to mar the smooth and formal performance. Eris, Strife, who is wont to come after the ceremony, unasked, felt she should have been invited. She threw a golden apple

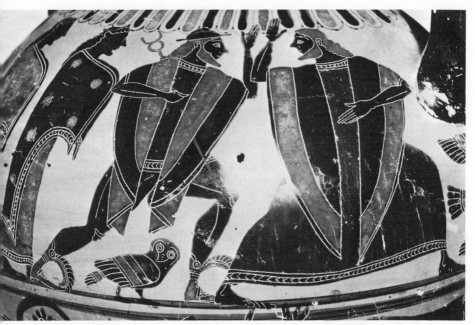

58 • Judgment of Paris. Lydos, neck amphora, Florence 70995. (Soprintendenza alle Antichità dell'Etruria, Firenze)

among the guests, inscribed "to the fairest," and Athena, Hera, and Aphrodite each saw a reference to herself.[6]

Zeus should have arbitrated but he refused and assigned the task to the mortal prince Paris. Paris, or Alexandros, was a son of Priam and Hekabe, king and queen of Troy. His birth had been attended by dire prophecies for the city and he was exposed to die on Mount Ida but, as all exposed mythological babies, was rescued. He was brought up by a shepherd and when he comes into our story he is watching his flocks on Ida. Hermes has escorted the goddesses to Ida and communicates to Paris the command of Zeus.

The scene comes into Protocorinthian vase painting just after the middle of the seventh century.[7] In Attic vase painting it has a long and prosperous life. In earlier black-figure Hermes has conducted the goddesses to Ida and may greet Paris or explain his mission, and Paris may receive the little procession quietly.[8] More often he hastens away, looking back in alarm as Hermes pursues, holding up a hand that cries, Stop! The goddesses follow, undistinguished from each other, triplets, a silent relentless phalanx advancing (FIG.58).[9]

A Wedding and a War 127

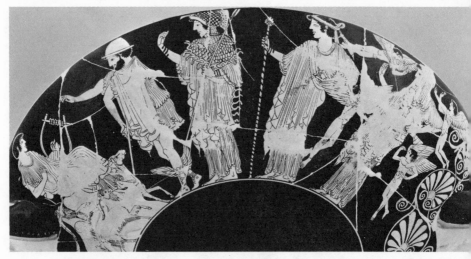

59 • Judgment of Paris. Makron, cup, Staatliche Museen Preussischer Kulturbesitz, Berlin 2291. (Staatliche Museen Preussischer Kulturbesitz, Antikenabteilung)

Why should Paris flee? Impossible to choose among the triplets? Only for us, who cannot see the vision. Two enemies as the price of a friend? Not so much as simple terror at the bright and blinding epiphany.[10]

In later black-figure the goddesses are characterized or, most often, Athena only, the most characterizable of the three as well as the most Athenian. She has the middle position for conspicuousness and symmetry. When all three goddesses are given attributes, or two, we learn the usual order: Hera, Athena, Aphrodite.[11]

Paris, bearded, mantled, faces the procession* or moves away with uneasy backward glance. Occasionally he carries a lyre. He may sit on a rocky slope holding his lyre, anticipating the pose of the youthful shepherd of red-figure.[12]

Or Paris is not in the picture at all. Hermes leads the goddesses; the little expedition is on the way to Ida.[13] Rarely Hermes, too, is missing, and the three travel unchaperoned to Paris' mountain fastness.

In red-figure the procession continues or the form, rather, for it is not amove, it is there. Hermes, in the lead, faces Paris. Red-figure Paris hardly ever flees—perhaps because he cannot: Hermes is not approaching but has miraculously appeared; there is no escape.[14] Paris, now youthful, sits upon a rock of Ida, sometimes surrounded by his flock (FIG.59).[15] He may be playing the lyre, lost

A Vase Painter's Notebook

in its magic, unconscious of the epiphany, or may be startled to awareness. Or he may sit in an attitude of thought, pondering Hermes' message or already studying the goddesses.[16]

In the late fifth century another change comes to the schema. First there was the procession, the moving column, then the form of the procession. Now the form dissolves and the goddesses are grouped about Paris. They pose before him or sit about him in attitudes limply graceful. Bright and insubstantial figures may populate the scene (FIG.60).[17]

Paris is no longer a simple young shepherd but an elegant oriental prince.[18] He wears sleeved tunic, richly patterned, trousers, cap. He is seated, confident and relaxed, receiving Hermes as if in audience. Sometimes a little Eros leans on Paris' shoulder and whispers in his ear, Eros sent by Aphrodite to inflame Paris for her gift.[19]

For the prize went not to the fairest but to the one who offered the most attractive bribe. Hera offered empire, Athena victory in war, and Aphrodite offered Helen, the wife of Menelaos. And Paris would rather have his sweet,[20]

> Though rose-leaves die of grieving,
> Than do high deeds in Hungary
> To pass all men's believing.

Aphrodite kept her word. She arranged for Paris to visit Sparta as Menelaos' guest, then for Menelaos to be called away so that Paris could carry off his wife—Helen, who was ready to elope at first glimpse of the radiant Trojan prince.

There are many illustrations of the meeting of Paris and Helen, scenes hardly mythological, anheroized genre;[21] many illustrations of the meeting, few of the elopement. In two examples of the latter theme Paris grasps Helen's wrist as a bridegroom when he leads his bride.

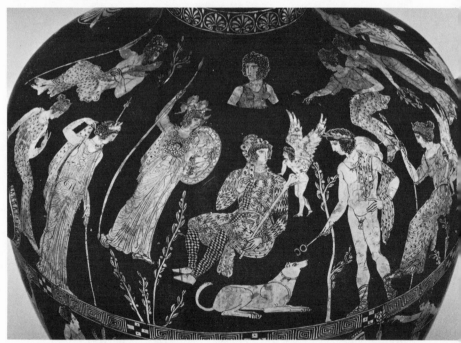

60 • Judgment of Paris. Painter of the Carlsruhe Paris, hydria, Carlsruhe 259. (Badisches Landesmuseum)

O happy bride, turn back!

Menelaos returned to Sparta to find he had been tricked. He called upon the Achaian chiefs for help. When they had all been suitors of the beautiful Helen they had sworn to defend the man who won her. They gathered now with men and ships, and Menelaos' brother Agamemnon commanded, king of golden Mycenae. A thousand ships set sail for Ilium.

In the early part of the war the Achaians kept close to the ships and the Trojans could venture outside their walls.[22] One day Troilos, a young son of King Priam, went to a fountain outside the citadel to water his horses. He was accompanied by his sister Polyxena, who brought a pitcher, a hydria, to fill. Achilles had been lying in wait at the fountain; he sprang out, pursued Troilos, caught him, and cut off his head. Polyxena escaped.

In the scene of the ambush Achilles crouches behind the fountain, in armor, spear ready. In Attic black-figure Polyxena stands at the fountain to fill her hydria. Troilos comes up with his horses, riding one and leading the other, a young boy with long hair. A

A Vase Painter's Notebook

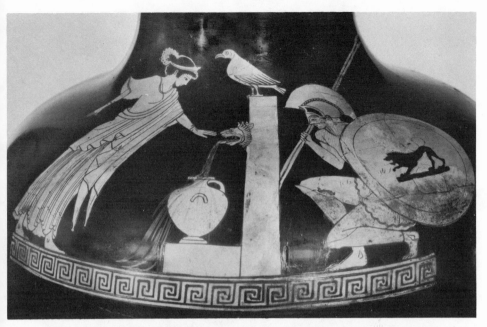

61 • Polyxena and Achilles at the fountain. Berlin Painter, kalpis, Leningrad 628. (Hermitage State Museum)

raven may be perched upon the fountain, Apollo's messenger, whose presence is a warning.*[23] Apollo had a personal interest in the crime for it was committed at his altar.

Or the scene is trimmed of Troilos and his horses. Polyxena fills her pitcher, Achilles lurks. This version occurs on several black-figure vases and on a beautiful red-figure hydria (FIG.61). The spotlight has moved from Troilos to pick up Polyxena. Polyxena would later be slain at Achilles' tomb: his ghost would remember her and demand that she come with him.[24] Now the water splashes gaily, overflows the pot. Polyxena has a bright and appealing youthfulness as she goes about the tasks of life, innocently, and the shadow of death falls upon the fountain.

Scene two: the pursuit. We begin with an extract (FIG.1) and we shall build the scene to intelligibility. A boy is riding a horse. A young woman runs ahead but turns back, anxious. In a fuller excerpt (FIG.62) the boy—Troilos—has two horses, rides one and leads the other, as in the scene of the ambush. He is in desperate haste, urging his horses forward, looking back fearfully. A new detail identifies the scene, a hydria, broken and spilling out water, dropped by Polyxena as she flees. To be complete the scene needs

A Wedding and a War 131

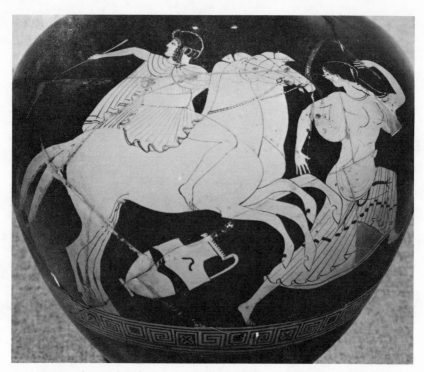

62 • Troilos and Polyxena. Troilos Painter, hydria, British Museum
99.7–21.4. (Trustees of the British Museum)

only Achilles. He pursues on foot, the swift-footed Achilles,
bronze clad as before, spear or sword in hand,* sometimes spring-
ing out from behind the fountain house.

The fountain house appears in resplendent detail on Kleitias'
great krater (FIG.57). A boy is filling a hydria at the fountain, un-
concerned, for he belongs to an earlier moment, represents the
activity at a fountain house on the quiet days when murderers do
not leap from behind its walls. A girl stands on the step, flinging up
both hands in horror as she turns from one moment to the next,
from the scene at the fountain to the pursuit.[25] And still a third
moment is woven into the narrative. Old Priam has been sitting
before the walls of Troy but is rising anxiously as his friend An-
tenor rushes up with the news. Hektor and Polites come out of the
city gate, full-armed, marching to the rescue, though they could
not yet be in harness with the news just coming.[26]

Scene three: the death of Troilos. Black-figure illustrations are
uninspired. Achilles seizes the boy at the altar and threatens him

132 A Vase Painter's Notebook

with his sword; or grasps him by the leg and holds him, head down, over the altar where he will kill him. Or he has already cut off the head and hurls it, as a missile, at the Trojans coming up, at first to bring help, now to recover the body.

In the early fifth century the death of Troilos moves the imagination of painters.[27] In a few red-figure pictures Achilles has caught the boy by his long hair and pulls him from his horse, or drags him to Apollo's altar, a boy very young and helpless, in the clutch of the mighty hero.

Why? Why this purposeless and skulking murder by the greatest of the heroes at Troy? Perhaps a shadow lurking is as much a part of the fountain scene as a boy filling his pitcher. But why Achilles' shadow? The ancients asked and offered explanations,[28] but they could never explain it.

19

The Mourning
Achilles

The wrath of Achilles was brought on by Agamemnon, commander of the Achaian armies at Troy. Agamemnon had taken as a prize of war a girl of the Troad, Chryseis, daughter of a priest of Apollo. Apollo forced him to return the girl, and Agamemnon in rage and spite carried off Achilles' prize, Briseis.[1] Achilles withdrew from the fighting and Thetis, his mother, persuaded Zeus to turn the war against the Achaians.

When the fortunes of the Achaians had become desperate, the wise old Nestor advised Agamemnon to win back Achilles by restoring Briseis to him. Agamemnon sent Phoinix, Aias, and Odysseus to make peace. In the scene of the mission Achilles sits on a stool, sulking, wrapped in his mantle, huddled in self-pity, head bowed, a figure known as the "mourning Achilles." Odysseus faces him, sitting easily on a camp stool or standing before him. Old Phoinix may be in the picture, and Aias; also Diomedes, who had no part in the mission. The scene is set as the hut of Achilles by armor hung up on the wall.[*2]

Achilles at first refused a reconciliation. Then, when the battle was pounding against the very ships of the Achaians, his friend Patroklos begged Achilles to lend him his armor. He would go into the fight hoping the Trojans might think it was Achilles. As fire was eating the ships, Patroklos led the Myrmidons into battle, Achilles' men. He drove back the Trojans, then fell, wounded by Euphorbos, slain by Hektor.

Now Achilles desired only the life of Hektor but he had no armor. Thetis visited the smithy of Hephaistos (FIG.63) and Hephaistos made a great shield and on it he worked the earth and

A Vase Painter's Notebook

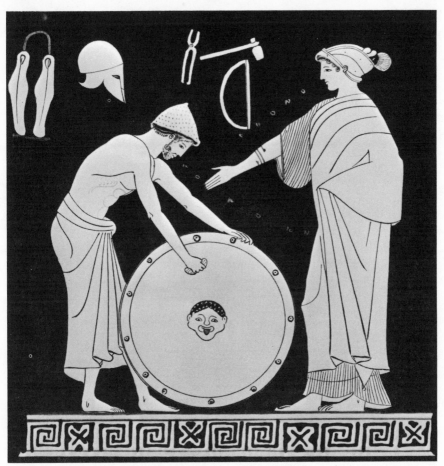

63 • Hephaistos and Thetis. Dutuit Painter, neck amphora, Boston
13.188. (Courtesy Museum of Fine Arts, Boston)

the sky and the sea . . . , and he made corslet and helmet and greaves.³

And Thetis like a hawk swooped down from snowy Olympos bringing the gleaming armor, but on the monuments she is helped by her sisters the Nereids. In the scene of the rearming, developed in the early classical period, Achilles may sit sadly, the "mourning Achilles" of the mission, as Thetis and her sisters approach with helmet, corslet, greaves.⁴ Or—a fantasy of the pictorial tradition—Nereids riding dolphins or sea horses bring the arms across the sea, a frieze of Nereids or a single one.*⁵

New-armed, Achilles went into battle, like a lion with glaring eyes, and killed till his hands were weary.⁶ He drove the Trojans back within their walls and only Hektor stood before the gates. Achilles chased him three times round the city of Priam, then Hektor turned and fought. Hektor fell and Achilles bored holes in the ankles, tied the body to his chariot, and dragged it in the dust to the ships of the Achaians.

After the funeral of Patroklos and the funeral games, the Achaians went to the ships to sleep but Achilles could not sleep for grief. At last he yoked his horses, fastened Hektor's body to the chariot, and dragged it three times round the tomb of Patroklos. In the illustrations—all black-figured—he has a charioteer; he himself runs beside the chariot, full-armed. The charioteer, wearing the long chiton of his trade, urges the horses; the horses rush on, dragging the body. The tomb is represented by a mound, and above it hovers a little winged warrior, the ghost of Patroklos. Sometimes there is a snake, chthonian beast, symbol of death.*⁷

But—the armed runner occasionally forgets his role: he runs toward the chariot as if to attack it. Once a warrior, fallen under the horses, defends himself with his shield. The body of Hektor —the subject of the scene—may be missing. The painter has mis-

A Vase Painter's Notebook

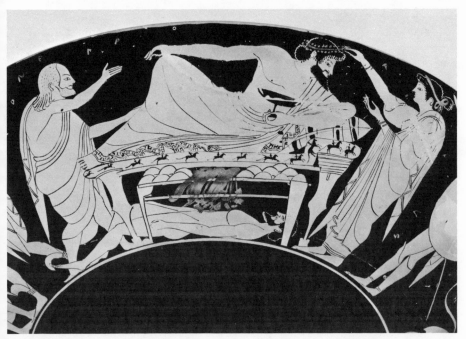

64 • Ransom of Hektor. Oltos, cup, Munich 2618. (Staatliche Anti-
kensammlungen und Glyptothek)

understood the type he is reproducing. Chariot, running hoplite,
dead body—all suggest a battle, and he has made a battle scene of
the type for the dragging of Hektor's body.[8] He is repeating, mind-
lessly, elements of a scene that does not inspire.

When Zeus had had enough of Achilles' outrages, he arranged
for King Priam to go to the camp of the Achaians to ransom the
body of his son. In the illustrations Achilles is reclining at dinner.
There may be a boy to serve him or a girl, Briseis perhaps, to
wreathe the banqueter or pour his wine. Priam comes, holding
out a hand in appeal, followed by attendants who bring gifts or
join in his entreaty. Finally, the body of Hektor lies under the
couch.[9] The scene is a brutal variant—apparently—of the one in
the *Iliad*, for here Achilles is feasting over the dead body of his
enemy. Actually, the pictorial tradition introduces the body only
for clarity: a banqueter and a suppliant might not otherwise be
recognized as Achilles and Priam.[10]

Unlike the scene of the dragging of Hektor's body, here is a
type transmutable in the alchemy of imagination. Achilles may

The Mourning Achilles 137

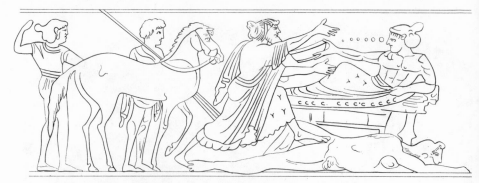

65 • Ransom of Hektor. Sappho Painter ("probably"), lekythos, once
Roman market. *AZ*, 12 (1854), plate 72, 3.

turn toward Priam as he approaches. Or he may look away, pre-
tending not to see him—characterization in the turn of a head:
this is the implacable Achilles who insulted the body of Hektor.[11]
The role of Priam, too, is various. He comes with large command-
ing gestures or with frail but kingly dignity. Or he is a broken
old man who comes to Achilles and holds him with his skinny
hand (FIG.64).

In the black-figure examples Priam comes on the scene with
impassioned, that is, hasty, step; occasionally, in careless late
black-figure, with an elan so undignified as to verge on the comic.
Once (FIG.65) he comes bounding over the body, reaching out both
hands to Achilles. Achilles holds out a wine cup. "Have a drink,"
he seems to say. A parody of the ransom? No. Robert has explained
the scene as one that combines two moments: Priam arrives in
the hut of Achilles; later, when the ransom has been arranged,
Achilles invites Priam to dinner—for even the fair-haired Niobe
remembered food.[12] A wonderful passage of Homer shines through
a careless and insignificant drawing.

A Vase Painter's Notebook

20

The Fate
of Heroes

After Hektor's death Penthesileia, queen of the Amazons, daughter of Ares, came with her army to help the Trojans. She died in battle, the victim of Achilles. In the high period of Attic black-figure the fight is wonderfully illustrated by Exekias (FIG.66). Achilles presses forward, Penthesileia has fallen to one knee. The archaic movements of the figures and the conventions of black-figure, the costumes, as it were—Achilles in his black tights, Penthesileia in her white ones—suggest a stylized dance, a ballet of combat. A dance, conventional, impersonal, but transformed by the meeting of eyes. Achilles' white eye stares from his black face, Penthesileia's black eye from her white face. The gallant warrioress is dying and Achilles, too late, feels for her. The eyes, speaking to each other, speak to us.

The figures are named. Without inscriptions or without, at least, a Trojan context, the duel is indistinguishable from an "anonymous" Amazonomachy, and perhaps when we ask which battle is represented, we are asking the wrong question. Perhaps it came to the painter occasionally, only as an afterthought, to name the figures of a conventional Amazonomachy.[1]

After Penthesileia Memnon came to the aid of the Trojans, son of Eos, the Dawn, king of the blameless Ethiopians. Like Penthesileia he met his end at the hand of Achilles. He had killed Antilochos, Nestor's son, and Achilles undertook revenge. So evenly matched were these sons of immortal mothers and mortal fathers that victory had to be allotted on high. Several vase paintings show Hermes, sometimes in the presence of the anxious

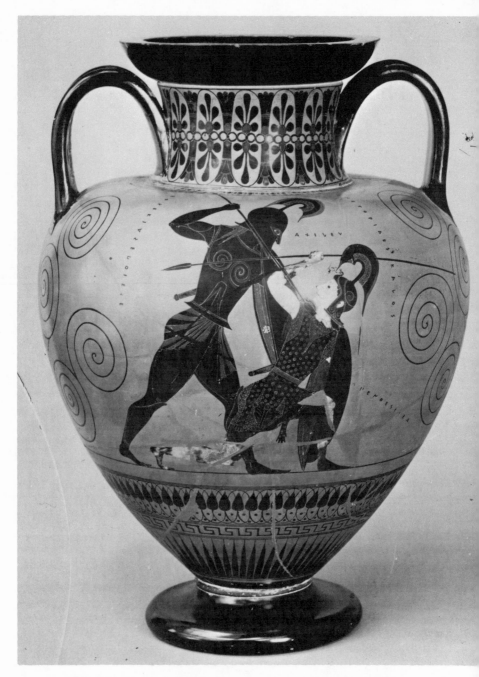

66 • Achilles and Penthesileia. Exekias, neck amphora, British Museum B 210. (Trustees of the British Museum)

A Vase Painter's Notebook

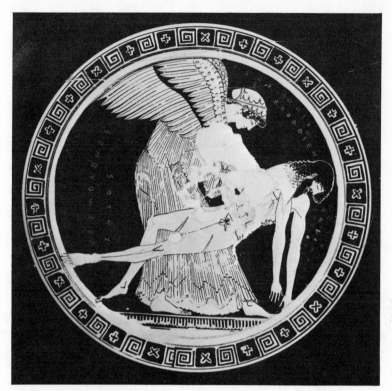

67 • Eos with the body of Memnon. Douris, cup, Louvre G 115. (Musée National du Louvre)

mothers, weighing the fate of the heroes, weighing their lives, one against the other.[2] The lives, the psychai, stand on the scales, little figures, nude and winged or armed and wingless.* Memnon's psyche sank, and he went down to death.[3]

For the battle itself the schema is that of the duel, a duel as any other. It may be fought over a fallen figure but more often is not.[4] It may be undecided* or Memnon may be wounded and falling. In the absence of inscriptions there is only one criterion of the scene: the mothers stand behind the heroes, watching, impassively in black-figure, frantically in red-figure.[5]

Memnon fell and Eos flew down to rescue the body of her son, the shining Dawn with black night in her heart (FIG.67).

Then came Thetis' turn to mourn. Achilles fell by an arrow of Paris, guided by the archer Apollo. Mighty Aias, under a shower of arrows, lifted up the body and carried it out of the battle.*

The Fate of Heroes 141

21

Hidden Swords

A heroic life was lost. There ensued a sordid quarrel over possessions. The arms of Achilles, the work of Hephaistos, were to go to the best of the Achaians. Aias claimed the prize, Telamon's mighty son, who had rescued Achilles' body. Odysseus, too, claimed the arms, that resourceful and wily man, and the one who had protected Aias' rescue.

The dispute was decided by vote, and a few red-figure vase paintings show the Achaian chiefs depositing their pebbles, a scene modeled on the type for Achilles and Aias gaming.[1]

The model, first. Flashback: a story of the boredom of war, even heroic war. To pass the time at Troy the Greeks resorted to games, and one day Achilles and Aias were so engrossed in a board-and-dice game that they did not notice the battle being fought around them. They continued to throw their dice and move their men, oblivious of the cries and clatter.[2] The scene is popular in black-figure and continues into red-figure. The heroes sit on blocklike seats at a low table.[3] They are in armor, hold their spears ready; their shields usually stand behind them, Boeotian shields with Corinthian helmets resting upon them. Often Athena is present, behind or before the table, the center of the scene. She moves to the right but looks back, a figure with potential for passion or grace. She wears aegis and Attic helmet, carries a spear, and raises her free hand in a call to arms.*

This scene provides the type for the vote on the arms of Achilles. In our finest example the quarrel is illustrated on one side of a cup, the vote on the other. On the obverse Aias has caught sight of Odysseus and comes at him with murderous sword. Odysseus has seen Aias only later, is just drawing his sword. The Achaians intervene.[4] On the reverse they vote (FIG.68). Each comes up and places his pebble on a low table. Athena stands behind it,

A Vase Painter's Notebook

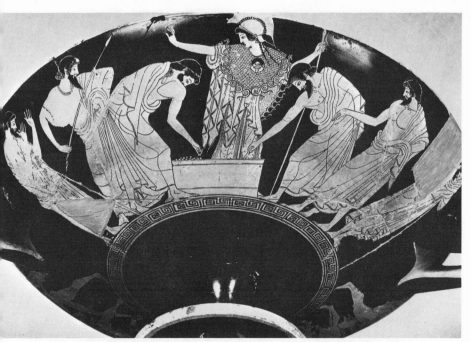

68 • Quarrel over the arms of Achilles: the vote. Douris, cup, Vienna
3695. (Kunsthistorisches Museum)

like the unseen divinity in the center of a pediment, holding out
her hand to her favorite, Odysseus.[5] As the pebbles pile up on his
side, Odysseus flings up both hands in his delight. At the other
end Aias turns away with head bowed, mantle drawn about him.
On the inside of the cup the quarrel ends in a reconciliation: Odys-
seus gives the arms to Neoptolemos, the son of Achilles.[6]

Here is a tragedy presented on a cup, a complete action with
beginning, middle, and end. The borrowed type gives depth to the
middle scene. It suggests the fellowship of the two greatest of the
Greek heroes and the unjustness of the award. It brings a shock
as the viewer recalls that the second of the Achaian heroes was
soon to follow the first, that Aias would find a lonely spot and hide
his sword, the gift of Hektor.[7]

Aias, defeated, planned revenge, but his enemy Athena sent
madness upon him and turned his plot against him. When he
came to himself he knew that all he had was lost,[8] and he must

Hidden Swords 143

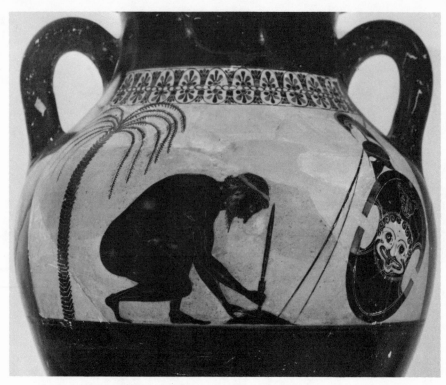

69 • Suicide of Aias. Exekias, amphora, Boulogne 558. (Musée des
Beaux-Arts et d'Archéologie, Boulogne-sur-Mer)

die. Corinthian painters show him impaled upon his sword,* blood
spurting. This crude type has been transformed by the Attic master
Exekias (FIG.69). Exekian Aias prepares to die,[9] the lonely Aias
with lined face, planting his sword in the ground. Behind him is
a weeping tree. Before him stand his arms, Boeotian shield with
Corinthian helmet resting upon it, spears at hand; a ghostly war-
rior looking on with empty eyes, sternly directing. And the fine
long hand smooths a little mound of earth around the sword.

With the greatest of the Achaian heroes gone, fiery men with
shining spears, a chapter of the Trojan story comes to an end.
Odysseus had won more than the arms. After the deaths of Achilles
and Aias, Troy would be taken not by great deeds but by stratagem.
The Greeks withdrew. They had built and left behind, ostensibly as
an offering to Athena, a gigantic wooden horse, a hollow horse

A Vase Painter's Notebook

which Odysseus manned with the best fighters. The others burnt their huts and sailed away—waiting a signal to return. Next morning the Trojans awoke to find the enemy gone. Rejoicing, they brought the wooden horse inside the citadel.

22

The Sack
of Troy

At night, when the Trojans were asleep after their celebration, the Greeks stole out of the belly of the wooden horse and were joined by their comrades. Then began the "night battle," the slaughter of sleep-sodden Trojans. The sack of Troy is a favorite theme of Athenian vase painters, and into one of the scenes they depict may come real feeling.[1]

This is the murder of King Priam, an old man who has outlived his family and his country. Now he has fled for his own life, a ragged remnant of life. He has taken refuge at the altar of Zeus Herkeios, Zeus whose altar is in the courtyard, the protector of the household. He clambers up the altar, for Neoptolemos, Achilles' son, is upon him.

Black-figure Priam sits on the altar, hands held out in a last appeal or in a hollow gesture of defense (FIG.70); or he may be fallen on the altar for fright or in death.[2] The scene had come into Greek art as an independent type but soon, in Attic vase painting, it was fused with the other crime of Neoptolemos, the murder of Priam's little grandson Astyanax, the last hope of the Trojan line.[3] In the *Iliupersis* Neoptolemos kills Priam at the altar of Zeus Herkeios; in the *Little Iliad* he takes Astyanax by the foot and flings him from the battlements of Troy. On archaic vases Neoptolemos has seized the child by the ankle and seems to be hurling him at the old king—both murder weapon and victim (FIG.10). Seems, because these are the enlaced moments of the archaic artist: Neoptolemos is hurling Astyanax over the wall; he is killing Priam at the altar.[4]

The fused, as the single, scene continues in red-figure.[5] Most

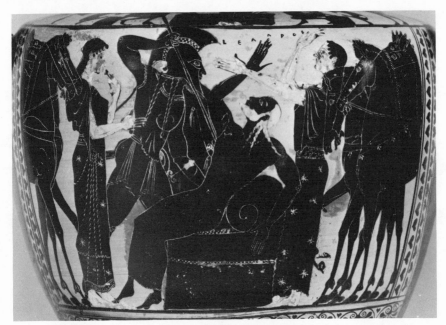

70 • Death of Priam. Leagros Group, hydria, Würzburg 311. (Martin von Wagner–Museum der Universität Würzburg)

painters repeat the old type but at least one late-archaic painter saw in it something new, saw it as we see it today, Neoptolemos flinging the child upon the old man, horribly smashing one victim against the other (FIG.71). In the clear light of the fifth century the old vase-painters' type takes a new and terrifying power.

For this theme variations are of particular interest. On a late black-figure lekythos in Athens Priam is seated on the altar, repelling with his hands a horrible missile.[6] Neoptolemos is hurling not a boy but a head. It must be Astyanax' head—but Astyanax was not beheaded. The head is borrowed—the type is borrowed—from the story of another young Trojan prince. In the early days of the war Achilles had cut off the head of Troilos; there are a few black-figure scenes in which Trojan warriors march up to recover the body and Achilles throws the head as a weapon against them.[7]

It was long ago pointed out that there is a fusion, or confusion, in the pictorial tradition, of the stories of Troilos and Astyanax, a confusion favored by similarities of circumstance.[8] Of the two murdered Trojan princes, one is Priam's son, the other his grandson. Of the mighty heroes who slay them, one is the son of the other. Finally, Troilos is murdered at an altar, as Astyanax in the

The Sack of Troy 147

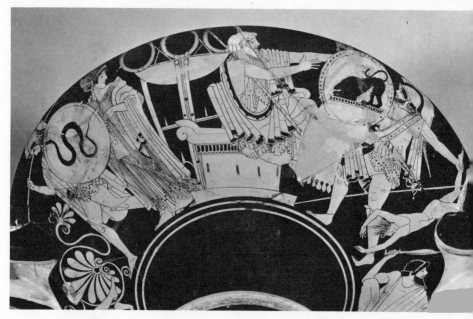

71 • Iliupersis. Brygos Painter, cup, Louvre G 152. (Musée National du Louvre)

graphic tradition, in which his death is woven into the scene of the death of Priam.[9]

Neoptolemos borrows not only the head but the weapon. On a lekythos in Syracuse Neoptolemos is about to kill Astyanax with a sword—Astyanax because Priam lies dead on the altar.[10] Achilles, too, borrows. On a hydria in Munich (FIG.72) it seems to be Achilles who has caught Troilos by the leg and is about to fling him. Athena guards the rear, turning aside rescue—as never at the murder of Astyanax.[11] And poor old Priam crouches on the ground, huddled in his despair, his white hair shining in the dark. Troilos hurled is also Astyanax.[12] Achilles–Neoptolemos is flinging Troilos–Astyanax—as if Achilles' murder lived after him or Neoptolemos' was fated before he ever came to Troy.

One of the most moving of the scenes of the death of Priam is the one painted by the Kleophrades Painter on the vase known as

A Vase Painter's Notebook

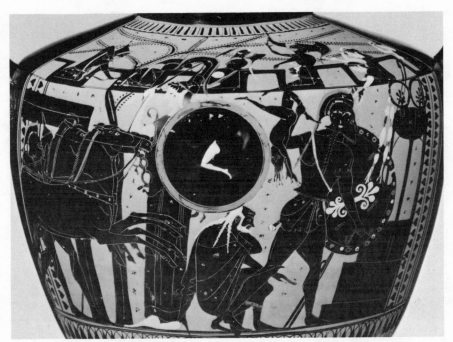

72 • Achilles and Troilos. Leagros Group, hydria, Munich 1700.
(Staatliche Antikensammlungen und Glyptothek)

the Vivenzio hydria (FIG.73). Here is suggested the whole sack of
Troy: the young men fallen and women weeping, and the mighty
figure of a woman swinging a pestle at a Greek warrior, the first
weapon that came to hand when the alarm sounded and the Tro-
jans, women and men, ran out of their houses to defend the city.[13]

In the midst of it all Priam sits upon the altar. The dead body
of Astyanax, still bleeding, lies on his lap. The old king, already
wounded, is not pleading for his life. Having nothing, he wants
nothing. He sits there, head in his hands, too crushed to care, even
to notice, that Neoptolemos is swinging his sword for the final
blow.

Behind the altar women sit weeping and next is played another
scene from the sack of Troy. A woman, nude except for a short
mantle that frames her nudity, clings to an image of Athena. She
turns back and holds out a hand in appeal to a Greek warrior who

The Sack of Troy

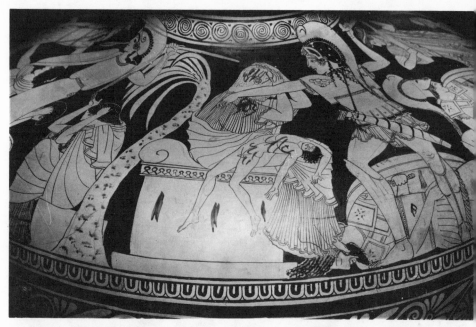

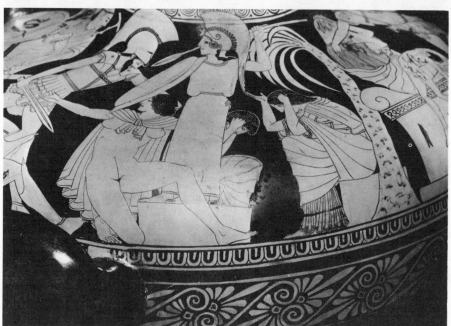

73 • 74 • Iliupersis. Kleophrades Painter, kalpis, Naples 2422, Museo Archeologico Nazionale. (Fotografia della Soprintendenza alle Antichità delle Province di Napoli e Caserta—Napoli)

strides toward her, seizing her by the hair and threatening her with his sword (FIG.74).

This scene depicts the crime of Aias the Less, the Lokrian Aias, son of Oileus. Aias went out to rape the prophetess Kassandra, the most beautiful of the daughters of Priam. She fled to the temple of Athena and clung to the image. Aias pulled, she clung, pulled, clung, and the image toppled to the floor. The Achaians would have stoned Aias for his sacrilege, but he fled to the altar of the very goddess he had offended and was spared. Kassandra, too, was saved—for Agamemnon and Klytaimnestra's ax.

The scene needs three players: Aias, Kassandra, and the statue of Athena. Black-figure Kassandra is drawn, as a rule, on a smaller scale than the other two: she is small to make them mighty.[14] She is in the bent-knee pose: has run to Athena, and looks back at Aias in appeal (FIG.17). And—rarity in black-figure women— she is scantly clad: she wears a little mantle or a short chiton or is wholly nude. The old explanation was that, in the suddenness of the attack, the panic of the night battle, she had no time to dress.[15] But Furtwängler pointed out that other women in Trojan scenes are fully dressed: the nudity, or seminudity, indicates the erotic character of the scene of attempted rape.[16]

Aias, fierce, large, armored, threatens the naked little figure with his sword but he is met by a redoubtable opponent. Athena strides up, no statue standing on a pedestal but the goddess herself, swinging her spear menacingly and holding out her great round shield to protect her suppliant.[17]

We know this warrior goddess. She is Athena of the Panathenaic vases, the prize amphoras that were filled with oil and awarded to the victors at the Panathenaic games in Athens.[18] We meet her first in the sixties of the sixth century, which is just the time of the dedication of the Hekatompedon on the Athenian Acropolis, the hundred-foot temple of Athena.[19] The coincidence

of dates has suggested that the Panathenaic Athena may go back for prototype to the cult image of that temple.[20] This statue would have been a mighty striding figure, so numinous that painters unwittingly portrayed it alive.

Red-figure Athena, no longer under the spell of the old image, is free to revert to the iconic condition. She becomes a stiff xoanon, standing on a base.[21] As if statues had learned their place, or gods no longer walked among men. Painters now prefer a moment just earlier: Aias is still pursuing; he is within reach of Kassandra and seizes her by the hair or shoulder.[22] Kassandra is now life-size and sometimes, not always, has taken "time to dress."

At the sack of Troy Menelaos found Helen and led her back to the ships. Both scenes, the meeting and the recovery, occur on black-figure vases but both employ general types, ambiguous types, and the scenes cannot be recognized without a clue from the artist.[23]

The meeting: a warrior faces a woman, lays hand on her mantle, and threatens her with his sword. The woman stands before him, quietly, drawing aside her mantle.[24] Is this the meeting of Menelaos and Helen? Or only a warrior threatening a woman?[25] On an amphora with the death of Priam (FIG.10) the Trojan context identifies the pair as Menelaos and Helen.[26] But a frame of warriors and civilian spectators need not indicate the Trojan scene. We cannot say whether the painter had Menelaos in mind.

For the recovery, or escort, again a general type exists; perhaps the painter remembers Menelaos. The warrior leads the woman, seizing the edge of her mantle or grasping her wrist, and turns back to her with menacing sword.[27]

There are a few red-figure examples of the escort, one happily inscribed with the names of Menelaos and Helen. The warrior holds the woman's wrist and leads her as the bridegroom leads the

A Vase Painter's Notebook

bride in the wedding ceremony—but looks back and threatens with his sword.[28]

In red-figure times, when the pursuit has its heyday, Menelaos pursues Helen. No, almost always a warrior pursues a woman. The warrior grips his naked sword. The woman, as she flees, turns round to her pursuer and holds out a hand in entreaty—Helen when Aphrodite is present to protect, or the Iliophile Apollo.[29]

In a subtype of the pursuit the woman turns back and the sight of her is too much for the warrior. Anger melts, the sword falls from his hand.*[30] This distinctive detail was picked up by the pictorial tradition from a poem of the lyric poet Ibykos, and it reveals the scene: Menelaos drops his sword at the sight of Helen. Helen may flee to an image of Apollo, or Apollo himself may appear, or Aphrodite, or both.[31] Dei ex machina, but the play needs no machine. The triumph is Helen's, within the burnt towers of Ilium.

We return to the Vivenzio hydria. At either end of the frieze violence opens into escape. At the right two warriors help an old woman to rise from a low seat. The woman is Aithra, Theseus' mother, who had been carried off by the Dioscuri when they rescued their sister Helen from Theseus. They had given Aithra to Helen as a slave and Helen had taken her along to Troy. Now Theseus' sons, Akamas and Demophon, have found her and will bring her home. In this scene, which appears first in the fifth century, two young men gently lead an old woman,* one of the very few old women in Greek art.[32]

At the left Aeneas escapes, a cousin of the Trojan royal family. He carries his old father Anchises; his young son Askanios is at his side. The scene of Aeneas carrying Anchises on his back is a favorite of late black-figure, infrequent in red-figure. In the black-figure type Aeneas, in armor, grips his two spears in his left hand, or spears and big Boeotian shield. Anchises' legs are drawn up and

folded back, and Aeneas supports them with his free hand. Anchises has one arm round Aeneas' neck; in the other hand he grasps a scepter or staff, a last symbol of royal power or aged impotence.*[33]

On the Vivenzio hydria Aeneas, Anchises, Askanios all turn back: Aeneas looks for the enemy, Anchises toward the past that is coming to an end in scenes of violence. They look back but move on:

> The world is all before them, where to choose
> Their place of rest

A Vase Painter's Notebook

23

The Torch
of Murder

The actions of the Achaians at Troy were such as to appall even the Olympian gods. They sent storms to accompany the homeward journeys, strewed the sea with dead, and hounded the survivors.

The homecoming we know best is that of the commander-in-chief, Agamemnon. He returned to Mycenae with Kassandra, who had escaped from Aias to fall into his hands. At Mycenae both fell to the ax of Agamemnon's wife Klytaimnestra. Klytaimnestra had been improving the ten years with Aigisthos, Agamemnon's cousin and secret enemy, the cowardly Aigisthos who left his murder to a woman. Not that she minded. She killed her husband in the bath: she threw a robe over him, then struck with an ax and, as the blood spurted upward, rejoiced, as buds in the showers of spring.[1]

On a krater in Boston (FIG. 75) Agamemnon falls back, hemmed by the robe, wounded once and now attacked again not by Klytaimnestra, as in Aischylos' tragedy, but by Aigisthos, backed, to be sure, by the determined lady with the ax. A shrouded figure, Agamemnon seems to rise up from the base of the picture, a ghost unappeased. It is in this role that he introduces the scene on the other side of the vase, the murder of Aigisthos.

Klytaimnestra and Aigisthos ruled in Mycenae for seven years and in the eighth year Orestes, Agamemnon's son, came for revenge, sent by Apollo. He had been spirited away as a child, at the time of the murders. Now he was grown and the torch of murder was passed to his hands. He returned secretly to Mycenae.

Just at the time of Orestes' return an ominous dream came to Klytaimnestra and she took thought to appeasing the spirit of

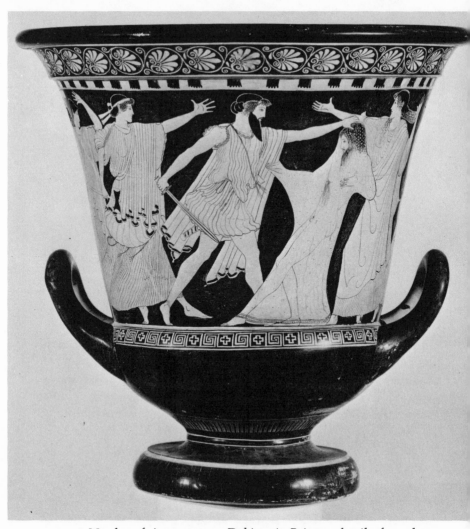

75 • Murder of Agamemnon. Dokimasia Painter, detail of a calyx krater, Boston 63.1246. (Courtesy Museum of Fine Arts, Boston)

A Vase Painter's Notebook

Agamemnon. Since she herself would hardly be well received at the tomb, she sent her daughter Elektra with offerings—Elektra who lived for revenge on her mother and Aigisthos. In the shadow of the tomb when Elektra came, her brother, Orestes, lurked.

The scene of the meeting of Orestes and Elektra at the tomb of Agamemnon, a scene of the *Choephoroi* of Aischylos, is recalled by South Italian vase painters in the fourth century.[2] In Greek South Italy the great Athenian tragedies must have been frequently revived, for many vase painters went to them for subjects. This scene, the meeting at the tomb, illustrates no actual production of the *Choephoroi:* there is never the tragic costume, never any indication of the theater, no precise reference to the play. Rather the theme has been taken into the graphic tradition. The tomb is represented by a column mounted upon steps; offerings are placed on the steps. On the steps, too, in most examples, Elektra sits with bowed head. Two young men approach, dressed as travelers, Orestes and his faithful friend Pylades. They would speak to her but Elektra is walled by her melancholy and neither hears nor sees.[*3] Sometimes Orestes is about to pour a libation; sometimes there is a Hermes-like figure in the scene, probably not Hermes, who has no part in the action, but Pylades, who has.[4] A careless vase painter has put into his hand the kerykeion, has given a herald to the un-heralded Orestes. Another figure in the scene, an attendant of Elektra, suggests, if she does not represent, the chorus of libation bearers, choephoroi.[5]

After the meeting at the tomb and the recognition, Orestes goes forth to murder. We know the story of his revenge on Klytaimnestra and Aigisthos from the three great tragic poets; and we have red-figure scenes of the murder of Aigisthos that cannot illustrate the plays because the series begins and the iconography is set long before any were produced.[6] The vase painters go for their

prototype to an earlier source, one from which the tragic poets perhaps also drew.[7]

The youthful Orestes has seized Aigisthos and is plunging his sword. Aigisthos is seated upon the usurped throne or collapses, legs thrashing helplessly in air. From the left Klytaimnestra comes to the rescue of her beloved Aigisthos. In the *Choephoroi* she calls for her ax; in the graphic tradition she has it and is swinging it against her son.[8] She is, in some pictures, held back just in time by the old Talthybios, herald of Agamemnon, or by the youthful Pylades. From the right Elektra rushes into the scene, a passionate figure, signaling with urgent hand the danger behind.*[9] Orestes may heed and turn back.

When the series opens, with a pelike of about the turn of the sixth century to the fifth (FIGS.3, 4), the warning cry comes not from Elektra but from her sister Chrysothemis—we know because she is named on the vase. The scene is divided between the two sides of the vase, and Chrysothemis shrinks, trembling, caught between two scenes of violence. After this moment in the history of the type, the resolute and ruthless Elektra makes her way into the scene—certainly Elektra, since she, too, is named.[10]

Now it is Orestes' turn to fear. He has passed the torch of murder and the Erinyes are upon him, the Furies of his slain mother Klytaimnestra. They come like gorgons, snake-wreathed.[11]

For Orestes' flight from the Erinyes and his refuge with Apollo at Delphi, most of our illustrations are fourth-century South Italian vase paintings. Though all reflect the *Eumenides* of Aischylos, all but a few reflect it in a vague and general way. They do not go back to a production but to a graphic prototype.[12] But there are a few illustrations that seem to take us to a provincial theater and let us glimpse a moment or two of a production of the play.

First, the pictorial type. The scene is set in Delphi: a column or

A Vase Painter's Notebook

the mantic tripod represents the temple of Apollo; or the omphalos symbolizes Delphi, earth's navel, the stone that marks the center of the earth.

Orestes kneels on one leg upon Apollo's altar or at the omphalos, a frontal figure, nude, with chlamys fluttering behind him. The pose comes into Attic art of the classical period and is handed on to South Italy.[13] Orestes clutches his sword as an Erinys runs to the attack, or Erinyes, wingless or winged, clad in the short dress of the huntress. They may have snakes in their hair and their weapons are snakes and torches. Apollo, wreathed with laurel and holding his laurel bough, repels the Furies with commanding gesture or holds out a hand to Orestes. A priestess may flee from the temple, flinging up her hands in horror.*

A few South Italian vases go directly to the play.[14] On a krater in Leningrad is an almost literal illustration of the prologue of the *Eumenides*.[15] The priestess of Apollo has given instructions to clients of the oracle. She goes inside the temple but rushes out, terrified: she has seen Orestes, his sword still dripping with blood, surrounded by loathsome creatures, sleeping, the Furies of Klytaimnestra.

A beautiful krater in the Louvre (FIG. 14) illustrates a later moment of the prologue. A veiled figure rises out of the night of the vase wall: the ghost of Klytaimnestra appears to wake the Furies, as she does in the play. Two lie relaxed in sleep, a third is just waking. Orestes is seated—not kneeling as in the pictorial type—beside the omphalos.[16] Apollo stands behind him, purifying him with the blood of a young pig. The blood of the victim will wash away the human blood, will cleanse the murderer, ritually—as a man may be cleansed who has murdered his mother and is hounded by Furies armed with the torch of madness. As he may, Apollo purifies Orestes. As he does in the play? Not unless as business or in a fourth-century "improvement."[17] A purification by Apollo, in any

case, could not come while Klytaimnestra is waking the Furies, so that two moments are woven together in the manner of tragic representation.[18]

Artemis stands behind Apollo, a huntress like the Erinyes and like them dressed for the hunt. As in the play? No, she has no part in the play but comes into the picture, here and elsewhere, by a natural association with Apollo.[19]

In another illustration (FIG.15) Orestes is kneeling before the omphalos as Apollo exchanges angry glances with a Fury and another Fury glares down at him from above the tripod. Thus, a combination of the prologue, in which Orestes is a suppliant at Delphi, and the first episode, in which Apollo drives away the Furies. And there is more, a third moment of the action and a second place.[20] Both are represented by Athena, who stands at the left, looking down at Orestes. In the first episode a year elapses and the scene shifts to Athens; the Furies overtake Orestes. It is not until the second episode that Athena appears and decides to hold a trial. Prologue, first episode, second episode—recollections of all three are interlaced in this "poster" for the play.[21]

At the trial the jury was deadlocked and Athena cast the deciding vote. Since she had not been born of woman and had no children, she did not consider matricide a very great crime. Which is why the court found the defendant not guilty.

24 ❧❧❧

Odyssey

Two years after the events in Mycenae Odysseus returned to Ithaka. The year the gods had ordained for his homecoming was the tenth of his journey, the twentieth since his departure for Troy. As the *Odyssey* opens the gods are sitting in council and Odysseus sits lamenting on the beach of Ortygia, a captive of the nymph Kalypso. He has lost his ships, his companions, and his hope of ever seeing his home.

To Kalypso comes Hermes with orders from Zeus to give up Odysseus. She allows him to build a raft and sends him on his way. He loses the raft in a storm, is thrown ashore in the land of the Phaiakes, and, by Athena's planning, meets the princess Nausikaa. Nausikaa has come with her companions to do the palace laundry in a river near the shore. When Odysseus rises out of the bushes, *like a mountain lion . . . with blazing eyes,* he sends the girls running off for fright, all but the princess. Nausikaa guides Odysseus to the city. He is kindly received by King Alkinoos, who promises to send him home but first entertains him. At the banquet Odysseus tells his story.

One of the early adventures was the visit to the land of the Cyclopes. These were a race of savage giants who dwelt in caves, tended flocks, and lived on milk and cheese unless travelers appeared to provide better fare. Odysseus and twelve companions found their way to the cave of Polyphemos and waited for him to return with his flocks. He came, mountain-tall, shut the door of the cave with a huge boulder and, noticing that he had guests, seized two of them and devoured them, bones and all. Next morning he breakfasted on two more men and went to his work, blocking the mouth of the cave behind him. Now Odysseus devised a plan. If they killed the Cyclops they would never get out of the

76 • Blinding of Polyphemós. Aristonothos, krater, Rome, Museo dei
Conservatori. (Musei Capitolini)

cave because they could not move the rock. They must put out his
eye—he only had one—and escape unseen. Odysseus cut a stake
of green wood, sharpened it to a point, and hardened it in the fire.
When Polyphemos came home that night and had dined on two
of the men, Odysseus offered him wine he had brought from the
ship. The Cyclops drank it down and fell into a drunken sleep.

Vase paintings of the blinding of Polyphemos are few and scat-
tered: pre-black-figure, assorted black-figure, and in red-figure a
single South Italian picture that goes back not to the *Odyssey* but
to a satyr play, probably the *Cyclops* of Euripides.[1] Few illustra-
tions, but a significant proportion of them are of particular interest.

One of these is painted on the well-known krater signed by
Aristonothos (FIG.76), a work of the middle of the seventh century.
This picture is, curiously, both the most abstract and the most
literal illustration of all. Abstract: the figures form a lattice made
up of crossing arms and legs, a pattern repeated and complicated
by the filling ornaments, dotted circles arranged, as a dot puzzle,
in diagonals or zigzags.[2] Literal: only here Odysseus and the full
complement of four companions drive in the stake. Only here

A Vase Painter's Notebook

Odysseus, in rear position, braces himself against the panel frame so that he seems, as in the epic, to revolve the stake as a drill. Here, too, is a unique detail of the setting, the baskets in which the Cyclops kept his cheeses.[3]

As in the Odyssey Polyphemos has waked with a great cry of pain and is pulling out the stake. All is faithful to the Odyssey— all but one feature, the towering size of the Homeric Polyphemos. He is no bigger here than the others, and the men need carry the stake only at waist level. Elsewhere they carry it at shoulder level or high above their heads to reach the eye of the Cyclops, though he is sitting on the ground, or half sitting, truly a giant.[4]

A giant he is on the neck picture of the great Protoattic amphora from Eleusis (FIG.44) and the men must hold the stake over their heads. This finest of all scenes of the blinding is one of two finds of the 1950's that have carried illustration of the adventure back to the second quarter of the seventh century. In the Protoattic picture, big, spare, monumental, the Cyclops is pulling out the stake, his mouth open in the roar of pain—a most remarkable early expression.[5] He holds a cup. We have already seen the wine cup on a Lakonian kylix (FIG.8), where three moments are woven together: Polyphemos' dinner on the men, the offering of the cup, and the driving in of the stake. On the Eleusinian amphora the cup does not seem to represent a moment of time, only to recall one.

The escape. Polyphemos moved the boulder and as the flock left the cave for pasture, felt the backs for riders. But Odysseus had lashed the rams together, three abreast, and bound a companion under the middle of each trio. He himself went out last under a single ram.

The escape comes into Greek art as early as the blinding, before the middle of the seventh century. On the Protoattic Ram jug from Aigina, the ancestor of the series, the companions of Odysseus ride underneath their rams. The vase is fragmentary but it is

77 • Escape from Polyphemos. Painter of Vatican G.49, oinochoe, Louvre A 482. (Musée National du Louvre)

certain that only the forepart of the last ram was represented: the ram is just coming out of the cave.[6]

After the Ram jug, on Attic black-figure cups, a few Greeks ride under rams, but it is not until late black-figure times that the scene becomes something of a favorite of vase painters. Odysseus rides under the belly of the ram, holding on or brandishing his sword.* Or there is a procession, as if in the tradition of the Ram jug.[7] Again, there are a few pictures that seem to carry on the tradition in another way. A ram bearing Odysseus is just emerging from the cave, as the last ram of the Ram jug. The device of cutting off a scene, the "window," is a rediscovery of late black-figure painters; we view as through a window a scene of life or mythological life. In the windowed scene Polyphemos leans against the wall of the cave, holding out a hand to feel the ram for riders, as Odysseus makes his silent escape (FIG.77).[8]

Another land of anthropophagous giants, another disaster, and Odysseus escaped with a single ship and the crew. They came to the island of Circe, an enchantress who specialized in turning men into animals. A party under Eurylochos set out to explore the island. They found the palace and, roaming about its grounds, tame and friendly lions and wolves, enchantees of Circe. Eurylochos sus-

A Vase Painter's Notebook

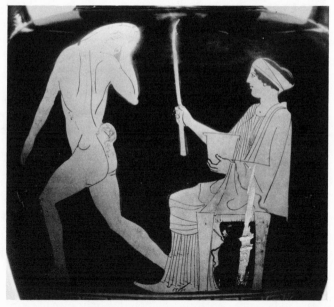

78 • Circe and victim. Phiale Painter, Nolan amphora, Staatliche Museen zu Berlin 2342. (Staatliche Museen zu Berlin)

pected a trap and stayed outside when the others went in. Circe gave them a drink of forgetfulness, struck them with her wand to make them pigs, and drove them into a sty. Meantime Eurylochos returned to the ship and reported to his chief that the men had vanished.

Odysseus to the rescue. On the way he met Hermes, who told him what had happened, gave him an herb, a charm against enchantment, and instructed him to draw his sword against Circe. Odysseus does just that in a small group of black-figure paintings, as Circe, surrounded by the transformed men, is stirring her potion.*[9] Metamorphoses are represented by animal parts added to the human frame: animal heads and tails, sometimes hooves. Transformed man is composite man.[10] Interestingly, the men are not only pig-men, but also lion-, wolf-, panther-, goat-, ass-men, and others. The tame wolves and lions have come into the pictorial tradition, and the vase painters have given them companions.[11]

In red-figure, Odysseus may attack or Circe may be alone with a victim. The painters no longer take delight in inventing monstrous forms but are content almost only with pig-men. A painting of the classical period (FIG.78) presents a transformation in

progress. The victim is not yet a pig but is becoming one. He has pig's ears and tail but his face is still human. The fingers of one hand are growing together into a hoof. He puts the other hand to his head, feels the bristly crest, bows his head in shame. Here is not only a picture of a transformation but a picture of how it feels.[12]

Not that it is always painful. On an Attic black-figure lekythos of the late sixth century and a Boeotian skyphos of the late fifth, the companions dance with their cups, rejoicing in the porcine condition.[13] This conception is carried further in Etruscan art, where the transformed companions come to the rescue of their hostess and hold back Odysseus as he attacks her.[14] The pig within shows his tusks, a figure very different from Homeric pig.

Circe, herself transformed,[15] disenchanted the men, and now they could make pigs of themselves, as they feasted in the palace for a year. Then they journeyed on, stopping first in the underworld to get directions from the seer Teiresias. On the wine-bright sea again, they passed the land of the sirens, whose magic song made men forget their homes. The bones of their victims lay heaped in a flowery meadow. The companions stopped their ears with wax, that they might continue their rowing; they bound Odysseus to the mast that he might hear the song but could not follow its call.

Homer does not describe the sirens. We only know that they are female and are two. Vague, lovely, sinister beings, almost song without body. In art they are bird-women, monsters who had come to Greece from the east and were adopted by illustrators of the myth.[16] They may play instruments,* a musical activity more representable than singing, and for this they need human arms.[17]

Only a few vase paintings illustrate the adventure. In a painting of the early fifth century (FIG.79) the sail is reefed, the men are rowing, the steersman is giving orders. Odysseus is bound to the

A Vase Painter's Notebook

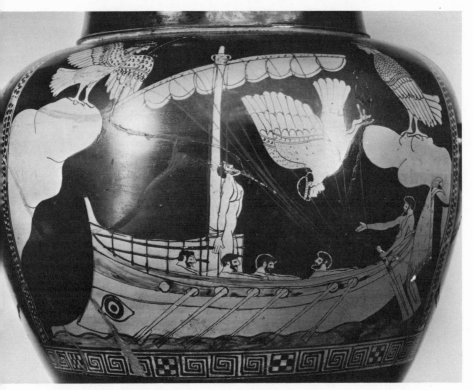

79 • Odysseus and the sirens. Siren Painter, stamnos, British Museum E 440. (Trustees of the British Museum)

mast, listening greedily. Two sirens are perched upon the rocks. A third is falling into the sea. Her eye is closed: she is dead.

This third siren is of great interest. Three sirens appear in late black-figure and again here but in literature first in the Hellenistic period.[18] Hellenistic, too, is the story that the sirens were fated to die when a ship would pass their land unharmed.[19] The vase painting, which must go back to a lost poem or a popular tale, gives roots to the Hellenistic version. It has a place in the literary tradition as well as the graphic.

They sailed on. Odysseus lost six companions to the man-eating monster Skylla and all the others after they had feasted upon the cattle of Helios. At last, shipless and alone, he was cast upon the island of Kalypso.

Odysseus ends his tale. The Phaiakes take him to Ithaka. Athena is on hand to greet him. She disguises him as a beggar and sends him to the swineherd Eumaios, who will be his ally. Meanwhile Telemachos, Odysseus' son, returns to Ithaka. He has been away seeking word of his father, for the palace is full of the suitors of his mother Penelope. Penelope wouldn't say yes and she wouldn't say no . . . and Telemachos had to sit by and watch the suitors eat up his substance.

Odysseus reveals himself to Telemachos and they plan revenge. Odysseus, still disguised, goes to the palace, meets Penelope, and promises that Odysseus will return. She invites him to stay overnight and calls Eurykleia, Odysseus' old nurse, to wash his feet. Eurykleia feels a scar on Odysseus' leg and recognizes her master, but Odysseus commands silence.

Next day Penelope holds a contest for the suitors, a competition in archery, and sets herself up as the prize. None has the strength to string Odysseus' great bow. Odysseus takes it and strings it easily. With a little army of three, and Athena in the wings, he slaughters the suitors, and Hermes leads their souls to the meadows of asphodel.[20]

That night Odysseus sleeps at the side of his wife and next day visits his aged father Laertes.

An army gathers, the fathers and brothers of the suitors. They march to Laertes' farm. A battle is begun but Athena intervenes to end it. The old warrioress has turned peacemaker. She will no longer enter battles to stand at the side of her favorites. Ten years after the fall of Troy the bright age of the heroes is passing, fading into history and hard times.

A Vase Painter's Notebook

ABBREVIATIONS

AA	*Archäologischer Anzeiger*
ABL	Haspels, C. H. Emilie. *Attic Black-figured Lekythoi.* École française d'Athènes, Travaux et mémoires, 4 (1936).
ABV	Beazley, J. D. *Attic Black-figure Vase-Painters.* Oxford: Clarendon Press, 1956.
AJA	*American Journal of Archaeology*
AM	*Mitteilungen des deutschen archäologischen Instituts. Athenische Abteilung*
Annali	*Annali dell'Instituto di Corrispondenza Archeologica*
Annuario	*Annuario della Scuola Archeologica di Atene*
AntCl	*L'Antiquité Classique*
ARV²	Beazley, J. D. *Attic Red-figure Vase-Painters.* Second edition. Oxford: Clarendon Press, 1963.
AZ	*Archäologische Zeitung*
BCH	*Bulletin de correspondance hellénique*
Beazley, EVP	Beazley, J. D. *Etruscan Vase-Painting.* Oxford: Clarendon Press, 1947.
BSA	*Annual of the British School at Athens*
Bull. Vereen.	*Bulletin van de Vereeniging tot Bevordering der Kennis van de Antieke Beschaving*
BWP	*Winckelmannsprogramm der archäologischen Gesellschaft zu Berlin*
CB	Caskey, L. D., and J. D. Beazley. *Attic Vase Paintings in the Museum of Fine Arts, Boston.* London: Oxford University Press and Boston: Museum of Fine Arts, 1931–1963.
CVA	*Corpus Vasorum Antiquorum*
FR	Furtwängler, A., K. Reichhold, and others. *Griechische Vasenmalerei.* Munich: F. Bruckmann, 1904–1932.
Gerhard, AV	Gerhard, Eduard. *Auserlesene griechische Vasenbilder.* Berlin: G. Reimer, 1840–1858.
Gerhard, EKV	Gerhard, Eduard. *Etruskische und kampanische Vasenbilder des königlichen Museums zu Berlin.* Berlin: G. Reimer, 1843.

Hampe, *Sagenbilder*	Hampe, Roland. *Frühe griechische Sagenbilder in Böotien.* Athens: Deutsches archäologisches Institut, 1936.
HWP	*Hallisches Winckelmannsprogramm*
Inghirami	Inghirami, Francesco. *Pitture di vasi fittili.* [Fiesole]: Poligrafia fiesolana, 1833–1837.
Jb.	*Jahrbuch des deutschen archäologischen Instituts*
Jh.	*Jahreshefte des österreichischen archäologischen Institutes in Wien*
JHS	*Journal of Hellenic Studies*
Kunze, *Schildbänder*	Kunze, Emil. *Archaische Schildbänder.* Deutsches archäologisches Institut, Olympische Forschungen, 2. Berlin: Walter de Gruyter, 1950.
LBICS	University of London, Institute of Classical Studies, *Bulletin*
MdaI	*Mitteilungen des deutschen archäologischen Instituts*
Metzger, *Représentations*	Metzger, Henri. *Les représentations dans la céramique attique du IVe siècle.* Bibliothèque des Écoles françaises d'Athènes et de Rome, 172 (1951).
ML	Accademia Nazionale dei Lincei, *Monumenti antichi*
Mon.	*Monumenti inediti pubblicati dall'Instituto di Corrispondenza Archeologica*
MonPiot	Fondation Eugène Piot, *Monuments et mémoires publiés par l'Académie des Inscriptions et Belles-Lettres*
MWP	*Marburger Winckelmann-Programm*
NSc	Accademia Nazionale dei Lincei, *Notizie degli scavi di antichità*
Paralipomena	Beazley, J. D. *Paralipomena. Additions to Attic Black-figure Vase-Painters and to Attic Red-figure Vase-Painters.* Oxford: Clarendon Press, 1971.
Payne, *NC*	Payne, Humfry. *Necrocorinthia. A Study of Corinthian Art in the Archaic Period.* Oxford: Clarendon Press, 1931.

Preller-Robert	Preller, L. *Griechische Mythologie.* Fourth edition, revised by Carl Robert. Berlin: Weidmann, 1894–1926.
RA	*Revue archéologique*
Raoul-Rochette	Raoul-Rochette, Désiré. *Monumens inédits d'antiquité figurée, grecque, étrusque et romaine.* Paris: Imprimerie royale, 1833.
RE	*Paulys Realencyclopädie der classischen Altertumswissenschaft.* Edited by Georg Wissowa and others. Stuttgart, 1894–.
REA	*Revue des études anciennes*
REG	*Revue des études grecques*
Richter and Hall	Richter, Gisela M. A. *Red-figured Athenian Vases in the Metropolitan Museum of Art.* With eighty-three drawings by Lindsley F. Hall. New Haven: Yale University Press, 1936.
Riv. Ist.	*Rivista dell'Istituto Nazionale d'Archeologia e Storia dell'Arte*
RM	*Mitteilungen des deutschen archaeologischen Instituts. Roemische Abteilung*
Robert, *Bild und Lied*	Robert, Carl. *Bild und Lied. Archäologische Beiträge zur Geschichte der griechischen Heldensage.* Berlin: Weidmann, 1881.
Robert, *Herm.*	Robert, Carl. *Archaeologische Hermeneutik. Anleitung zur Deutung klassischer Bildwerke.* Berlin: Weidmann, 1919.
Roscher	Roscher, W. H., editor. *Ausführliches Lexikon der griechischen und römischen Mythologie.* Leipzig: B. G. Teubner, 1884–1937.
Séchan, *Tragédie*	Séchan, Louis. *Études sur la tragédie grecque dans ses rapports avec la céramique.* Paris: Librairie ancienne Honoré Champion, 1926.
Trendall, *PP*	Trendall, A. D. *Paestan Pottery.* London: British School at Rome, 1936.
Vasenlisten²	Brommer, Frank. *Vasenlisten zur griechischen Heldensage.* Second edition. Marburg/Lahn: N. G. Elwert, 1960.
WV	*Wiener Vorlegeblätter*

Abbreviations 171

Notes

Chapter 1

1. Robert, *Herm.*, pp.213-214.
2. George M. A. Hanfmann, "Narration in Greek Art," *AJA*, 61 (1957), p.72.
3. Robert, *Herm.*, p.18.
4. Robert, *Herm.*, p.21.
5. George E. Mylonas, Ὁ πρωτοαττικὸς ἀμφορεὺς τῆς Ἐλευσῖνος, Βιβλιοθήκη τῆς ἐν Ἀθήναις Ἀρχαιολογικῆς Ἑταιρείας, 39 (Athens, 1957), p.123.
6. Euripides, *Bacchae*, l. 300
7. Netos, Nettos are Attic spellings.
8. There are, of course, many exceptions to this convention. Herakles is beardless, e.g., in the early red-figure period, on a plate of the Cerberus Painter (Paseas), Boston 01.8025 (*ARV*², p.163, 6) and regularly in the later fifth and the fourth century. Theseus is bearded, e.g., on an amphora of the Antiope Painter, Naples inv. 128333 (*ABV*, p.367, 93).
See Josef Fink, "Zur Bärtigkeit der griechischen Götter und Helden in archaischer Zeit," *Hermes*, 80 (1952), pp.110-114.
9. Robert, *Herm.*, p.18.

Chapter 2

1. "The Hoplite Phalanx," *BSA*, 42 (1947), p.105.
2. *Protocorinthian Vase-Painting*, English translation of *Protokorinthische Vasenmalerei* (Berlin: Heinrich Keller, 1933), p.2.
3. Theseus and Ariadne: Robert, *Herm.*, p.38; Paris and Helen: Hampe, *Sagenbilder*, pp.78-79. But see Klaus Fittschen, *Untersuchungen zum Beginn der Sagendarstellungen bei den Griechen* (Berlin: Bruno Hessling, 1969), pp.51-58.
4. Franz Willemsen, *Dreifusskessel von Olympia, alte und neue Funde*, Deutsches archäologisches Institut, Olympische Forschungen, 3 (Berlin: Walter de Gruyter, 1957), B 1730. The subject: Emil Kunze, *Neue Meisterwerke griechischer Kunst aus Olympia* (Munich: Filser-Verlag, 1948), pp. 6-7; *Schildbänder*, p.115; but also Fittschen, pp.28-32.

5. Metropolitan Museum 17. 190. 2072. Zeus: Ernst Buschor, "Kentauren," *AJA*, 38 (1934), p.130; Francis Vian, *La guerre des Géants* (Paris: C. Klincksieck, 1952), pp.11-12. Herakles and Nessos: Gisela M. A. Richter, *Handbook of the Greek Collection*, Metropolitan Museum of Art (Cambridge, Mass.: Harvard University Press, 1953), p.22; Fittschen, pp.119-125.

6. T. J. Dunbabin, *The Greeks and their Eastern Neighbours* (London: Society for the Promotion of Hellenic Studies, 1957), p.55.

7. Robert, *Bild und Lied*, pp.10-11, 23-24.

8. H. Luckenbach, *Das Verhältniss der griechischen Vasenbilder zu den Gedichten des epischen Kyklos* (Leipzig: B. G. Teubner, 1880), p.509; Robert, *Bild und Lied*, p.19; *Herm.*, pp.168-169.

9. Robert, *Bild und Lied*, pp.10-11, 23; Charles Dugas, "Tradition littéraire et tradition graphique," *AntCl*, 7 (1936), p.26; Hans von Steuben, *Frühe Sagendarstellungen in Korinth und Athen* (Berlin: Bruno Hessling, 1968), pp.88-91.

10. Robert, *Bild und Lied*, pp.5-6. For a picture of the period of the rise of types see von Steuben, pp. 73-76.

11. *Bild und Lied*, p.24.

12. Robert's discussion, followed here: *Bild und Lied*, pp. 14-16.

13. Friedrich Hauser, FR 3, p. 4.

14. Robert's discussion, followed here: *Bild und Lied*, pp.19-20; *Herm.*, p.182.

15. Robert's discussion: *Herm.*, pp.148-149.

16. Robert, *Bild und Lied*, pp.15-18; *Herm.*, pp.148-149.

17. Kurt Weitzmann, *Illustrations in Roll and Codex; a Study of the Origin and Method of Text Illustration* (Princeton: Princeton University Press, 1947), pp.13-14.

18. My sister, Mary Henle, has pointed out to me the analogy between this archaic treatment of time and that in the "appositional style" of early Greek literature. See Harry and Agathe Thornton, *Time and Style, a Psycho-Linguistic Essay in Classical Literature* (London: Methuen & Co. Ltd., 1962).

19. *Bild und Lied*, p.29.

20. L. D. Caskey, CB 1, p.51.

21. Achilles Painter, Nolan amphora, Boston 06.2447. ARV^2, p.989, 26.

22. Robert, *Bild und Lied*, pp.43-46; Metzger, *Représentations*, especially pp.223, 273-274, 283-284, 416; Hans Walter, *Vom Sinnwandel griechischer Mythen* (Waldsassen/Bayern: Stiftland, 1959).

23. Robert, *Herm.*, p.149.

24. Robert, *Bild und Lied*, pp.43-44; Walter, p.34. The sea monster now is only an attribute of the scene.

25. Walter, pp.36-37.

26. Frank Brommer, *Herakles, die zwölf Taten des Helden in antiker Kunst und Literatur* (Münster/Köln: Böhlau-Verlag, 1953), p.50; Pierre Amandry, "Bellérophon et la Chimère dans la mosaïque antique," *RA*, 1956, 2, pp.158-159.

27. There are Attic, and earlier, examples but the rich source of illustration of the theater is South Italian vase painting of the fourth century.

28. Hauser, FR 2, p.332.
29. Robert, *Bild und Lied*, p.38; Séchan, *Tragédie*, p.100.
30. *Herm.*, pp.138-141. "Complementary figures": Weitzmann, p.15.

CHAPTER 3

1. Martin P. Nilsson, *The Minoan-Mycenaean Religion and its Survival in Greek Religion*, second edition (Lund: C. W. K. Gleerup, 1950), p.5.
2. R. Engelmann, "Die Io-Sage," *Jb.*, 18 (1903), p.41. Engelmann illustrates an intermediate form, p. 39: Io is a human-headed cow: Pisticci Painter, oinochoe, Boston 00.366. A. D. Trendall, *The Red-Figured Vases of Lucania, Campania and Sicily* (Oxford: Clarendon Press, 1967), No. 9.
3. P. de La Coste-Messelière, *Au Musée de Delphes*, Bibliothèque des Écoles françaises d'Athènes et de Rome, 138 (1936), p.160; Werner Technau, "Die Göttin auf dem Stier," *Jb.*, 52 (1937), pp.90-93.
4. La Coste-Messelière; Technau.
5. Technau, p.93; Metzger, *Représentations*, pp.306-312.
6. Hellmut Sichtermann, *Ganymed, Mythos und Gestalt in der antiken Kunst* (Berlin: Gebr. Mann, n. d.), pp.20-25.
7. Aigina: L. D. Caskey, CB 1, p.14; Thetis: J. D. Beazley, CB 2, p.68.
8. Frank Brommer, "Amymone," *AM*, 63-64 (1938-39), pp.171-173.
9. Beazley, CB 2, p.37.
10. Sichtermann, pp.24-25.
11. Sichtermann, pp.39-52.
12. Sichtermann, p.36.

CHAPTER 4

1. Homeric Hymn XXVIII, ll. 4-7.
2. There may be more than two Eileithyiai. For the gods recognizable in this scene, see Frank Brommer, "Die Geburt der Athena," *Jahrbuch des römisch-germanischen Zentralmuseums*, Mainz, 8 (1961), p.76.
3. Brommer, "Geburt der Athena," p.78.
4. Brommer, "Geburt der Athena," pp.80-83; *Die Skulpturen der Parthenon-Giebel* (Mainz: Philipp von Zabern, 1963), pp.142-144.
5. Alkimachos Painter, lekythos, Boston 95. 39. ARV^2, p.533, 58.
6. Terme Museum, Rome. Erika Simon, *Die Geburt der Aphrodite* (Berlin: Walter de Gruyter, 1959), p.10.
7. Charis is named on the pyxis of the Splanchnopt Painter, Ancona 3130. ARV^2, p.899, 144. Raffaele Umberto Inglieri, "Pisside policroma di Numana con la genesi di Afrodite," *Riv. Ist.*, 8 (1940), p.53; Andreas Rumpf, "Anadyomene," *Jb.*, 65-66 (1950-51), p.167; Simon, p.43. Pausanias names Charis among the divinities present at the birth of Aphrodite sculptured on the base of the Olympian Zeus of Pheidias—V, 11, 8.
8. Splanchnopt Painter, pyxis, Ancona 3130.
9. Rumpf, p.170.
10. "A deep place"—J. D. Beazley, CB 2, pp.61-62. See Percy Gardner, "A New Pandora Vase," *JHS*, 21 (1901), pp.4-5; Simon, p.14.
For illustrations of the rising of Pandora, some of which reflect satyr

plays, see Carl Robert, "Pandora," *Hermes*, 49 (1914), pp.17-38; Margherita Guarducci, "Pandora, o i Martellatori," *ML*, 33 (1929), cols. 5-38; Ernst Buschor, *Feldmäuse*, Sitzungsberichte der bayerischen Akademie der Wissenschaften, philosophisch-historische Abteilung, 1937, 1; Beazley, "Hydria-Fragments in Corinth," *Hesperia*, 24 (1955), pp.305-319.

On the mallets or pickaxes sometimes carried by satyrs or other figures in scenes of the anodos of a goddess, see the articles cited by Robert, Guarducci, and Buschor. See also Metzger, *Représentations*, pp.75-77.

11. Persephone Painter, bell krater, New York 28.57.23. *ARV*², p.1012, 1. Gisela M. A. Richter, Richter and Hall, p.157.

12. Group of Polygnotos, calyx krater, Dresden 350. *ARV*², p.1056, 95.

13. Erichthonios Painter, pelike, Rhodes 12454. *ARV*², p.1218, 2.

14. Penthesilea Painter, skyphos, Boston 01.8032. *ARV*², p.888, 155.

15. Brommer, "Pan im 5. und 4. Jahrhundert v. Chr.," *Marburger Jahrbuch für Kunstwissenschaft*, 15 (1949–50), p.23; Rumpf, p.170; Metzger, *Représentations*, p.73. Cf. Beazley, CB 2, p.62.

16. Robert, pp.17-19; Metzger, *Représentations*, pp.75, 232-233.

17. Metzger, *Représentations*, pp.74-77.

18. Fernand Chapouthier, "Léda devant l'oeuf de Némésis," *BCH*, 66-67 (1942–43), pp.16-17; Beazley, *EVP*, p.40; CB 3, p.73.

19. Beazley, CB 3, p.73.

20. Xenotimos Painter, cup, Boston 99.539. *ARV*², p.1142, 1; *Vasenlisten*², p.362, B 2.

CHAPTER 5

1. I, ll. 43-52.

2. *Iliad*, XXI, l. 470. For *potnia theron* see Gerda Bruns, *Die Jägerin Artemis* (Borna-Leipzig: Robert Noske, 1929), pp.5-18.

3. Athens 3961.

4. Adolf Greifenhagen, "Tityos," *Jahrbuch der Berliner Museen*, 1 (1959), p.19.

5. She is named on the Tyrrhenian neck amphora, Louvre E 864. *ABV*, p.97, 33.

6. *Argonautica*, I, ll. 759-762. Ch. Lenormant and J. de Witte, *Élite des monuments céramographiques*, 2 (Paris: Leleux, 1857), p.165.

7. J. Overbeck, *Griechische Kunstmythologie*, 3 (Leipzig: Wilhelm Engelmann, 1889), pp.387-391; A. Furtwängler, FR 1, pp.276-277.

8. P. Zancani Montuoro and U. Zanotti-Bianco, *Heraion alla foce del Sele*, 2 (Rome: Libreria dello Stato, 1954), p.326. This is the figure of the black-figure vases who seems to be fleeing with Tityos, though actually she is his captive—Greifenhagen, pp.22-28.

9. Compare the lost work of the Syriskos Painter (*ARV*², p.261, 25) where there is no Leto to identify the victim of the Letoids, and identification of the scene is an answer to the question, What uncouth fellow, not Tityos, incurred the anger of Apollo and Artemis?

Of course the goddess need not be the same in every case. Leto may belong to the type, but a painter may depart from the type. On the calyx

krater of the Aigisthos Painter, Louvre G 164 (*ARV²*, p.504, 1) it is hard to see the goddess struck by arrows as Leto. See Ernst Buschor, FR 3, pp. 278-280.

10. Buschor, FR 3, pp.278-279; Greifenhagen, pp.19-20.

11. Penthesilea Painter, cup, Munich 2689. *ARV²*, p.879, 2. Buschor, FR 3, pp.278-279.

12. *Iliad*, XXIV, ll. 603-604. Or more in other versions.

13. R. M. Cook, *Niobe and her Children* (Cambridge: University Press, 1964), pp.14-17, 29-30.

14. Niobid Painter, calyx krater, Louvre G 341. *ARV²*, p.601, 22; Cook, No.3.

15. Phiale Painter, cup, British Museum E 81. *ARV²*, p.1024, 150; Cook, No.5.

16. Beazley, *EVP*, p.75; Metzger, *Représentations*, p.158; Christoph W. Clairmont, "Studies in Greek Mythology and Vase-Painting. Apollo and Marsyas," *Yale Classical Studies*, 15 (1957), p.164; Konrad Schauenburg, "Marsyas," *RM*, 65 (1958), p.56.

17. Clairmont's Type A—pp.163-165. In a few examples Marsyas plays the lyre or cithara, Apollo's instruments, in a scene that seems to reflect a version of the myth we do not know: A. Michaelis, "Marsyas," *AZ*, 27 (1869), p.42; Beazley, *EVP*, p.75; Metzger, *Représentations*, p.165; John Boardman, "Some Attic Fragments: Pot, Plaque, and Dithyramb," *JHS*, 76 (1956), pp.18-19; Clairmont, pp.163-164.

18. Clairmont's Types B and C—pp.165-169.

19. See Schauenburg, pp.59-61.

20. E. Schwartz, "Su due dipinti vascolari rappresentanti la morte di Atteone ed Ercole bambino che strozza i serpenti," *Annali*, 54 (1882), pp. 295-296.

21. Friedrich Hauser, FR 2, p.290.

22. Schwartz, p.296.

23. Paul Jacobsthal, "Aktaions Tod," *Marburger Jahrbuch für Kunstwissenschaft*, 5 (1929), p.4. Beazley points out the reversal of the triangular design, to form a V, on the bell krater of the Pan Painter, Boston 10. 185 (*ARV²*, p.550, 1; *Vasenlisten²*, p.336, B 3)—*The Pan Painter*, English translation of *Der Pan-Maler* (Berlin: Heinrich Keller, 1931), p.1. On this krater Artemis is, exceptionally, shooting Aktaion.

24. Apparently the Stesichoran version of the myth—Pausanias, IX, 2, 3: Robert, *Bild und Lied*, p.26; Schwartz, p.297; Hauser, FR 2, p.290. See Beazley, CB 2, p.48, on the stag suit worn by Aktaion on the volute krater of the Pan Painter, Athens, Acropolis 760 (*ARV²*, p.552, 20; *Vasenlisten²*, p.336, B 4).

25. Euripides, *Herakles*, l. 860.

26. Schwartz, pp.297-298; Elisa Mercanti, "Rappresentanze del mito di Atteone," *Neapolis*, 2 (1914), pp.127-131; Séchan, *Tragédie*, p.134.

27. Beazley, CB 2, p.85.

28. Schwartz, p.299.

29. Apollodoros, III, 4, 4; Pausanias, IX, 2, 3. See Schwartz, pp.296-297.

30. Schwartz, p.297; Séchan, *Tragédie*, pp.134-135; Jacobsthal, p.13.

CHAPTER 6

1. Kleitias, volute krater, Florence 4209. *ABV*, p. 76, 1.
2. The myth is all but lost in literature. This is the inference, from the scene on the François vase, of Ulrich von Wilamowitz-Moellendorff, "Hephaistos," *Nachrichten von der Königlichen Gesellschaft der Wissenschaften zu Göttingen, philologisch-historische Klasse*, 1895, pp.217-245.
3. Frank Brommer, "Die Rückführung des Hephaistos," *Jb.*, 52 (1937), p.204.
4. A black-figure amphora in Oxford and, later, a group of red-figure vases show Hephaistos brought to the throned Hera—Brommer, pp.204, 212, 214, 216.
5. Brommer, p.205.
6. Brommer, p.214.
7. FR 1, p.36.
8. Furtwängler, FR 1, p.36.
9. Karl Schefold, "Zwei dionysische Vasenbilder," *AM*, 59 (1934), pp. 141-142; Niels Breitenstein, "Ein Hephaistos-Bild," *Acta Archaeologica*, 9 (1938), p.132.
10. Calyx krater, Agrigento. *ARV²*, p.1347; *Paralipomena*, p.482. See Metzger, *Représentations*, pp.125-129.

CHAPTER 7

1. Francis Vian, *Répertoire des Gigantomachies figurées dans l'art grec et romain* (Paris: C. Klincksieck, 1951); *La guerre des Géants; le mythe avant l'époque hellénistique* (Paris: C. Klincksieck, 1952).
2. Vian, *Guerre*, p.30.
3. Vian, *Guerre*, p.96.
4. Zeus: Vian, *Guerre*, pp.47-51; Herakles: pp. 51-56; Athena: pp. 56-68.
5. Vian, *Guerre*, pp.73-76.
6. Vian, *Guerre*, pp. 76-79.
7. Vian, *Guerre*, pp.79-82.
8. Vian, *Guerre*, pp. 71-73.
9. Vian, *Guerre*, pp.83-90.
10. Vian, *Guerre*, pp.90-91.
11. Vian, *Guerre*, pp.22-26.
12. Vian, *Guerre*, pp.26, 127, 145-147. At the beginning of the fourth century snake legs come in, symbolizing the earth-born nature of the Giants, first on an Attic lekythos, Berlin inv. 3375. Vian, *Répertoire*, No. 400; *Guerre*, p.147.
13. Descriptions and discussions: A. Furtwängler, FR 2, pp.193-199; Arnold von Salis, "Die Gigantomachie am Schilde der Athena Parthenos," *Jb.*, 55 (1940), pp.90-169; Hans Walter, "Gigantomachien," *AM*, 69-70 (1954–55), pp.95-104; Bernard Andreae, "Gefässkörper und Malerei bei der Gigantenkampf-Amphora aus Melos im Louvre," *RM*, 65 (1958), pp. 33-40.
14. I, 6, 1.

15. Another "Amazon" is restored by von Salis, pp.126-133 and figs.21-24, in the fragments of a volute krater, Würzburg inv. 4729: near the Pronomos Painter. *ARV²*, pp.1338, 1346, 1690; Vian, *Répertoire*, No.392. The "Amazon" of the Paris Gigantomachy has been called a "Giantess" by Furtwängler, FR 2, p.197. She has been called the goddess Hera, whom Porphyrion tried to rape, by P. Devambez, "L'Amazone de l'amphore de la Gigantomachie au Louvre et le bouclier de la Parthénos," Χαριστήριον εἰς Ἀναστάσιον Κ. Ὀρλάνδον, Βιβλιοθήκη τῆς ἐν Ἀθήναις Ἀρχαιολογικῆς Ἑταιρείας, 54 (Athens, 1965–68), 3, pp.105-109.

Von Salis, pp.133-137, suggests that she is an Amazon who strayed into the scene from the Amazonomachy of the outside of the shield of Athena Parthenos, an Amazon, that is, who comes into the Gigantomachy by association, in the mind of a careless vase painter.

There is one female figure who belongs to the Giants' side of the Gigantomachy, not as a participant but as a suppliant. This is Ge, their mother. She had dropped out of the Gigantomachy after the archaic period and reappears now, rising out of the earth to plead for her defeated sons. The position of the "Amazon" in the lower row of the Paris Gigantomachy corresponds to that of Ge rising in the Naples Gigantomachy. The "Amazon," as Ge, is in great distress. Perhaps our "Amazon" has something in her, both of an Amazon from the outside of the shield of Athena Parthenos, and of Ge, who may have been on the inside.

16. Robert, *Herm.*, p.11; Andreae, p.35.

17. Other gods who take part in the battle are Apollo (under a handle, holding his bow and aiming a torch) and Artemis (below Apollo, with bow and torches). The scene on the reverse centers about Ares, who fights from a chariot driven by Aphrodite. Below is Kore (with sword) and above Kore (to the left, under a handle) is Demeter (with torch and scepter). Directly above Demeter is Hekate (Furtwängler, FR 2, pp.198-199) or Amphitrite (since she is close to Poseidon: references: FR 2, p.198, note 4). To the right of Kore is one of the Dioscuri; above him, the other. Both fight on horseback. For these identifications, see note 13.

18. Walter Hahland, *Studien zur attischen Vasenmalerei um 400 v. Chr.* (Marburg, 1931), pp.12, 14; von Salis, p.125.

19. Furtwängler, FR 2, pp.194-196; von Salis.

20. Discussions: Cecil Smith, "A New Copy of the Athena Parthenos," *BSA*, 3 (1896–97), pp.121-148; Furtwängler; Hahland, pp.10-20; von Salis; Walter.

21. Vian, *Guerre*, pp. 146, 164.

22. Hahland, p.14.

23. Vian, *Guerre*, pp.96-97, 145.

24. Furtwängler, *Meisterwerke der griechischen Plastik* (Leipzig-Berlin: Giesecke & Devrient, 1893), pp.70-71; FR 2, p.196; Smith, p.136.

25. Smith, pp.133-134.

26. Smith, p.136; von Salis, p.121 and fig.17.

27. Von Salis, p.122. There is also a kneeling archer, Herakles as on the Paris amphora—pp.124-125.

28. Furtwängler, FR 2, p.196; von Salis, pp.122-123.
29. Furtwängler, FR 2, p.196.
30. Sir Cecil Harcourt-Smith (1859–1944).
31. Furtwängler, *Meisterwerke*, pp.70-71; FR 2, p.196; Smith, pp.132, 137; von Salis, p.99.
32. Smith, p.137.
33. Smith, p.137. Actually the similarity is not so great as near identity. See von Salis, p.98.
34. Von Salis, p.96 and figs.4 and 5.
35. Von Salis, pp.98-99, 121-122.
36. Furtwängler, *Meisterwerke*, pp.69-71; FR 2, p.196; von Salis, pp.137-142.
37. Smith, pp.135-136; von Salis, p.99. If the painting was not by Pheidias' own hand, at least it would have been done under his direction. See von Salis' discussion, pp.152-153.
38. Furtwängler, *Meisterwerke*, p.71; von Salis, pp.118-119; Bernhard Schweitzer, "Pheidias der Parthenonmeister," *Jb.*, 55 (1940), pp.182-187.
Von Salis has brilliantly suggested that the vault originates in the metal ring that held the shield cushion in place—pp.109-113. For a critique of this idea, see K. Schauenburg, "Gestirnbilder in Athen und Unteritalien," *Antike Kunst*, 5 (1962), pp.55-57.
39. Sophokles, *Aias*, ll. 857-858.

CHAPTER 8

1. Stuart Piggott, "The Hercules Myth—Beginnings and Ends," *Antiquity*, 12 (1938), p.323.
2. Piggott, p.328. For Greek times see Margarete Bieber, *The History of the Greek and Roman Theater*, second edition (Princeton: Princeton University Press, 1961), Chapter 10; A. D. Trendall, *Phlyax Vases*, second edition, *LBICS* Supplement, 19 (1967).
3. See note 5.
4. J. D. Beazley, "Geras," *Bull. Vereen.*, 24-26 (1949–51), p.19.
5. For the victory over death, as expressed in the later labors, and the winning of eternal youth, as expressed in the marriage to Hebe, see C. Robert, "Alkyoneus," *Hermes*, 19 (1884), p.484. See also Cecil Smith, "Vase with Representation of Herakles and Geras," *JHS*, 4 (1883), p.110; A. Furtwängler, "Herakles," Roscher, 1, col. 2215.
6. Frank Brommer, *Herakles, die zwölf Taten des Helden in antiker Kunst und Literatur* (Münster/Köln: Böhlau-Verlag, 1953), p.3. See Otto Brendel, "Der schlangenwürgende Herakliskos," *Jb.*, 47 (1932), pp.191-238.
7. The cycle of the twelve labors is a late organization of the myths, known to us first in the twelve sculptured metopes of the temple of Zeus at Olympia, but canonical number and canonical order come centuries later. The twelve years, twelve labors, canonical order are followed here for the sake of convenience. See Furtwängler, Roscher, 1, cols. 2242, 2251-2252; Preller-Robert, 2, pp.431-439; Brommer's chapter, "Der Zyklus der

zwölf Taten," *Herakles*, pp.53-63; Ulrich Hausmann, *Hellenistische Reliefbecher aus attischen und böotischen Werkstätten* (Stuttgart: W. Kohlhammer, 1959), pp.98-99.

8. Kunze, *Schildbänder*, p.95; Brommer, *Herakles*, p.7; *Vasenlisten*[2], pp.85-111.

9. Kunze, *Schildbänder*, p.98. The law of dexterality: Georges Méautis, *L'ame hellénique d'après les vases grecs* (Paris: L'artisan du livre, 1932), pp.75-83; P. de La Coste-Messelière, *Au Musée de Delphes*, Bibliothèque des Écoles françaises d'Athènes et de Rome, 138 (1936), pp.316-319; P. Courbin, "Un nouveau canthare attique archaïque," *BCH*, 76 (1952), pp.374-375.

10. E. Norman Gardiner, "Wrestling. II," *JHS*, 25 (1905), p.272.

11. Goffredo Bendinelli, "Studi intorno ai frontoni arcaici ateniesi: II. Eracle e il leone nemeo," *Ausonia*, 10 (1921), pp.131-149, especially p.145 (theory of an archaic pediment) and p.147 (Athena as the apex figure, another group in the right wing of the pediment).

Actually pankratiasts, not wrestlers. See Gardiner, "The Pankration and Wrestling. III," *JHS*, 26 (1906), p.11.

12. See Furtwängler, Roscher, 1, cols. 2139-2153; P. Zancani Montuoro, "Il tipo di Eracle nell'arte arcaica," *Rendiconti della R. Accademia dei Lincei*, classe di scienze morali, storiche e filologiche, ser. 8, 2 (1947), pp. 207-221; Brommer, "Der Wandel des Heraklesbildes," *Herakles*, pp.64-66.

13. William N. Bates, "Two Labors of Heracles on a Geometric Fibula," *AJA*, 15 (1911), p.6; Hampe, *Sagenbilder*, pp.41-42; Pierre Amandry, "Skyphos corinthien du Musée du Louvre," *MonPiot*, 40 (1944), pp.39-40. On the date, see Klaus Fittschen, *Untersuchungen zum Beginn der Sagendarstellungen bei den Griechen* (Berlin: Bruno Hessling, 1969), pp.213-221.

14. Private collection, Philadelphia. Hampe, *Sagenbilder*, No.135.

15. Amandry, "Héraklès et l'hydre de Lerne," *Bulletin de la Faculté des Lettres de Strasbourg*, 30 (1952), p.317; Brommer, *Herakles*, p.14.

16. Payne, *NC*, p.128; Amandry, *MonPiot*, 40, pp.40-43; Bull. Strasbourg, 30, pp.318-319.

17. A battle of Herakles and plural centaurs is the battle of the pithos; a battle of Herakles and a single centaur is most often the fight with Nessos (see Chapter 10), though it might also be the fight with Eurytion, an excerpt from the battle of the pithos, or an unspecified reference to the centauromachies of Herakles.

18. There are illustrations of Herakles capturing the boar or carrying it to Mycenae or walking it by the hind legs, "like a wheelbarrow"—Brommer, *Herakles*, p.18. But black-figure vase painters delighted in the scene at the pithos—Stephen Bleecker Luce, "Studies of the Exploits of Heracles on Vases," *AJA*, 28 (1924), pp.313-314; Brommer, *Herakles*, p.18.

19. Antlers in a female for recognizability—Hampe, *Sagenbilder*, pp. 42-43. But why antlers in literature? See Karl Meuli, "Scythica Vergiliana. 4. Herakles und die kerynitische Hindin," *Schweizerisches Archiv für Volkskunde*, 56 (1960), pp.125-139.

20. Gerhard, *AV*, 2, p. 54; Furtwängler, Roscher, 1, col. 2200; Robert, *Herm.*, p.273; Meuli, p.126. For the struggle for the tripod, see Chapter 10.

21. Preller-Robert, 2, pp.439, 453; Ernst Buschor and Richard Hamann,

Die Skulpturen des Zeustempels zu Olympia (Marburg an der Lahn: Verlag des kunstgeschichtlichen Seminars der Universität Marburg, 1924), p.23; Brommer, *Herakles*, pp.28-29; *Vasenlisten*[2], p.26; Hausmann, p.70.

22. Preller-Robert, 2, p.432.

23. Furtwängler, Roscher, 1, col. 2201.

24. I, 27, 9.

25. Brommer, *Herakles*, p.35.

26. II, 5, 9.

27. Brommer, *Herakles*, p.36.

28. Dietrich von Bothmer, *Amazons in Greek Art* (Oxford: Clarendon Press, 1957), pp.6,15.

29. Von Bothmer, pp.37-63.

30. Brommer, *Herakles*, pp.35-37; von Bothmer, p.133. For South Italian vase painting see Konrad Schauenburg, "Der Gürtel der Hippolyte," *Philologus*, 104 (1960), pp.1-13.

31. Robert, "Alkyoneus," *Hermes*, 19 (1884), p.484.

32. Munich 2620. *ARV*[2], p.16, 17; *Vasenlisten*[2], p. 51, B 1. The Geryonomachy underlies this Amazonomachy: Furtwängler, *La collection Sabouroff* (Berlin: A. Asher & Co., 1883–87), text to pl. 49, 2; FR 2, p.12; Werner Technau, "Eine Amphora des Andokidesmalers in der Sammlung des Conte Faina zu Orvieto," *Corolla Ludwig Curtius* (Stuttgart: W. Kohlhammer, 1937), p.137; von Bothmer, p.136. For the Amazonomachy of the Andokides Painter, see Technau, pp.136-137. For the relation of the Amazonomachies of the Andokides Painter and Euphronios, von Bothmer, p.136.

33. See especially the amphoras Moscow 70 (*ABV*, p.255, 8; *Vasenlisten*[2], p.72, A 33) and Louvre F 204 (*ARV*[2], p.4, 11; *Vasenlisten*[2], p.74, B 1). They are illustrated together by Konrad Schauenburg, "Eine neue Amphora des Andokidesmalers," *Jb.*, 76 (1961), pp.60, 61, figs.13 and 14.

34. Furtwängler, Roscher, 1, col. 2205; Brommer, *Herakles*, p.45.

35. For the various locations of the garden of the Hesperides and the falling away of geography for symbolism, see Metzger, *Représentations*, pp. 207-210.

36. Ernst Buschor, *Meermänner*, Sitzungsberichte der bayerischen Akademie der Wissenschaften, philosophisch-historische Abteilung, 1941, 2, 1, pp.9-11, 15-18; John Boardman, "An Early Actor; and Some Herakles-and-Nereus Scenes, II," *LBICS*, 5 (1958), p.8. Both Nereus and Herakles are named on a fragmentary hydria of the KX Painter (*ABV*, p.25, 18; *Vasenlisten*[2], p.115, A 76).

37. Buschor, pp.11, 22-23; Boardman, pp.8-9.

38. Gardiner, *JHS*, 26, pp.16-17.

39. Buschor, p.18.

40. Stephen Bleecker Luce, "Heracles and the Old Man of the Sea," *AJA*, 26 (1922), pp.178-179. Nereus is twice named: on the neck amphora, British Museum B 223 (*ABV*, p.284, 7; *Vasenlisten*[2], p.112, A 9) and the hydria, Louvre F 298 (*ABV*, p.264, 1; *Vasenlisten*[2], p.114, A 57).

41. Furtwängler, Roscher, 1, cols. 2206, 2208; FR 2, p.173. Wrestling or the pankration. Gardiner, *JHS*, 25, pp.283-284. For the late

story that Antaios could be defeated only by being lifted from the earth, see Furtwängler, Roscher, 1, col. 2208; Gardiner, *JHS*, 25, p.282.

42. Vienna 3576. *Vasenlisten*[2], p.28, C 1.

43. Usually a symmetrical scene: Bianca Maria Felletti Maj, "Due nuove ceramiche col mito di Herakles e Busiris provenienti da Spina," *Riv. Ist.*, 6 (1938),pp.207, 210; Umberto Ciotti, "Una nuova opera firmata di Epitteto," *Arti Figurative*, 2 (1946), p.12. For the Pan Painter's original version, see Beazley, *The Pan Painter*, English translation of *Der Pan-Maler* (Berlin: Heinrich Keller, 1931), pp.3-4; Felletti Maj, pp.211-215.

44. Brommer, "Herakles und die Hesperiden auf Vasenbildern," *Jb.*, 57 (1942), pp.105-112.

45. Brommer, *Jb.*, 57, pp.112, 116-117; Metzger, *Représentations*, pp. 205-206.

46. Furtwängler, FR 1, p.42; Brommer, *Jb.*, 57, p.116; Metzger, *Représentations*, p.207. Occasionally there is not even a serpent.

CHAPTER 9

1. Pindar, Isthmian VI, l. 32.

2. Otto Jahn, "Einige Abenteuer des Herakles auf Vasenbildern," *Berichte der sächsischen Gesellschaft der Wissenschaften zu Leipzig*, 5 (1853), pp.137-140; Friedrich Koepp, "Herakles und Alkyoneus," *AZ*, 42 (1884), cols. 31-32, 46; Bernard Andreae, "Herakles und Alkyoneus," *Jb.*, 77 (1962), p.208.

3. Jahn, pp.140-141; Koepp, cols. 44-45; Andreae, p.162, note 97; Francis Croissant, "Remarques sur la métope de la 'Mort d'Alkyoneus' à l'Héraion du Silaris," *BCH*, 89 (1965), p.392.

When Herakles wrestles with a sleepy giant, it may be Alkyoneus rather than Antaios: see Jahn, p.144; Brommer, *Vasenlisten*[2], pp.3, 22; Andreae, pp. 182-184, 186-190.

4. Kunze, *Schildbänder*, p.118.

5. Francis Vian, "Le combat d'Héraklès et de Kyknos d'après les documents figurés du VIe et du Ve siècle," *REA*, 47 (1945), p.27. This is the full scene: Vian, Nos.2-20.

6. Zeus withdraws: Vian, Nos.22-37; Athena and Ares withdraw: Nos. 57-64. For the sequence, pp.25-27.

7. The type: Nicola Terzaghi, "Monumenti di Prometeo," *Studi e materiali di archeologia e numismatica*, 3 (Florence, 1905), pp.203-207.

8. Jahn, "Herakles und Syleus," *AZ*, 19 (1861), col. 161.

CHAPTER 10

1. *Trachinian Women*.

2. Oltos' representation of Acheloos in the guise of Triton (stamnos, British Museum E 437: *ARV*[2], p.54, 5; *Vasenlisten*[2], p.2, B 1) is unique—A. Furtwängler, "Herakles," Roscher, 1, col. 2209; E. Norman Gardiner, "The Pankration and Wrestling. III," *JHS*, 26 (1906), p.17; Stephen Bleecker Luce, "Heracles and Achelous on a Cylix in Boston," *AJA*, 27 (1923), p.432.

3. With a few exceptions. For water see Klaus Fittschen, "Zur Herakles–Nessos–Sage," *Gymnasium*, 77 (1970), p.162; for distance (Herakles shoots), pp.168-169.

4. *Trachinian Women*, ll. 575-577.

5. For illustrations of the murder of Iphitos, see P. Hartwig, "Herakles and Eurytos on a Cylix at Palermo," *JHS*, 12 (1891), pp.334-340; Gisela M. A. Richter, "A New Euphronios Cylix in the Metropolitan Museum of Art," *AJA*, 20 (1916), pp.128-131.

6. The two types: Furtwängler, Roscher, 1, cols. 2213-2214; FR 1, p.170; Luce, "Studies of the Exploits of Herakles on Vases. II. The Theft of the Delphic Tripod," *AJA*, 34 (1930), pp.322-329; Kunze, *Schildbänder*, pp. 113-117; Franz Willemsen, "Der delphische Dreifuss," *Jb.*, 70 (1955), p.95; John Boardman, "The Struggle for the Tripod and the First Sacred War," *JHS*, 77 (1957), pp.278-279.

The frequent leftward direction of the scene: P. Zancani Montuoro and U. Zanotti-Bianco, *Heraion alla foce del Sele*, 2 (Rome: Libreria dello Stato, 1954), p.180 and note 1; Willemsen, p.96.

The frequent occurrence of a deer in the scene: Boardman, pp.280-281.

7. Walther Wrede, "Kriegers Ausfahrt in der archaisch-griechischen Kunst," *AM*, 41 (1916), p.253; Paolo Mingazzini, "Le rappresentazioni vascolari del mito dell'apoteosi di Herakles," *Atti della R. Accademia Nazionale dei Lincei*, Memorie della classe di scienze morali, storiche e filologiche, ser. 6, 1 (1925), p.420.

8. Furtwängler, Roscher, 1, col. 2219; Mingazzini, Type I. In Type II, Iolaos takes Athena's place. See also Konrad Schauenburg, "Herakles unter Göttern," *Gymnasium*, 70 (1963), p.117.

9. Mingazzini, Type IV; occasionally over Herakles' pyre—Type V.

10. Rarely Iolaos. See Schauenburg, p.117.

11. Mingazzini, Type VI. Zeus is usually throned, occasionally stands —pp.442-443.

12. Ζεῦ φίλε. Sosias Painter, cup, Berlin 2278. *ARV²*, p.21, 1; *Vasenlisten²*, p.132, B 2.

Herakles' reluctance: Furtwängler, Roscher, 1, col. 2217; Friedrich Hauser, FR 2, p.255; Erika Simon, *Opfernde Götter* (Berlin: Gebr. Mann, 1953), p.89.

CHAPTER 11

1. H. Steuding, "Theseus," Roscher, 5, col. 699; Payne, *NC*, p.133; Ernst Buschor, FR 3, p.117; K. Friis Johansen, *Thésée et la danse à Délos; étude herméneutique* (Copenhagen: E. Munksgaard, 1945), pp.27-28; Kunze, *Schildbänder*, p.129.

2. Charles Dugas, "L'évolution de la légende de Thésée," *REG*, 56 (1943), p.8.

3. Buschor, FR 3, p.117; Friis Johansen, p.59.

4. ἄλλος οὗτος Ἡρακλῆς—Plutarch, *Theseus*, XXIX, 3. E. Pottier, "Pourquoi Thésée fut l'ami d'Hercule," *Revue de l'art ancien et moderne*, 9 (1901), pp.10-16; Buschor, FR 3, pp.117-118; Hans Herter, "Theseus der Athener,"

Rheinisches Museum für Philologie, 88 (1939), pp. 280-285, 302-303; Friis Johansen, pp.56-58; Kunze, Schildbänder, pp.128-129.

5. Konrad Wernicke, "Kerkyaneus," Jb., 7 (1892), p.212; A. Furtwängler, FR 1, p.27; Herter, "Griechische Geschichte im Spiegel der Theseussage," Die Antike, 17 (1941), p.222.

6. Euthymides, amphora, Munich 2309. ARV^2, p.27, 4.

7. Carl Robert, "Theseus und Meleagros bei Bakchylides," Hermes, 33 (1898), pp.149-150; O. Höfer, "Periphetes," Roscher, 3, cols. 1975-1976; Steuding, Roscher, 5, col. 683; Preller-Robert, 2, p.724; Buschor, FR 3, p.118. But see Brian B. Shefton, "Herakles and Theseus on a Red-Figured Louterion," Hesperia, 31 (1962), p.368.

8. Theseus, IX, 1.

9. E. Norman Gardiner, "Wrestling. II," JHS, 25 (1905), pp.280-281, 284-286; Athletics of the Ancient World (Oxford: Clarendon Press, 1930), pp.193-195.

10. Otto Waser, "Theseus und Prokrustes," AA, 1914, col. 38; Nereo Alfieri, "Grande kylix del pittore di Pentesilea con ciclo teseico," Riv. Ist., n. s. 8 (1959), p.78.

11. For the version of the myth in which the fight with the bull precedes the recognition, see Preller-Robert, 2, pp.725-726; Shefton, "Medea at Marathon," AJA, 60 (1956), pp.159-163.
For relations between the two tauromachies, Herakles' and Theseus', see Ulrich Hausmann, Hellenistische Reliefbecher aus attischen und böotischen Werkstätten (Stuttgart: W. Kohlhammer, 1959), pp.70-71.

12. Steuding, Roscher, 5, cols. 688-689; José Dörig, "Sunionfriesplatte 13," AM, 73 (1958), p.92; Hausmann, p.72.

13. Steuding, Roscher, 5, col. 687; Hausmann, pp.69-73; Shefton, Hesperia, 31, pp.348, 367-368.

14. Alfieri, p.70; Hausmann, pp.73-74; Shefton, Hesperia, 31, pp.348-350.

15. Dugas, p.13.

16. For black-figure representations of the Labyrinth see, with references to earlier works, ABL, p.179, note 2; Phyllis Williams Lehmann, "The Meander Door: a Labyrinthine Symbol," Studi in onore di Luisa Banti (Rome: "L'Erma" di Bretschneider, 1965), pp.215-222.

17. Robert, Herm., p.239; Steuding, Roscher, 5, col. 731; Buschor, FR 3, pp.118-119.

18. Chronology, of course, is in terms of the geography of the road. L. A. Milani, "Tazza di Chachrylion ed alcuni altri vasi con le imprese di Teseo," Museo Italiano di antichità classica, 3 (1890), p.223; Alfieri, p.68.

19. "Kylix with Exploits of Theseus," JHS, 2 (1881), p.61.

20. Chrysoula P. Kardara, "On Theseus and the Tyrannicides," AJA, 55 (1951), pp.293-300.

21. The ring does not figure in the illustrations—Robert, Hermes, 33, p. 140; A. H. Smith, "Illustrations to Bacchylides," JHS, 18 (1898), p.279; Furtwängler, FR 1, p.29.
For a relation of some examples of this scene to the introduction of Herakles, see Paul Jacobsthal, Theseus auf dem Meeresgrunde (Leipzig: E. A. Seemann, 1911), pp.6-8.

22. H. W. Stoll, "Ariadne," Roscher, 1, col. 541; Anna Maria Marini, "Il mito di Arianna nella tradizione letteraria e nell'arte figurata," *Atene e Roma*, n. s. 13 (1932), p.63.

23. Manner of the Foundry Painter, cup, Tarquinia RC 5291. *ARV²*, p. 405, 1; *Vasenlisten²*, p.166, B 3. Ludwig Curtius rejects the usual interpretation of this scene as Theseus abandoning Ariadne, "Lekythos in Tarent," *Jh.*, 38 (1950), p.7.

24. Stoll, Roscher, 1, col. 545; Marini, pp.123-130.

25. Lilly B. Ghali-Kahil, *Les enlèvements et le retour d'Hélène*, École française d'Athènes, Travaux et mémoires, 10 (1955), pp.309-310. But see Klaus Fittschen, *Untersuchungen zum Beginn der Sagendarstellungen bei den Griechen* (Berlin: Bruno Hessling, 1969), pp.161-165.

26. Ghali-Kahil, pp.310-311. On Euthymides' amphora, Munich 2309 (*ARV²*, p.27, 4) there is no chariot: Perithoos acts as lookout. In the red-figure examples Theseus is beardless, Perithoos bearded—Ghali-Kahil, pp. 310-311.

27. B. Graef, "Amazones," *RE*, 1, col. 1777; Steuding, Roscher, 5, col. 740; Dugas, pp.21-23; Dietrich von Bothmer, *Amazons in Greek Art* (Oxford: Clarendon Press, 1957), p.118.

28. Plutarch, *Theseus*, XXXV, 5; Pausanias, I, 15, 3.

29. Pausanias, I, 17, 2.

30. Pausanias, I, 15, 2.

31. A. Kluegmann, "Combattimento di Amazzoni a cavallo sopra i vasi di stile bello," *Annali*, 39 (1867), p.222; Graef, *RE*, 1, cols. 1777-1778; Friedrich Hauser, FR 2, pp.313-315; T. B. L. Webster, *The Niobid Painter*, English translation of *Der Niobidenmaler* (Leipzig: Heinrich Keller, 1935), p.10; Erwin Bielefeld, *Amazonomachia* (Halle: Max Niemeyer, 1951), pp. 13-14; Paolo Enrico Arias, "Cratere con Amazzonomachia nel Museo di Ferrara," *Riv. Ist.*, n. s. 2 (1953), pp.24-25; von Bothmer, pp.163, 167.

32. Kluegmann, pp.212-217; Graef, *RE*, 1, col. 1778; Steuding, Roscher, 5, cols. 740-741; Dugas, p.23; Bielefeld, pp.13-14, 60-65; von Bothmer, Chapter 10.

33. See Preller-Robert, 2, p.704. For the scene of Theseus and Perithoos in the underworld: P. Weizsäcker, "Peirithoos," Roscher, 3, cols. 1786-1790; Paul Jacobsthal, "The Nekyia Krater in New York," *Metropolitan Museum Studies*, 5(1934-36), pp.123-125; Heinz Götze, "Die attischen Dreifigurenreliefs," *RM*, 53 (1938), pp.207-220; Kunze, *Schildbänder*, pp.112-113; Martin Robertson, "The Hero with Two Swords," *Journal of the Warburg and Courtauld Institutes*, 15 (1952), pp.99-100; J. D. Beazley, CB 3, pp.69-70.

34. Preller-Robert, 2, p.756.

CHAPTER 12

1. Folktale elements of the myth: Edwin Sidney Hartland, *The Legend of Perseus* (London: D. Nutt, 1894-96), vols. 1 and 3, passim; E. Kuhnert, "Perseus," Roscher, 3, cols. 1988-1989; Ulrich von Wilamowitz-Moellendorff, "Die griechische Heldensage, I," *Sitzungsberichte der preussischen Akademie der Wissenschaften, philosophisch-historischen Klasse*, 1925,

pp.59-60.

Mycenaean background: Preller-Robert, 2, p.237; Martin P. Nilsson, *The Mycenaean Origin of Greek Mythology* (Cambridge: University Press, 1932), pp.40-41.

2. The underground chamber was shown to Pausanias: II, 23, 7. It was long ago suggested that the story of the brazen chamber grew up about a plundered Mycenaean tholos tomb: W. Helbig, *Das homerische Epos aus den Denkmälern erläutert* (Leipzig: B. G. Teubner, 1884), pp.330-331. The tomb would be standing open, its original use forgotten: Preller-Robert, 2, p.230; Nilsson, pp.40-41.

For illustrations of the scene of Zeus' visit to Danae, see Arthur Bernard Cook, *Zeus, a Study in Ancient Religion*, 3 (Cambridge: University Press, 1940), pp.455-471; Semni Papaspyridi-Karouzou, "Sur un miroir du Musée Britannique," *BCH*, 70 (1946), pp.436-443; Brommer, *Vasenlisten*[2], pp.204-205; Konrad Schauenburg, *Perseus in der Kunst des Altertums* (Bonn: Rudolf Habelt, 1960), pp.3-7.

3. For illustrations of the rescue see H. Luschey, "Danae auf Seriphos," *Bull. Vereen.*, 24-26 (1949–51), pp.26-28; Christoph Clairmont, "Studies in Greek Mythology and Vase-Painting. 3. Danae and Perseus in Seriphos," *AJA*, 57 (1953), pp.92-94.

4. Preller-Robert, 2, p.232.

5. For references and examples see Thalia Phillies Howe, "The Origin and Function of the Gorgon-Head," *AJA*, 58 (1954), p.210 and notes 9 and 10.

6. Homer knows the gorgon's head with glaring eyes (*Iliad*, XI, ll. 36-37, is the most explicit passage), but not, apparently, whole gorgons. From Corinth come gorgoneia before the middle of the seventh century—Payne, *NC*, p. 80. These early Protocorinthian gorgoneia, taken with the Homeric passages, once seemed to indicate that the gorgoneion was earlier—an apotropaic or ritual mask—than the whole gorgon. See, e.g., J. H. Croon, "The Mask of the Underworld Daemon," *JHS*, 75 (1955), p.13. The story of the decapitation seemed to be an aetiological myth to account for the disembodied head. See, e.g., Howe, pp.215-216. But in 1954 George E. Mylonas found at Eleusis a Protoattic amphora with a scene of the flight of Perseus after the slaying of Medusa: Ὁ πρωτοαττικὸς ἀμφορεὺς τῆς Ἐλευσῖνος, Βιβλιοθήκη τῆς ἐν Ἀθήναις Ἀρχαιολογικῆς Ἑταιρείας, 39 (Athens, 1957). The myth, therefore, was known almost as early, or as early, as the head—p.123. Perhaps we are dealing with two traditions—Hampe, *Sagenbilder*, p.66; Kunze, *Schildbänder*, p.65. And perhaps we should not ask when so much as where: Gorgoneia appear earlier than whole gorgons at Corinth but mythical gorgons earlier than gorgoneia in Attica.

7. There are a few other Medusas in Greek mythology. W. H. Roscher, "Medusa," Roscher, 2, cols. 2518-2519, lists five mythological Medusas: the gorgon, a daughter of King Priam, a granddaughter of Perseus, the wife of King Polybos of Corinth in one version of the Oidipus myth, and one of the daughters of Pelias.

Four are minor figures, queens and princesses, royal nobodies. They are nobodies who need names and are simply called Queen. In tragedy there is

a name of similar meaning, Kreousa, with the masculine Kreon, a name for a ruler who would otherwise be nameless.

Our Medusa, of course, is not a nobody, and it is strange that she comes on the scene with a name so nondescript, so generic, as Queen.

8. For illustrations of this scene see J. D. Beazley, "The Rosi Krater," *JHS*, 67 (1947), pp.7-9; Schauenburg, pp.14-15.

9. British Museum B 155. *Vasenlisten*², p.219, C 1.

10. This is usually represented as a traveler's hat, the petasos as here or the pilos. Later the pilos is winged.

11. Roland Hampe, "Korfugiebel und frühe Perseusbilder," *AM*, 60-61 (1935-36), p.283; E. Will, "La décollation de Méduse," *RA*, 1947, 1, p.72.

12. G. Löschcke, "Dreifussvase aus Tanagra," *AZ*, 39 (1881), cols. 30-31; A. Merlin, "Pégase et Chrysaor sur une pyxide attique du Musée du Louvre," *Mélanges Gustave Glotz* (Paris: Les presses universitaires de France, 1932), p.606; Kunze, *Schildbänder*, pp.138-139; Schauenburg, p.53. In the course of the fifth century Perseus becomes youthful in the pursuit as well—Merlin, p.606; Hampe, "Korfugiebel," p.283; Schauenburg, p.29.

13. Guido Libertini, "Grandiosa Pelike col Mito di Perseo," *Bollettino d'Arte*, ser. 3, 3 (1933–34), p.556; Gerhart Rodenwaldt, *Korkyra, 2. Die Bildwerke des Artemistempels von Korkyra* (Berlin: Gebr. Mann, 1939), p. 137; Giuliana Riccioni, "Origine e sviluppo del Gorgoneion e del mito della Gorgone-Medusa nell'arte greca," *Riv. Ist.*, n. s. 9 (1960), p.184; Guntram Beckel, *Götterbeistand in der Bildüberlieferung griechischer Heldensagen* (Waldsassen/Bayern: Stiftland-Verlag, 1961), p.37; Paul Zanker, *Wandel der Hermesgestalt in der attischen Vasenmalerei* (Bonn: Rudolf Habelt, 1965), p.8.

14. Pythian XII, l. 16. For the evolution of the gorgon from archaic to Hellenistic times, the classic article is Furtwängler, "Die Gorgonen in der Kunst," Roscher, 1, cols. 1709-1727. For Medusa of this vase: Libertini, pp. 557-558; Marjorie J. Milne, "Perseus and Medusa on an Attic Vase," *Metropolitan Museum of Art, Bulletin*, n. s. 4 (1945–46), p.126.

15. Mylonas, p.123; Beckel, pp.32-33.

16. Kuhnert, Roscher, 3, col. 2029; Beckel, p.33; B. A. Sparkes, "Black Perseus," *Antike Kunst*, 11 (1968), p.12.

17. Dinos, Louvre E 874. *ABV*, p.8, 1; *Vasenlisten*², p.209, A 1.

18. Krater fragment, Moscow. *ABV*, p.77, 2; *Vasenlisten*², p.210, A 5.

19. British Museum B 380. *ABV*, p.55, 91; *Vasenlisten*², p.209, A 2.

20. Jocelyn M. Woodward, *Perseus, a Study in Greek Art and Legend* (Cambridge: University Press, 1937), p.41; Beckel, p.34; Zanker, p.6; Sparkes, p.12.

21. Cecil Smith, "Four Archaic Vases from Rhodes," *JHS*, 5 (1884), p. 240; J. D. Beazley, "The Troilos Cup," *Metropolitan Museum Studies*, 5 (1934–36), p.110; Schauenburg, p.44; Sparkes, p.13.

22. Sparkes, p.13.

23. Panathenaic amphora, Munich 2312. *ARV*², p.197, 11; *Vasenlisten*², p.213, B 1.

24. Sparkes, p.13.

25. Amphora, Berlin 1652. Payne, *NC*, No. 1431; *Vasenlisten*², p.216, C 1.

26. Preller-Robert, 2, p.239.

27. Margarete Bieber, *The History of the Greek and Roman Theater,* second edition (Princeton: Princeton University Press, 1961), pp.24-26; A. W. Pickard-Cambridge, *The Dramatic Festivals of Athens* (Oxford: Clarendon Press, 1953), pp.212-223.

28. E. Bethe, "Der Berliner Andromedakrater," *Jb.,* 11 (1896), p.295.

29. Bethe, pp.297-300. Andromeda is characterized as an oriental by the tiara.

30. Séchan, *Tragédie,* pp.268-269; Schauenburg, p.62. But see T. B. L. Webster, "The *Andromeda* of Euripides," *LBICS,* 12 (1965), p.30; Kyle M. Phillips, Jr., "Perseus and Andromeda," *AJA,* 72 (1968), p.7.

Perseus is dressed as a traveler but carries his attribute, the harpe, now a compound of sword and sickle. Kepheus is characterized as a king by his scepter, as an easterner by his tiara.

The figures of Hermes and Aphrodite do not necessarily represent persons of the play but perhaps come into the scene by association in the mind of the painter: Hermes for his frequent role as helper of heroes, including, of course, Perseus; Aphrodite because of the importance of the theme of love in the play—Bethe, pp.297-298.

For the gifts to the bride of Hades, see, e.g., Séchan, *Tragédie,* p.266; Phillips, p.10.

31. Séchan, *Tragédie,* p.269.

32. Polydektes Painter, bell krater, Bologna 325. *ARV²,* p.1069, 2; *Vasenlisten²,* p.218, B 2.

33. Schauenburg, pp.77-81.

CHAPTER 13

1. The goat's head apparently gives the chimaera her name: χίμαιρα is a female goat. But see T. J. Dunbabin, "Bellerophon, Herakles and Chimaera," *Studies Presented to David Moore Robinson,* 2 (St. Louis: Washington University, 1953), p.1169.

2. Karl Lehmann-Hartleben, "Bellerophon und der Reiterheilige," *RM,* 38-39 (1923-24), p.264; Dunbabin, p.1164; Klaus Fittschen, *Untersuchungen zum Beginn der Sagendarstellungen bei den Griechen* (Berlin: Bruno Hessling, 1969), pp.157-161.

3. Pierre Amandry, "ΠΥΡΠΝΟΟΣ ΧΙΜΑΙΡΑ," *RA,* 1949: *Mélanges Charles Picard,* 1, pp.5-6.

4. George H. Chase, "Three Bronze Tripods belonging to James Loeb, Esq.," *AJA,* 12 (1908), p.294; Lehmann-Hartleben, p.265.

5. Amandry, "Bellérophon et la Chimère dans la mosaïque antique," *RA,* 1956, 2, pp.157-158; B. B. Shefton, "Odysseus and Bellerophon Reliefs," *BCH,* 82 (1958), pp.40-44.

6. David M. Robinson, "Mosaics from Olynthos," *AJA,* 36 (1932), p.18; Amandry, "Bellérophon," pp.155-161; Shefton, pp.40-44.

7. Frank Brommer, "Bellerophon," *MWP,* 1952-54, pp.5-6; Konrad Schauenburg, "Bellerophon in der unteritalischen Vasenmalerei," *Jb.,* 71 (1956), p.65.

8. Brommer, pp.6, 9-10; Amandry, "Bellérophon," p.157.

9. Bellerophon rides again: as Axel Seeberg, "Hephaistos Rides Again," *JHS*, 85 (1965), pp.102-109.

10. R. Engelmann, "Bellerofonte e Pegaso," *Annali*, 46 (1874), p.30; Dunbabin, p.1179; Brommer, p.10.

11. Schauenburg, pp. 82-84.

12. *Iliad*, VI, ll. 200-202.

CHAPTER 14

1. In sculpture the scene occurs much earlier. See P. de La Coste-Messelière, *Au Musée de Delphes*, Bibliothèque des Écoles françaises d'Athènes et de Rome, 138 (1936), pp.168-176; Konrad Schauenburg, "Phrixos," *Rheinisches Museum für Philologie*, 101 (1958), p.41.

2. Paul Hartwig, "Phrixos und eine Kentauromachie auf einer Schale der Mitte des V. Jahrhunderts," *Festschrift für Johannes Overbeck* (Leipzig: Wilhelm Engelmann, 1893), pp.17-18; La Coste-Messelière, p.170.

3. Schauenburg, pp.43-44.

On the problem of identifying a female figure on a ram as Helle, see O. Höfer, "Helle," Roscher, 1, col. 2028; P. Friedländer, "Helle," *RE*, 8, cols. 162-163; Schauenburg, p.42.

4. Or he has already bound him. For the illustrations see L. Marchese, "Il mito di Àmico nell'arte figurata—Fortuna di un mito greco nell'arte etrusca," *Studi Etruschi*, 18 (1944), pp.45-81; Beazley, *EVP*, pp.56-60.

Epicharmos and Peisandros say that Polydeukes bound Amykos—scholiast on Apollonios, *Argonautica*, II, l. 98. See H. W. Stoll, "Amykos," Roscher, 1, col. 326; Marchese, pp.74-79.

5. Volute krater, Naples 3248 (82126). Trendall, *PP*, No. 380; *Vasenlisten*[2], p.347, D 1.

6. Orchard Painter, column krater, New York 34. 11. 7. *ARV*[2], p.524, 28; *Vasenlisten*[2], p.346, B 2.

7. Charles T. Seltman, *Attic Vase-Painting*, Martin Classical Lectures, 3 (Cambridge, Mass.: Harvard University Press, 1933), p.63.

8. Heinrich Heydemann, *Jason in Kolchis*, 11. *HWP* (1886), p.21; A. Lesky, "Medeia," *RE*, 15, col. 34; Ludwig Radermacher, *Mythos und Sage bei den Griechen* (Baden bei Wien/Leipzig: Rudolf M. Rohrer, 1938), p.183.

9. For variant forms of the myth, see Robert, *Herm.*, pp.261-262; Preller-Robert, 2, pp.847-848.

10. Robert, *Herm.*, pp.261-264. For a fragmentary near replica of the Ruvo vase, without horses, see Giovanna Bermond Montanari, "Il mito di Talos su un frammento di vaso da Valle Trebba," *Riv. Ist.*, n. s. 4 (1955), pp. 179-189.

11. A. Furtwängler, FR 1, pp.198-199; Robert, *Herm.*, pp.262-263.

At the lower right a woman flees, aghast. She is Krete, the personification of the island—Furtwängler, FR 1, pp.198-199; Robert, *Herm.*, pp.262-263.

12. Séchan, *Tragédie*, p.480; Erika Simon, "Die Typen der Medeadarstellung in der antiken Kunst," *Gymnasium*, 61 (1954), p.208.

The three-figure Peliad relief is related to this group. Here Medea is in the scene; in the vase paintings she is absent. For this relief, see Heinz Götze, "Die attischen Dreifigurenreliefs," *RM*, 53 (1938), pp.200-207.

13. Götze, pp.258-260 ("perhaps a painting of the middle of the fifth century"). This is the time, too, of the production of Euripides' first trilogy, in 455, which included the *Peliads*. The character of the doubter perhaps goes back to tragedy—Séchan, *Tragédie*, p.476; Götze, p.260, note 3; Simon, p.208.

14. Gilbert Lawall, "Apollonius' *Argonautica:* Jason as Anti-Hero," *Yale Classical Studies*, 19 (1966), pp.119-169.

15. Preller-Robert, 2, pp.870-875.

16. Nevio Degrassi, "Il pittore di Policoro e l'officina di ceramica proto-italiota di Eraclea Lucana," *Bollettino d'Arte*, ser. 5, 50 (1965), pp.8-10; "Meisterwerke frühitaliotischer Vasenmalerei aus einem Grabe in Policoro-Herakleia," *RM Ergänzungsheft*, 11 (1967), pp.204-207.

17. A gallery of interested spectators: the Argonauts Herakles and the Dioscuri and Athena, with Hera patroness of the voyage—Robert, *Herm.*, p.167; Séchan, *Tragédie*, p.408.

18. Furtwängler, FR 2, p.165; Robert, *Herm.*, p.166.

19. The dragon chariot represents a third moment—Robert, *Herm.*, pp. 164-165.

20. Furtwängler, FR 2, pp.165-166; Robert, *Herm.*, pp.165-167.

21. Furtwängler, FR 2, pp.164-165; Otto Regenbogen, "Randbemerkungen zur Medea des Euripides," *Eranos*, 48 (1950), pp.34-36; Simon, p.215.

CHAPTER 15

1. A. Furtwängler, "Orpheus. Attische Vase aus Gela," 50. *BWP* (1890), p.158; O. Gruppe, "Orpheus," Roscher, 3, col. 1179.

2. Orpheus: Furtwängler, pp.156-157; Carl Watzinger, FR 3, p.357; Herbert Hoffmann, "Orpheus unter den Thrakern," *Jahrbuch der Hamburger Kunstsammlungen*, 14-15 (1970), p.38.

Orpheus on South Italian vases: Konrad Schauenburg, "Marsyas," *RM*, 65 (1958), p.52, note 68.

Thracians: Herodotos, VII, 75. Furtwängler, pp.156-160.

3. Gruppe, Roscher, 3, col. 1180.

4. Friedrich Hauser, "Orpheus und Aigisthos," *Jb.*, 29 (1914), pp.26, 29-30; J. D. Beazley, CB 2, p. 73.

5. Jane E. Harrison, "Some Fragments of a Vase presumably by Euphronios," *JHS*, 9 (1888), p.145; Watzinger, FR 3, pp.355-356.

6. III, 67, 2.

7. Pausanias, X, 30, 8. R. Zahn, *AA*, 1902, p.86; Hauser, "Nausikaa," *Jh.*, 8 (1905), p.37; B. Schröder, "Die polygnotische Malerei und die Parthenongiebel," *Jb.*, 30 (1915), pp.114-115.

8. A. C. Pearson, *The Fragments of Sophocles* (Cambridge: University Press, 1917), 1, p.178; Séchan, *Tragédie*, p.195.

9. For this scene see Chapter 9.

CHAPTER 16

1. *Iliad*, IX, l. 539.

2. Ernst Buschor, FR 3, p.220; Rolf Blatter, "Dinosfragmente mit der kalydonischen Eberjagd," *Antike Kunst*, 5 (1962), p.47.

3. P. de La Coste-Messelière, *Au Musée de Delphes*, Bibliothèque des Écoles françaises d'Athènes et de Rome, 138 (1936), p.132.

4. Leukios: Archikles and Glaukytes, cup, Munich 2243. *ABV*, p.163, 2; *Vasenlisten²*, p.236, A 14. On the name: Antonio Minto, *Il Vaso François*, Accademia toscana di scienze e lettere, Studi, 6 (1960), p.38; Blatter, p.46.

5. On the François vase (Kleitias, volute krater, Florence 4209; *ABV*, p.76, 1; *Vasenlisten²*, p.235, A 1) and on the dinos, Vatican 306 (*Vasenlisten²*, p.236, A 4) she carries her quiver but throws a spear.

6. Ernst Kuhnert, "Meleagros," Roscher, 2, cols. 2604, 2609-2610; La Coste-Messelière, p.133.

7. La Coste-Messelière, pp.138-143.

8. On the cup of the Codrus Painter, Berlin 2538 (*ARV²*, p.1269, 5; *Vasenlisten²*, p.236, B 1) the hunt is not really the Kalydonian: Friedrich Hauser, FR 3, p.111; Dietrich von Bothmer, "An Attic Black-figured Dinos," *Bulletin of the Museum of Fine Arts*, Boston, 46 (1948), p.47. The painter had depicted a boar hunt, then recalled the Kalydonian hunt and wrote the name Meleagros.

9. Kuhnert, Roscher, 2, col. 2611.

10. *Paradise Lost*, II, l. 628.

11. C. Robert, "Theseus und Meleagros bei Bakchylides," *Hermes*, 33 (1898), pp.157-158; A. C. Pearson, *The Fragments of Sophocles* (Cambridge: University Press, 1917), 2, p.65; Séchan, *Tragédie*, p.426.

CHAPTER 17

1. The woman has been called Harmonia but seems too closely associated with the serpent. Harmonia: Gisela M. A. Richter, Richter and Hall, p.160; Trendall, *PP*, p.23. Thebe: Enrico Stefani, *NSc*, 1935, p.172; Francis Vian, *Les origines de Thèbes. Cadmos et les Spartes* (Paris: C. Klincksieck, 1963), p.48. Thebe is named on the hydria of the Kadmos Painter, Berlin 2634 (*ARV²*, p.1187, 33; *Vasenlisten²*, p.339, B 7) and on the bell krater of Asteas, Naples 3226 (82258) (Trendall, *PP*, No.37; *Vasenlisten²*, p.340, D 4).

2. For two black-figure illustrations of the wedding procession, see Konrad Schauenburg, "Zu Darstellungen aus der Sage des Admet und des Kadmos," *Gymnasium*, 64 (1957), pp.210-230.

3. Euphronios, psykter, Boston 10. 221. *ARV²*, p.16, 14; *Vasenlisten²*, p.343, B 1.

4. A. Rapp, "Pentheus," Roscher, 3, col. 1936; Guido Libertini, "Una nuova rappresentazione del mito di Penteo," *Annuario*, n. s. 1-2 (1939–40), p.143.

5. P. Hartwig, "Der Tod des Pentheus," *Jb.*, 7 (1892), pp.158-159.

6. Sophokles, *Oidipus Tyrannos*, l. 1525.

7. For a summary of the older view of the sphinx as death daemon, see A. Lesky, "Sphinx," *RE*, 3 A, cols. 1704-1706. For the sphinx as incubus, see Marie Delcourt, *Oedipe ou la Légende du Conquérant*, Bibliothèque de la Faculté de Philosophie et Lettres de l'Université de Liége, 104 (1944), pp. 119-124.

8. Carl Robert, *Oidipus* (Berlin: Weidmann, 1915), I, pp.48-58; Delcourt, p.124.

9. Robert, *Oidipus*, I, p.52.

10. Pasquale Cosi, "Sulla datazione dell'Arca di Cipselo," *Archeologia classica*, 10 (1958), pp.81-83; Erika Simon, "Kypselos," *Enciclopedia dell'Arte Antica*, 4, pp.427-432.

11. Pausanias, V, 17, 7-8. Translation of W. H. S. Jones. Pausanias, *Description of Greece*, 2. The Loeb Classical Library (London: William Heinemann; New York: G. P. Putnam's Sons, 1926). Friedrich Hauser, FR 3, p.2. There are, of course, differences of detail. For the resemblances and differences: C. Robert, "La partenza di Anfiarao e le feste funebri a Pelia su vaso ceretano," *Annali*, 46 (1874), pp.86, 98; Hauser, FR 3, p.4; Payne, *NC*, p. 140.

12. Robert, *Annali*, 46, p.98; Hauser, FR 3, p.2. Two other vase paintings combine the departure of Amphiaraos with a chariot race which might be intended as representing the funeral games for Pelias. See Robert, *Annali*, 46, pp.100-105; Hauser, FR 3, pp.5, 10-11.

13. Robert, *Annali*, 46, pp.94, 98; Hauser, FR 3, p.3.

14. Édouard Will, *Korinthiaka* (Paris: E. de Boccard, 1955), p.414.

15. H. Luckenbach, *Das Verhältniss der griechischen Vasenbilder zu den Gedichten des epischen Kyklos* (Leipzig: B. G. Teubner, 1880), p.542; Giulio Emanuele Rizzo, "Vasi greci della Sicilia," *ML*, 14 (1904), col. 70.

16. Walther Wrede, "Kriegers Ausfahrt in der archaisch-griechischen Kunst," *AM*, 41 (1916), pp.221-320.

17. Rizzo, cols. 69-71.

18. L. D. Caskey, CB 1, p.51.

19. Danae Painter, bell krater, Syracuse 18421. *ARV²*, p.1075, 7; *Vasenlisten²*, p.338, B 3. Rizzo, col. 71.

CHAPTER 18

1. Transformations are indicated beyond the archaic period, perhaps as attributes of the scene. When they are not indicated, the scene is recognizable by Peleus' hold or by dolphins, attributes of sea divinities, held by Thetis or her sisters.

2. The scene, a sanctuary, is occasionally indicated by an altar. See Preller-Robert, 2, p.65 and note 4; Ernst Buschor, FR 3, p.242.

3. For both scenes: C. H. Émilie Haspels, "Deux fragments d'une coupe d'Euphronios," *BCH*, 54 (1930), pp.422-444.

4. J. D. Beazley, "Two Swords: Two Shields," *Bull. Vereen.*, 14 (1939), p.5; K. Friis Johansen, "Achill bei Chiron," *Dragma Martino P. Nilsson ...dedicatum* (Lund: H. Ohlsson, 1939), p.184.

5. The earlier type: Beazley, p.6; Friis Johansen, pp.184-191. The later type: Beazley, p.6; Friis Johansen, pp.191-198.

6. The motive of the apple of discord is late—Preller-Robert, 2, pp.1073-1074; A. Severyns, "Pomme de discorde et Jugement des déesses," *Phoibos*, 5 (1950–51), pp.145-172; Lilly B. Ghali-Kahil, *Les enlèvements et le retour d'Hélène*, École française d'Athènes, Travaux et mémoires, 10 (1955), pp. 28-29.

7. Olpe, Villa Giulia 22679. Christoph Clairmont, *Das Parisurteil in der antiken Kunst* (Zurich, 1951), K 1.

8. The type: Jane E. Harrison, "The Judgment of Paris: Two Unpublished Vases in the Graeco-Etruscan Museum at Florence," *JHS*, 7 (1886), p. 203; Ernst Wüst, "Paris," *RE*, 18, cols. 1518-1519; Roland Hampe, review of Clairmont, *Parisurteil*, *Gnomon*, 26 (1954), pp.548-549.

9. The type: Harrison, p.203; Wüst, *RE*, 18, col. 1519; Hampe, p.549. The lack of attributes: Clairmont, pp.23, 107-108.

10. P. Perdrizet, "Hypothèse sur la première partie du *Dionysalexandros* de Cratinos," *REA*, 7 (1905), pp.110-113.

11. Harrison, p.206; Clairmont, p.95. Attributes: Clairmont, pp.107-108.

12. G. Türk, "Paris," Roscher, 3, col. 1608; Wüst, *RE*, 18, cols. 1518, 1520-1521; Clairmont, p.94.

13. The type: Harrison, p.202; Wüst, *RE*, 18, cols. 1519-1520; Hampe, p. 549. The type without Hermes: Wüst, *RE*, 18, col. 1520.

14. F. von Duhn, "Parisurtheil auf attischer Amphora," *AZ*, 41 (1883), col. 309.

15. The type: Harrison, p.204; Wüst, *RE*, 18, col. 1521; Clairmont, pp. 100-101.

16. Clairmont, p.105.

17. The type: Harrison, p.204; Metzger, *Représentations*, pp.274-275.

18. A. Furtwängler, FR 1, pp.141-142.

19. Furtwängler, FR 1, p.142; Clairmont, p.112; Metzger, *Représentations*, p.275.

20. Ezra Pound, "An Immorality," *Ripostes* (London: Stephen Swift and Co., Ltd., 1912), p.34.

21. Heinrich Heydemann, "Heroisierte Genrebilder auf bemalten Vasen," *Commentationes philologae in honorem Theodori Mommseni* (Berlin: Weidmann, 1877), pp.163-179.
Ghali-Kahil, pp.325-326.
For scenes of the meeting and the elopement, see Metzger, *Représentations*, pp.279-286; Ghali-Kahil.

22. Preller-Robert, 2, p.1122.

23. For Lakonian scenes of the ambush, see Paola Zancani Montuoro, "L'agguato a Troilo nella ceramica laconica," *Bollettino d'Arte*, ser. 4, 39 (1954), pp.289-295.

24. M. Mayer, "Troilos," Roscher, 5, col. 1217; J. D. Beazley, "Achilles and Polyxene: on a Hydria in Petrograd," *Burlington Magazine*, 28 (1915–16), p.137.

25. Robert, *Bild und Lied*, pp.16-17; *Herm.*, p.184.

26. Robert, *Bild und Lied*, pp.16-17; *Herm.*, p.183.

27. Magda Heidenreich, "Zu den frühen Troilosdarstellungen," *MdaI*, 4 (1951), p.114.
28. See Preller-Robert, 2, p.1126.

CHAPTER 19

1. In the two examples of this scene a man leads a woman, "hand on wrist," the ritual gesture of the bridegroom leading the bride—Robert, *Bild und Lied*, pp.95-96; Antonio Minto, "Corteo nuziale in un frammento di tazza attica," *Ausonia*, 9 (1919), pp.66, 73; Kazimierz Bulas, *Les illustrations antiques de l'Iliade* (Lwów: Société polon. de philologie, Université, 1929), pp.2-5; C. H. E. Haspels, "Deux fragments d'une coupe d'Euphronios," *BCH*, 54 (1930), p.436.
2. Marcel Laurent, "L'Achille voilé dans les peintures de vases grecs," *RA*, 1898, 2, pp.153-172; Bulas, *Iliade*, pp.5-12; "La colère d'Achille," *Eos*, 34 (1932–33), pp. 241-243; K. Friis Johansen, *The Iliad in Early Greek Art* (Copenhagen: Munksgaard, 1967), pp.164-178; Bernhard Döhle, "Die 'Achilleis' des Aischylos in ihrer Auswirkung auf die attische Vasenmalerei des 5. Jahrhunderts," *Klio*, 49 (1967), pp.99-125.
3. The scene: Bulas, *Iliade*, pp.12-13; J. D. Beazley, CB 2, p.36; Friis Johansen, pp.178-184.
4. Bulas, *Iliade*, pp.13-18, 55-57; *Eos*, 34, pp.244-245; Paul Jacobsthal, *Die melischen Reliefs* (Berlin-Wilmersdorf: Heinrich Keller, 1931), pp.182-184; Konrad Schauenburg, "Achilleus in der unteritalischen Vasenmalerei," *Bonner Jahrbücher*, 161 (1961), pp. 221-223; Friis Johansen, pp.126-127; Döhle, pp.125-136.
For the distinction between the two armings of Achilles, see Dietrich von Bothmer, "The Arming of Achilles," *Bulletin of the Museum of Fine Arts*, Boston, 47 (1949), pp.84-90; Friis Johansen, pp.93-127.
5. Bulas, *Iliade*, p.55.
6. For illustrations of combats of the *Iliad*, including combats Homeric in name only, see Robert, *Herm.*, pp.201-207; Bulas, *Iliade*, pp.28-36; Friis Johansen, pp.57-80, 191-219; Hans von Steuben, *Frühe Sagendarstellungen in Korinth und Athen* (Berlin: Bruno Hessling, 1968), pp.44-49.
7. Bulas, *Iliade*, pp.18-23, 64-65; *Eos*, 34, pp.245-246; Friis Johansen, pp. 138-153; Klaus P. Stähler, *Grab und Psyche des Patroklos. Ein schwarzfiguriges Vasenbild* (Münster i. W., 1967).
The scene reappears in the fourth century (Schauenburg, pp.223-224) and becomes popular in Roman times (Bulas, *Iliade*, pp.92-96).
Besides this type there is another type, represented by a few vases, in which the chariot has stopped before the tomb, and Achilles stands over the body of Hektor, voicing insults (Bulas, *Iliade*, pp.19, 21-22; Friis Johansen, pp.139-144; Stähler, pp.52-56). In either type a winged figure may approach—Iris: in Book XXIV, on the twelfth day of Achilles' outrages against Hektor's body, Zeus sends Iris to bring Thetis to him, then sends Thetis to Achilles with a message to accept a ransom for the body. The vase painters condense the two scenes into one and send Iris directly to Achilles—Bulas, *Iliade*, pp.21-22; Friis Johansen, pp.142-143.

8. Friis Johansen, pp.146-147.

9. A. Furtwängler, FR 2, pp.117-124; Robert, *Herm.*, pp.167-173; Bulas, *Iliade*, pp.25-28; Schauenburg, pp.224-225; Friis Johansen, pp.127-138.

10. H. Luckenbach, *Das Verhältniss der griechischen Vasenbilder zu den Gedichten des epischen Kyklos* (Leipzig: B. G. Teubner, 1880), p.509; Robert, *Bild und Lied*, p. 19; *Herm.*, pp.168-169.

11. Furtwängler, FR 2, p.118.

12. *Iliad*, XXIV, l. 602. Robert, *Herm.*, p.169.

CHAPTER 20

1. Trojan context, a Trojan scene on the other side of the vase—Dietrich von Bothmer, *Amazons in Greek Art* (Oxford: Clarendon Press, 1957), p.71.
Amazonomachy, "anonymous" or specific: Kunze, *Schildbänder*, p.148; von Bothmer, pp.71-72, 75, 82, 145-149.

2. Erika Simon, *Die Geburt der Aphrodite* (Berlin: Walter de Gruyter, 1959), p.74; J. D. Beazley, CB 3, p.44.

3. Cf. *Iliad*, XXII, ll. 212-213. Gustav Erich Lung, *Memnon. Archäologische Studien zur Aithiopis* (Bonn: Heinrich Ludwig, 1912), pp. 13-24; Ernst Wüst, "Psychostasie," *RE*, 23, cols. 1441-1443; Beazley, CB 3, pp.44-45.

4. The fallen figure is not necessarily always Antilochos. See Beazley, CB 2, pp.14-15.

5. G. Körte, "Tazza di Corneto con rappresentanza riferibile al mito di Meleagro," *Annali*, 53 (1881), pp.169-170; Carl Robert, *Scenen der Ilias und Aithiopis auf einer Vase der Sammlung des Grafen Michael Tyskiewicz.* 15. *HWP* (1891), p.4; Lung, pp.33,37, 41.
Eos may be winged; Thetis, too—by a misunderstanding of the painter.

CHAPTER 21

1. A. Furtwängler, FR 1, p.274.

2. Friedrich Hauser, FR 3, p.66.

3. Or, later, crouch on the ground—Kunze, *Schildbänder*, p.144.

4. There are a number of illustrations of quarrelers, rushing at each other, waving swords, held apart by companions. This scene is related only generally to the quarrel over the arms—Furtwängler, FR 1, p.273; Kunze, *Schildbänder*, p.172; Brommer, *Vasenlisten*[2], pp.301-304.

5. Athena moves to the right, looking back, as in the prototype.

6. Robert, *Bild und Lied*, p.216; Furtwängler, FR 1, p.273.

7. Sophokles, *Aias*, ll. 657-663.

8. *Aias*, l. 405.

9. Kunze, *Schildbänder*, p.156; Paola Zancani Montuoro, "Heraion alla foce del Sele. I. Altre metope del 'Primo Thesauros,'" *Atti e memorie della Società Magna Grecia*, n. s. 5 (1964), pp.75-76.

1. For the combination of single scenes, single events of the sack of Troy, see Robert, *Bild und Lied*, pp.59-79.

2. The types: A. Furtwängler, *La collection Sabouroff* (Berlin: A. Asher & Co., 1883–87), text to pl. 49, 3; H. Heydemann, "Osservazioni sulla morte di Priamo e di Astianatte," *RM*, 3 (1888), p.112; E. A. Gardner, "A Lecythus from Eretria with the Death of Priam," *JHS*, 14 (1894), pp.171-172; Charles Dugas, "Tradition littéraire et tradition graphique dans l'antiquité grecque," *AntCl*, 6 (1937), p.15.

3. Hampe, *Sagenbilder*, pp.83-84. In Attic vase painting one of the earliest examples, the lid of the C Painter (*ABV*, p.58, 119; *Vasenlisten*², p.285, A 1) probably represents the death of Astyanax earlier than, thus separate from, the death of Priam. See Kunze, *Schildbänder*, pp.159-160.

4. Robert, *Bild und Lied*, pp.74-75; Furtwängler, *Collection Sabouroff*, text to pl. 49, 3; FR I, pp.117-118; Preller-Robert, 2, pp.1261-1262.

I have not attempted to separate illustrations of the *Little Iliad* from illustrations of the *Iliupersis*.

5. But red-figure Priam is always alive.

6. Athens 11050. *Vasenlisten*², p.331, A 14.

7. See above, Chapter 18. Gardner, pp.170-174.

8. Gardner, pp.173-174.

9. Gardner, pp.173-174; Dugas, pp.20-21.

10. Syracuse 21894. *Paralipomena*, p.201; *Vasenlisten*², p.331, A 12. Ettore Gabrici, "Vasi greci arcaici della necropoli di Cuma," *RM*, 27 (1912), pp.130-131; "Cuma. Parte seconda," *ML*, 22 (1914), cols. 480-481; Dugas, pp.21-22; Charlette Mota, "Sur les représentations figurées de la mort de Troilos et de la mort d'Astyanax," *RA*, 1957, 2, pp.32-34.

11. Robert, *Bild und Lied*, p.112; J. D. Beazley, *The Development of Attic Black-Figure* (Berkeley and Los Angeles: University of California Press, 1951), p.84. Mota believes the scene represents the death of Astyanax— pp.28-29.

12. Dugas, p.24.

13. This is probably a figure who has come down to us from a lost wall painting of the late archaic period. See Furtwängler, FR I, pp.120, 183-184. The woman recurs—in different form: the vase painters recall but do not copy—on the Brygan Iliupersis (*ARV*², p.369, 1; *Vasenlisten*², p.332, B 11) and on an Iliupersis of the Tyszkiewicz Painter (*ARV*², p.290, 9; *Vasenlisten*², p.332, B 5).

14. Juliette Davreux, *La légende de la prophétesse Cassandre d'après les textes et les monuments*, Bibliothèque de la Faculté de Philosophie et Lettres de l'Université de Liége, 94 (1942), p.143. Cf. Beazley, CB 3, p.65.

15. R. Engelmann, "Kassandra," Roscher, 2, col. 983.

16. FR I, p.185.

17. W. Klein, "Aiace e Cassandra," *Annali*, 49 (1877), p.254; Karl Schefold, "Statuen auf Vasenbildern," *Jb.*, 52 (1937), p.41. Cf. Beazley, CB 3, p.64.

18. Klein, p.256; Beazley, CB 3, p.64.

19. William Bell Dinsmoor, "The Hekatompedon on the Athenian Acropolis," *AJA*, 51 (1947), p.110.

20. C. J. Herington, *Athena Parthenos and Athena Polias* (Manchester: Manchester University Press, 1955), pp.40-42.

21. Schefold, p.42.

22. The direction of the scene has changed in red-figure. The pursuit is now leftward more often than rightward—Kunze, *Schildbänder*, p.163. In South Italian vase painting the direction returns to rightward. Aias has seized Kassandra by the hair and is tearing her from the image.

23. Inscriptions or identifiable context. Pierre Amandry, review of Ghali-Kahil, *Les enlèvements et le retour d'Hélène*, *AJA*, 62 (1958), pp.338-339.

24. Kunze, *Schildbänder*, pp.163-164; Lilly B. Ghali-Kahil, *Les enlèvements et le retour d'Hélène*, École française d'Athènes, Travaux et mémoires, 10 (1955), pp.71-77.
For the gesture of "unveiling" see Ghali-Kahil, p.118.

25. Amandry, pp.338-339.

26. Paul A. Clement, "The Recovery of Helen," *Hesperia*, 27 (1958), pp. 61-62.

27. R. Engelmann, "Helena," Roscher, 1, col. 1970; Kunze, *Schildbänder*, pp.164-167; Ghali-Kahil, pp.99-103.

28. L. D. Caskey, CB 1, p.6. The inscribed example: Oltos, plate (?), Odessa. *ARV²*, p.67, 137; Ghali-Kahil, No.99; *Vasenlisten²*, p.297, B 1.

29. The type: Ghali-Kahil, pp.78-83; inscribed examples: Nos.44, 53.

30. The type: Ghali-Kahil, pp.86-91.

31. Ibykos, fr. 40. J. M. Edmonds, ed., *Lyra Graeca*, 2. The Loeb Classical Library (London: William Heinemann Ltd; New York: G. P. Putnam's Sons, 1931), p.104. See Ghali-Kahil, p.42. The identification of the type is confirmed by two inscribed examples: Nos.68, 72.
On the Vatican oinochoe (No.72) Helen runs to the image of Athena in a confusion, in the graphic tradition, with Kassandra—Robert, *Bild und Lied*, p.79; Amandry, p.338. And, as Helen flees to Athena, Kassandra flees to Apollo—Schefold, p.44; Clement, p.59.

32. Robert, *Bild und Lied*, pp.72-73. Old women in Greek art: see the short list of Andreas Rumpf, "Anadyomene," *Jb.*, 65-66 (1950-51), p.169.

33. Askanios is more often absent than present in the scene. There is often a surround of two women, probably anonymous extras, and not Aphrodite and Kreousa, the wife of Aeneas, as they are sometimes called. For the surround see Konrad Schauenburg, "Äneas und Rom," *Gymnasium*, 67 (1960), pp.178-183.

CHAPTER 23

1. Aischylos, *Agamemnon*, ll. 1389-1392.

2. With two Attic red-figure examples: *ARV²*, pp.1301, 5 and 1516, 80.

3. For the attitude, the "Penelope motive," see Séchan, *Tragédie*, pp. 92-93; Paul Jacobsthal, *Die melischen Reliefs* (Berlin-Wilmersdorf: Heinrich Keller, 1931), pp.192-198.

4. Jacobsthal, p.16.

5. See Séchan, *Tragédie*, pp.90, 93.

6. Robert, *Bild und Lied*, p.160.

7. Discussions of literary sources: Robert, *Bild und Lied*, pp.161-166; P. Zancani Montuoro and U. Zanotti-Bianco, *Heraion alla foce del Sele*, 2 (Rome: Libreria dello Stato, 1954), pp.281-286; Emily Vermeule, "The Boston Oresteia Krater," *AJA*, 70 (1966), pp.10-12.

Great painting as the prototype: A. Furtwängler, FR 2, pp.77-79; Vermeule, pp.14-15.

8. *Choephoroi*, l. 889, a line much discussed as echoing the source of the ax-swinging Klytaimnestra of the graphic tradition. See note 7, also Vermeule, p.6.

9. The type: Robert, *Bild und Lied*, p.159; Vermeule, p.19.

10. Furtwängler, FR 2, p.79.

11. *Choephoroi*, ll. 1048-1050.

12. Séchan, *Tragédie*, p.94; Carl Watzinger, FR 3, p.366.

13. Jacobsthal, "Aktaions Tod," *Marburger Jahrbuch für Kunstwissenschaft*, 5 (1929), pp.11-12, note 24; Watzinger, FR 3, pp.363-367; Albin Lesky, "Orestes," *RE*, 18, col. 994.

14. John H. Huddilston, *Greek Tragedy in the Light of Vase Paintings* (London and New York: Macmillan and Co., Limited, 1898), p.56; Hetty Goldman, "The *Oresteia* of Aeschylus as Illustrated by Greek Vase-Painting," *Harvard Studies in Classical Philology*, 21 (1910), p.155.

15. Konnakis Painter, calyx krater, Leningrad. T. B. L. Webster, "Towards a Classification of Apulian Gnathia," *LBICS*, 15 (1968), p.5; 1; *Vasenlisten*[2], p.325, D 12.

Konrad Wernicke, "Orestes in Delphi," *AZ*, 42 (1884), col. 201; Huddilston, pp.56-60; Séchan, *Tragédie*, pp.94-95.

16. Watzinger, FR 3, p.366.

17. Friedrich Hauser, FR 2, p.332: since there are only references in the play to the purification (ll. 281-283, 450).

18. Huddilston, p.65; Goldman, p.150.

19. Goldman, p.144; Watzinger, FR 3, p.363, note 5.

20. Huddilston, p.73; E. M. W. Tillyard, *The Hope Vases* (Cambridge: University Press, 1923), pp.138-139; Séchan, *Tragédie*, p.100.

21. Tillyard, p.139.

CHAPTER 24

1. Franz Winter, "Polyphem," *Jb.*, 6 (1891), pp.272-273.

2. Bernhard Schweitzer, "Zum Krater des Aristonothos," *RM*, 62 (1955), p.99.

3. Franz Müller, *Die antiken Odyssee-Illustrationen in ihrer kunsthistorischen Entwicklung* (Berlin: Weidmann, 1913), pp.2-3; Schweitzer, p.98.

4. Schweitzer, p.97.

5. Perhaps there is an allusion to the cry of pain also on the Protoargive krater—Paul Courbin, "Un fragment de cratère protoargien," *BCH*, 79 (1955), p.46. *Vasenlisten*[2], p.314, C 7; Odette Touchefeu-Meynier,

Thèmes odysséens dans l'art antique (Paris: E. de Boccard, 1968), No.2.

6. *Vasenlisten*², p.315, A 1; Touchefeu-Meynier, *Thèmes odysséens*, No.99. Ludwig Pallat, "Ein Vasenfund aus Aegina," *AM*, 22 (1897), pp. 327-328.

7. Odysseus, sometimes distinguished by beard and sword, does not go out last in the illustrations as in the *Odyssey*, but first. Again, of course, there is no attempt to draw rams three abreast—H.Luckenbach, *Das Verhältniss der griechischen Vasenbilder zu den Gedichten des epischen Kyklos* (Leipzig: B. G. Teubner, 1880), p.512; Jane E. Harrison, "Monuments Relating to the Odyssey," *JHS*, 4 (1883), pp.252-253; Paul Perdrizet, "Polyphème," *RA*, 1897, 2, pp.28-29; Müller, p.29.

8. J. E. Harrison divided the black-figure examples into two groups, those with Polyphemos and "only half of one figure-bearing ram," and those with a full ram and no Polyphemos—p.259. This classification now must admit exceptions. See Touchefeu-Meynier, *Thèmes odysséens*, Nos. 105-134.

9. The companions, of course, should not be in the palace when Odysseus arrives but in their sty. They are brought into the scene perhaps for clarity rather than in a combination of moments.

10. Luckenbach, p.507; Müller, p.51; Paul Wolters, "Kirke," *AM*, 55 (1930), p.220 and note 1.

11. Müller, p.50.

12. Müller, pp.56-57.

13. The Attic lekythos: Phanyllis Painter, lekythos, Taranto. *ABL*, p.199, 13; Touchefeu-Meynier, *Thèmes odysséens*, No.174. Touchefeu-Meynier, "Ulysse et Circé: notes sur le chant X de l'*Odyssée*," *REA*, 63 (1961), pp. 264-270.

The Boeotian skyphos: Nauplia 144. *Vasenlisten*², p.310, D 7; Touchefeu-Meynier, *Thèmes odysséens*, No.191. Wolters, pp.209-236.

14. Wolters, pp.231-234; Touchefeu-Meynier, *REA*, 63, pp.267-268; *Thèmes odysséens*, pp.111-112, 127-129.

15. Touchefeu-Meynier, *REA*, 63, p.264.

16. Emil Kunze, "Sirenen," *AM*, 57 (1932), pp.130-131.

17. Friedrich Hauser, FR 3, p.59; Haspels, *ABL*, p.158, note 2.

18. Three sirens in Attic black-figure: Touchefeu-Meynier, *Thèmes odysséens*, Nos.247 (*Paralipomena*, p.183) and 249 (*ABL*, p.253, 16).

19. Lykophron, *Alexandra*, ll. 712-716. Heinrich Bulle, "Odysseus und die Sirenen," *Strena Helbigiana* (Leipzig: B. G. Teubner, 1900), p.33; Georg Weicker, "Seirenen," Roscher, 4, cols. 603-606; Hauser, FR 3, p.25.

20. *Odyssey*, XXIV, l. 13.

Bibliography

CHAPTER 2

Brann, Eva T. H. "A Figured Geometric Fragment from the Athenian Agora," *Antike Kunst*, 2 (1959), pp.35-37.

Dunbabin, T. J. *The Greeks and their Eastern Neighbours.* London: Society for the Promotion of Hellenic Studies, 1957.

Fittschen, Klaus. *Untersuchungen zum Beginn der Sagendarstellungen bei den Griechen.* Berlin: Bruno Hessling, 1969.

Friis Johansen, K. *Ajas und Hektor. Ein vorhomerisches Heldenlied?* Copenhagen: Ejnar Munksgaard, 1961.

———. *The Iliad in Early Greek Art.* Copenhagen: Munksgaard, 1967. Pp. 17-41.

Hampe, Roland. *Frühe griechische Sagenbilder in Böotien.* Athens: Deutsches archäologisches Institut, 1936.

———. *Die Gleichnisse Homers und die Bildkunst seiner Zeit.* Tübingen: Max Niemeyer, 1952.

Hanfmann, George M. A. "Narration in Greek Art," *AJA*, 61 (1957), pp. 71-78.

Himmelmann-Wildschütz, Nikolaus. *Erzählung und Figur in der archaischen Kunst.* Akademie der Wissenschaften und der Literatur, Mainz, Abhandlungen der Geistes- und Sozialwissenschaftlichen Klasse, 1967, 2.

Metzger, Henri. *Les représentations dans la céramique attique du IV^e siècle.* Bibliothèque des Écoles françaises d'Athènes et de Rome, 172 (1951).

Robert, Carl. *Bild und Lied.* Berlin: Weidmann, 1881.

———. *Archaeologische Hermeneutik.* Berlin: Weidmann, 1919.

Schefold, Karl. *Myth and Legend in Early Greek Art.* New York: Harry N. Abrams, Inc., 1966.

Séchan, Louis. *Études sur la tragédie grecque dans ses rapports avec la céramique.* Paris: Librairie ancienne Honoré Champion, 1926.

Steuben, Hans von. *Frühe Sagendarstellungen in Korinth und Athen.* Berlin: Bruno Hessling, 1968.

Trendall, A. D. and T. B. L. Webster. *Illustrations of Greek Drama.* London: Phaidon, 1971.

Walter, Hans. *Vom Sinnwandel griechischer Mythen.* Waldsassen/Bayern: Stiftland, 1959.

Webster, T. B. L. "Homer and Attic Geometric Vases," *BSA,* 50 (1955), pp. 38-50.

Weitzmann, Kurt. *Illustrations in Roll and Codex; a Study of the Origin and Method of Text Illustration.* Princeton: Princeton University Press, 1947.

Chapter 3

Beazley, J. D. CB 2, pp.51-53 (Ganymede); CB 3, pp.49-51 (Io and Argos).

Bruneau, Philippe. "Ganymède et l'aigle: images, caricatures et parodies animales du rapt," *BCH,* 86 (1962), pp.193-228.

Bühler, Winfried. *Europa, ein Überblick über die Zeugnisse des Mythos in der antiken Literatur und Kunst.* Munich: Wilhelm Fink, 1968.

Cook, Arthur Bernard. *Zeus, a Study in Ancient Religion,* 3. Cambridge: University Press, 1940. Pp.615-628 (Europa).

Ducati, Pericle. "Frammenti di vaso attico con dipinto rappresentante la morte di Argo," *RM,* 21 (1906), pp.98-110.

Engelmann, R. "Die Io-Sage," *Jb.,* 18 (1903), pp.37-58.

Herbig, Reinhard. "Ganymed und der Adler," *Ganymed. Heidelberger Beiträge zur antiken Kunstgeschichte.* Heidelberg: F. H. Kerle, 1949. Pp.1-9.

Hoffmann, Herbert. "Eine neue Amphora des Eucharidesmalers," *Jahrbuch der Hamburger Kunstsammlungen,* 12 (1967), pp.9-34 (Io and Argos).

Kunze, Emil. "Zeus und Ganymedes, eine Terrakottagruppe aus Olympia," 100. *BWP* (1940), pp.25-50.

———. *V. Bericht über die Ausgrabungen in Olympia.* Berlin: Walter de Gruyter, 1956. Pp.103-114 (Ganymede).

La Coste-Messelière, P. de. *Au Musée de Delphes.* Bibliothèque des Écoles françaises d'Athènes et de Rome, 138 (1936), pp.153-168 (Europa).

Metzger, Henri. *Les représentations dans la céramique attique du IV^e siècle.* Bibliothèque des Écoles françaises d'Athènes et de Rome, 172 (1951), pp.306-312 (Europa); 338-340 (Io and Argos).

Rocco, Anna. "Un vaso cumano con rappresentazione del mito di Argo," *Archeologia classica,* 5 (1953), pp.88-91.

Schauenburg, Konrad. "Göttergeliebte auf unteritalischen Vasen," *Antike und Abendland,* 10 (1961), pp.77-101.

Sichtermann, Hellmut. *Ganymed, Mythos und Gestalt in der antiken Kunst.* Berlin: Gebr. Mann, n. d.

———. "Zeus und Ganymed in frühklassischer Zeit," *Antike Kunst,* 2 (1959), pp.10-15.

Technau, Werner. "Die Göttin auf dem Stier," *Jb.,* 52 (1937), pp.76-103.

Chapter 4

Beazley, J. D. *Etruscan Vase-Painting.* Oxford: Clarendon Press, 1947. Pp. 39-42, 115-116 (birth of Helen).

———. CB 2, pp.61-63 (birth of Aphrodite); CB 3, pp.47-48 (birth of Dionysos); 69-74 (birth of Helen).

———. "Hydria-Fragments in Corinth," *Hesperia,* 24 (1955), pp.305-319 (Pandora).

Brommer, Frank. "Pan im 5. und 4. Jahrhundert v. Chr.," *Marburger Jahr-*

buch für Kunstwissenschaft, 15 (1949–50), pp.5-42.
——. "Die Geburt der Athena," Jahrbuch des römisch-germanischen Zentralmuseums, Mainz, 8 (1961), pp.66-83.
——. Die Skulpturen der Parthenon-Giebel. Mainz: Philipp von Zabern, 1963. Pp.141-157.
Buschor, Ernst. Feldmäuse. Sitzungsberichte der bayerischen Akademie der Wissenschaften, philosophisch-historische Abteilung, 1937, 1.
Chapouthier, Fernand. "Léda devant l'oeuf de Némésis," BCH, 66-67 (1942–43), pp.1-21.
Cook, Arthur Bernard. Zeus, a Study in Ancient Religion, 3. Cambridge: University Press, 1940. Pp.79-89 (birth of Dionysos); 201-204 (Pandora); 662-688 (birth of Athena).
Cutroni, Aldina Tusa. "Anfora a figure nere del Museo Nazionale di Palermo," Archeologia classica, 18 (1966), pp.186-190 (birth of Athena).
Fuhrmann, Heinrich. "Athamas," Jb., 65-66 (1950–51), pp.103-134 (birth of Dionysos).
Guarducci, Margherita. "Pandora, o i Martellatori," ML, 33 (1929), cols. 5-38.
Inglieri, Raffaele Umberto. "Pisside policroma di Numana con la genesi di Afrodite," Riv.Ist., 8 (1940), pp.45-61.
Kekule von Stradonitz, Reinhard. Ueber ein griechisches Vasengemälde im akademischen Kunstmuseum zu Bonn. Bonn: Universitäts-Buchdruckerei von Carl Georgi, 1879.
——. "Die Geburt der Helena aus dem Ei," Sitzungsberichte der königlich preussischen Akademie der Wissenschaften, Berlin, 1908, pp.691-703.
Kunze, Emil. Archaische Schildbänder. Deutsches archäologisches Institut, Olympische Forschungen, 2. Berlin: Walter de Gruyter, 1950. Pp.77-82 (birth of Athena).
Metzger, Henri. Les représentations dans la céramique attique du IVe siècle. Bibliothèque des Écoles françaises d'Athènes et de Rome, 172 (1951), pp. 69-89 (birth of Aphrodite); 277-282 (birth of Helen).
Mustilli, D. "Leda e l'uovo di Nemesis," Annuario, 24-26, n. s. 8-10 (1946–48), pp.123-131.
Nilsson, Martin P. "Die eleusinischen Gottheiten. Exkurs: Die Anodos der Pherephatta auf den Vasenbildern," Archiv für Religionswissenschaft, 32 (1935), pp.131-140.
Robert, Carl. "Pandora," Hermes, 49 (1914), pp.17-38.
Rumpf, Andreas. "Anadyomene," Jb., 65-66 (1950–51), pp.166-174 (birth of Aphrodite).
Schneider, Robert. Die Geburt der Athena. Abhandlungen des archäologisch-epigraphischen Seminares der Universität Wien, 1 (Vienna, 1880).
Simon, Erika. Die Geburt der Aphrodite. Berlin: Walter de Gruyter, 1959.
Trendall, A. D. "A Volute Krater at Taranto," JHS, 54 (1934), pp.175-179 (birth of Dionysos).

CHAPTER 5

Beazley, J. D. Etruscan Vase-Painting. Oxford: Clarendon Press, 1947. Pp. 73-77 (Marsyas).
——. CB 2, pp.45-48, 83-86 (Aktaion).
Boardman, John. "Some Attic Fragments: Pot, Plaque, and Dithyramb," JHS, 76 (1956), pp.18-20 (Marsyas).

Bruns, Gerda. *Die Jägerin Artemis*. Borna–Leipzig: Robert Noske, 1929.
Buschor, Ernst. FR 3, pp.278-281 (Tityos).
Clairmont, Christoph W. "Studies in Greek Mythology and Vase-Painting.
Apollo and Marsyas," *Yale Classical Studies*, 15 (1957), pp.161-178.
———. "Niobiden," *Antike Kunst*, 6 (1963), pp.23-32.
Cook, R. M. *Niobe and her Children*. Cambridge: University Press, 1964.
Devambez, Pierre. "Deux nouvelles hydries de Caeré au Louvre," *MonPiot*,
41 (1946), pp.39-51 (Tityos).
———. "Un cratère à volutes attique du milieu du Ve siècle avant notre
ère," *MonPiot*, 55 (1967), pp.77-100 (Aktaion).
Furtwängler, A. FR 1, pp.276-278 (Tityos).
Greifenhagen, Adolf. "Tityos," *Jahrbuch der Berliner Museen*, 1 (1959),
pp.5-32.
Hauser, Friedrich. FR 2, pp.289-292 (Aktaion).
Hoffmann, Herbert. "The Oldest Portrayal of the Niobids," *Archaeology*,
13 (1960), pp.182-185.
———. "Eine neue Amphora des Eucharidesmalers," *Jahrbuch der Ham-
burger Kunstsammlungen*, 12 (1967), pp.9-34 (Aktaion).
Jacobsthal, Paul. "Aktaions Tod," *Marburger Jahrbuch für Kunstwissen-
schaft*, 5 (1929), pp.1-23.
Mercanti, Elisa. "Rappresentanze del mito di Atteone," *Neapolis*, 2 (1914),
pp.123-134.
Metzger, Henri. *Les représentations dans la céramique attique du IVe siècle*.
Bibliothèque des Écoles françaises d'Athènes et de Rome, 172 (1951), pp.
158-168 (Marsyas).
Schauenburg, Konrad. "Marsyas," *RM*, 65 (1958), pp.42-66.
———. "Aktaion in der unteritalischen Vasenmalerei," *Jb.*, 84 (1969), pp.
29-46.
Schwartz, E. "Su due dipinti vascolari rappresentanti la morte di Atteone
ed Ercole bambino che strozza i serpenti," *Annali*, 54 (1882), pp.290-299.
Séchan, Louis. *Études sur la tragédie grecque dans ses rapports avec la
céramique*. Paris: Librairie ancienne Honoré Champion, 1926. Pp.132-
138 (Aktaion).
Webster, T. B. L. *The Niobid Painter*, English translation of *Der Niobiden-
maler*. Leipzig: Heinrich Keller, 1935. Passim.
Willemsen, Franz. "Aktaionbilder," *Jb.*, 71 (1956), pp.29-58.
Zancani Montuoro, P. and U. Zanotti-Bianco. *Heraion alla foce del Sele*, 2.
Rome: Libreria dello Stato, 1954. Pp.320-329 (Tityos).

CHAPTER 6

Breitenstein, Niels. "Ein Hephaistos-Bild," *Acta Archaeologica*, 9 (1938),
pp.127-135.
Brommer, Frank. "Die Rückführung des Hephaistos," *Jb.*, 52 (1937), pp.198-
219.
Bruneau, Philippe. "Héphaistos à dos d'âne," *BCH*, 87 (1963), pp.509-516.
Christopulu-Mortoja, Eleni. *Darstellungen des Dionysos in der schwarz-
figurigen Vasenmalerei*. Berlin, 1964.
Delcourt, Marie. *Héphaistos ou la Légende du Magicien*. Bibliothèque de
la Faculté de Philosophie et Lettres de l'Université de Liège, 146 (1957),
pp.90-96.
Furtwängler, A. FR 1, pp.36-37, 138-139.

Schefold, Karl. "Zwei dionysische Vasenbilder," *AM*, 59 (1934), pp.137-142.
Seeberg, Axel. "Hephaistos Rides Again," *JHS*, 85 (1965), pp.102-109.
Villard, F. "Deux dinoi d'un peintre ionien au Louvre," *MonPiot*, 43 (1949), pp.33-57.

CHAPTER 7

Andreae, Bernard. "Gefässkörper und Malerei bei der Gigantenkampf-Amphora aus Melos im Louvre," *RM*, 65 (1958), pp.33-40.
Devambez, P. "L'Amazone de l'amphore de la Gigantomachie au Louvre et le bouclier de la Parthénos," Χαριστήριον εἰς 'Αναστάσιον Κ. 'Ορλάνδον. Βιβλιοθήκη τῆς ἐν 'Αθήναις 'Αρχαιολογικῆς 'Εταιρείας, 54 (Athens, 1965–68), 3, pp. 102-109.
Furtwängler, A. FR 2, pp.193-199.
Hahland, Walter. *Studien zur attischen Vasenmalerei um 400 v. Chr.* Marburg, 1931. Pp.10-20.
Heimberg, Ursula. *Das Bild des Poseidon in der griechischen Vasenmalerei.* Freiburg, 1968. Pp.44-48.
Salis, Arnold von. "Die Gigantomachie am Schilde der Athena Parthenos," *Jb.*, 55 (1940), pp.90-169.
Schauenburg, K. "Gestirnbilder in Athen und Unteritalien," *Antike Kunst*, 5 (1962), pp.51-64.
Smith, Cecil. "A New Copy of the Athena Parthenos," *BSA*, 3 (1896–97), pp.121-148.
Vian, Francis. *Répertoire des Gigantomachies figurées dans l'art grec et romain.* Paris: C. Klincksieck, 1951.
——. *La guerre des Géants; le mythe avant l'époque hellénistique.* Paris: C. Klincksieck, 1952.
Walter, Hans. "Gigantomachien," *AM*, 69-70 (1954–55), pp.95-104.

CHAPTER 8

Albizzati, Carlo. *Due nuovi acquisti del Museo Gregoriano-Etrusco.* Rome, 1929. Pp.7-16 (hind).
Amandry, Pierre. "Héraklès, Eurysthée et le sanglier d'Erymanthe sur deux appliques de bronze trouvées à Delphes," *BCH*, 66-67 (1942–43), pp.150-156.
——. "Skyphos corinthien du Musée du Louvre," *MonPiot*, 40 (1944), pp. 23-43 (hydra).
——. "Héraklès et l'hydre de Lerne," *Bulletin de la Faculté des Lettres de Strasbourg*, 30 (1952), pp.293-322.
Baur, Paul V. C. *Centaurs in Ancient Art. The Archaic Period.* Berlin: Karl Curtius, 1912.
Beazley, J. D. *The Pan Painter*, English translation of *Der Pan-Maler.* Berlin: Heinrich Keller, 1931. Pp.3-4 (Busiris).
——. "Geras," *Bull. Vereen.*, 24-26 (1949–51), pp.18-20.
Beckel, Guntram. *Götterbeistand in der Bildüberlieferung griechischer Heldensagen.* Waldsassen/Bayern: Stiftland-Verlag, 1961. Pp.41-66.
Bendinelli, Goffredo. "Studi intorno ai frontoni arcaici ateniesi: II. Eracle e il leone nemeo," *Ausonia*, 10 (1921), pp.131-149.
Boardman, John. "An Early Actor; and Some Herakles-and-Nereus Scenes, II," *LBICS*, 5 (1958), pp.7-10.

Bothmer, Dietrich von. *Amazons in Greek Art*. Oxford: Clarendon Press, 1957.
Brendel, Otto. "Der schlangenwürgende Herakliskos," *Jb.*, 47 (1932), pp. 191-238.
Brommer, Frank. "Herakles und die Hesperiden auf Vasenbildern," *Jb.*, 57 (1942), pp.105-123.
——. "Herakles und Hydra auf attischen Vasenbildern," *MWP*, 1949, pp. 3-8.
——. "Herakles und Geras," *AA*, 1952, cols. 60-73.
——. *Herakles, die zwölf Taten des Helden in antiker Kunst und Literatur*. Münster/Köln: Böhlau-Verlag, 1953.
—— with Anneliese Peschlow-Bindokat. *Denkmälerlisten zur griechischen Heldensage. I. Herakles*. Marburg: N. G. Elwert, 1971.
Buschor, Ernst. *Meermänner*. Sitzungsberichte der bayerischen Akademie der Wissenschaften, philosophisch-historische Abteilung, 1941, 2, 1.
Ciotti, Umberto. "Una nuova opera firmata di Epitteto," *Arti figurative*, 2 (1946), pp.8-14 (Busiris).
Clement, Paul A. "Geryon and Others in Los Angeles," *Hesperia*, 24 (1955), pp.1-12.
Croon, Johan Harm. *The Herdsman of the Dead*. Utrecht: S. Budde, 1952 (Geryon).
Felletti Maj, Bianca Maria. "Due nuove ceramiche col mito di Herakles e Busiris provenienti da Spina," *Riv. Ist.*, 6 (1938), pp.207-225.
Fittschen, Klaus. *Untersuchungen zum Beginn der Sagendarstellungen bei den Griechen*. Berlin: Bruno Hessling, 1969. Pp.111-127 (centauromachies), 147-152 (hydra, Geryon, Amazons).
Flacelière, R. and P. Devambez. *Héraclès, images et récits*. Paris: E. de Boccard, 1966.
Furtwängler, A. "Herakles," Roscher, 1, cols. 2135-2252.
——. FR 1, pp.42-44 (Hesperides), 255-260 (Busiris); FR 2, pp.1-13 (Amazons), 83-84 (Busiris), 172-176 (Antaios).
Giglioli, Giulio Q. "Una pelike attica da Cerveteri nel Museo di Villa Giulia a Roma con Herakles e Geras," *Studies Presented to David Moore Robinson*, 2. St. Louis: Washington University, 1953. Pp.111-113.
Götze, Heinz. "Die attischen Dreifigurenreliefs," *RM*, 53 (1938), pp.220-231 (Hesperides).
——. "Die Deutung des Hesperidenreliefs," *Jb.*, 63-64 (1948-49), pp.91-99.
Hafner, German. "Herakles-Geras-Ogmios," *Jahrbuch des römisch-germanischen Zentralmuseums*, Mainz, 5 (1958), pp.139-153.
Harrison, Evelyn B. "Hesperides and Heroes: a Note on the Three-Figure Reliefs," *Hesperia*, 33 (1964), pp.76-82.
Hartwig, P. "Herakles im Sonnenbecher," *RM*, 17 (1902), pp.107-109.
Haspels, C. H. Emilie. *Attic Black-Figured Lekythoi*. École française d'Athènes, Travaux et mémoires, 4 (1936), pp.120-124 (Helios).
van Hoorn, G. "Kynika," *Studies Presented to David Moore Robinson*, 2. St. Louis: Washington University, 1953. Pp.106-110 (Kerberos).
Jacopi, Giulio. "Figurazioni inedite e poco note di Ἡρακλῆς διαπλέων e di Ἡρακλῆς τοξεύων," *Bollettino d'Arte*, ser. 3, 6 (1936-37), pp.39-44 (Helios).
Kenner, Hedwig. "Amphorareste im Stil des Oltos," *Jh.*, 28 (1933), pp.41-51 (hind).
Kunze, Emil. *Archaische Schildbänder*. Deutsches archäologisches Institut, Olympische Forschungen, 2. Berlin: Walter de Gruyter, 1950. Pp.93-126.

Bibliography

Lezzi-Hafter, Adrienne. "Ein Frühwerk des Eretriamalers," *Antike Kunst*, 14 (1971), pp.84-89 (hind).
Luce, Stephen Bleecker. "The Nolan Amphora," *AJA*, 20 (1916), pp.460-474 (lion, birds).
——. "Heracles and the Old Man of the Sea," *AJA*, 26 (1922), pp.174-192 (Triton).
——. "Studies of the Exploits of Heracles on Vases," *AJA*, 28 (1924), pp. 296-325 (Pholos, boar).
Marwitz, Herbert. "Zur Einheit des Andokidesmalers," *Jh.*, 46 (1961–63), pp.76-82 (lion).
Metzger, Henri. *Les représentations dans la céramique attique du IVe siècle.* Bibliothèque des Écoles françaises d'Athènes et de Rome, 172 (1951), pp. 202-210 (Hesperides).
Meuli, Karl. "Scythica Vergiliana. 4. Herakles und die kerynitische Hindin," *Schweizerisches Archiv für Volkskunde*, 56 (1960), pp.125-139.
Neutsch, Bernhard. "Eine Amphora aus der Werkstatt des Exekias," *Ganymed. Heidelberger Beiträge zur antiken Kunstgeschichte.* Heidelberg: F. H. Kerle, 1949. Pp.29-41 (Geryon).
Robertson, Martin. "Europa," *Journal of the Warburg and Courtauld Institutes*, 20 (1957), pp.1-3 (bull).
Roux, Georges. "Héraclès et Cerbère sur une amphore du Louvre," *Mélanges d'archéologie et d'histoire offerts à Charles Picard.* Paris: Presses universitaires de France, 1949. Pp.896-904.
Schauenburg, Konrad. "Der Gürtel der Hippolyte," *Philologus*, 104 (1960), pp.1-13.
——. "Eine neue Amphora des Andokidesmalers," *Jb.*, 76 (1961), pp.60-67 (Kerberos).
——. "Herakles bei Pholos. Zu zwei frührotfigurigen Schalen," *AM*, 86 (1971), pp.43-54.
——. "Herakles und die Hydra auf attischem Schalenfuss," *AA*, 1971, pp.162-178.
Steuben, Hans von. *Frühe Sagendarstellungen in Korinth und Athen.* Berlin: Bruno Hessling, 1968. Pp.17-33.
Walters, H. B. "On some Black-figured Vases recently acquired by the British Museum," *JHS*, 18 (1898), pp.292-297 (Kerberos).
Zancani Montuoro, P. and U. Zanotti-Bianco. *Heraion alla foce del Sele*, 2. Rome: Libreria dello Stato, 1954. Pp.196-214 (boar, Antaios, lion).
Zanker, Paul. *Wandel der Hermesgestalt in der attischen Vasenmalerei.* Bonn: Rudolf Habelt, 1965. Pp.9-12.

CHAPTER 9

Andreae, Bernard. "Herakles und Alkyoneus," *Jb.*, 77 (1962), pp.130-210.
Bapp, K. "Prometheus," Roscher, 3, cols. 3083-3100.
Brommer, Frank. "Herakles und Syleus," *Jb.*, 59-60 (1944–45), pp.69-78.
Croissant, Francis. "Remarques sur la métope de la 'Mort d'Alkyoneus' à l'Héraion du Silaris," *BCH*, 89 (1965), pp.390-399.
Eckhart, Lothar. "Prometheus," *RE*, 23, cols. 702-719.
Jahn, Otto. "Einige Abenteuer des Herakles auf Vasenbildern," *Berichte der sächsischen Gesellschaft der Wissenschaften zu Leipzig*, 5 (1853), pp. 135-150 (Alkyoneus, Linos).
——. "Herakles und Syleus," *AZ*, 19 (1861), cols. 157-163.

Karouzou, Semni. "Fragments d'un cratère à volutes provenant de la collection Hélène Stathatos," *BCH*, 79 (1955), pp.177-191 (Kyknos).
Kluegmann, A. "Tazze a figure rosse con fatti di Ercole," *Annali*, 50 (1878), pp.34-38 (Syleus).
Koepp, Friedrich. "Herakles und Alkyoneus," *AZ*, 42 (1884), cols. 31-46.
Kunze, Emil. *Archaische Schildbänder*. Deutsches archäologisches Institut, Olympische Forschungen, 2. Berlin: Walter de Gruyter, 1950. Pp.91-92 (Prometheus); 117-119 (Kerkopes).
Séchan, Louis. *Le mythe de Prométhée*. Paris: Presses universitaires de France, 1951.
Terzaghi, Nicola. "Monumenti di Prometeo," *Studi e materiali di archeologia e numismatica*, 3 (Florence, 1905), pp.199-215.
Vian, Francis. "Le combat d'Héraklès et de Kyknos d'après les documents figurés du VIe et du Ve siècle," *REA*, 47 (1945), pp.5-32.
———. *La guerre des Géants*. Paris: C. Klincksieck, 1952. Pp.52-55 (Kyknos).
Zancani Montuoro, P. and U. Zanotti-Bianco. *Heraion alla foce del Sele*, 2. Rome: Libreria dello Stato, 1954. Pp.185-195 (Kerkopes).

CHAPTER 10

Baur, Paul V. C. *Centaurs in Ancient Art. The Archaic Period*. Berlin: Karl Curtius, 1912.
Beazley, J. D. *Etruscan Vase-Painting*. Oxford: Clarendon Press, 1947. Pp. 103-105 (apotheosis).
Clairmont, Christoph. "Studies in Greek Mythology and Vase-Painting. 1. Heracles on the Pyre," *AJA*, 57 (1953), pp.85-89.
Courbin, P. "Un nouveau canthare attique archaïque," *BCH*, 76 (1952), pp. 370-383 (Nessos).
Dugas, Charles. "La mort du centaure Nessos," *REA*, 45 (1943), pp.18-26.
———. "Héraclès mousicos," *REG*, 57 (1944), pp.61-70 (apotheosis).
Fittschen, Klaus. "Zur Herakles-Nessos-Sage," *Gymnasium*, 77 (1970), pp. 161-171.
Furtwängler, A. FR 1, pp.87-89 (apotheosis).
Hartwig, P. "Herakles and Eurytos on a Cylix at Palermo," *JHS*, 12 (1891), pp.334-340.
Hauser, Friedrich. FR 2, pp.254-257; FR 3, pp.13-15 (apotheosis).
Himmelmann-Wildschütz, Nikolaus. "Die Götterversammlung der Sosias-Schale," *MWP*, 1960, pp.41-48 (apotheosis).
Kunze, Emil. *Archaische Schildbänder*. Deutsches archäologisches Institut, Olympische Forschungen, 2. Berlin: Walter de Gruyter, 1950. Pp.113-117 (tripod).
Luce, Stephen Bleecker. "Heracles and Achelous on a Cylix in Boston," *AJA*, 27 (1923), pp.425-437.
———. "Studies of the Exploits of Herakles on Vases. II. The Theft of the Delphic Tripod," *AJA*, 34 (1930), pp.313-333.
Metzger, Henri. *Les représentations dans la céramique attique du IVe siècle*. Bibliothèque des Écoles françaises d'Athènes et de Rome, 172 (1951), pp. 210-224 (apotheosis).
Mingazzini, Paolo. "Le rappresentazioni vascolari del mito dell'apoteosi di Herakles," *Atti della R. Accademia Nazionale dei Lincei*, Memorie della classe di scienze morali, storiche e filologiche, ser. 6, 1 (1925), pp. 413-490.

Parke, H. W. and John Boardman. "The Struggle for the Tripod and the First Sacred War," *JHS*, 77 (1957), pp.276-282.

Richter, Gisela M. A. "A New Euphronios Cylix in the Metropolitan Museum of Art," *AJA*, 20 (1916), pp.128-131 (Eurytos).

Ridgway, Brunilde Sismondo. "The East Pediment of the Siphnian Treasury: a Reinterpretation," *AJA*, 69 (1965), pp.1-5 (tripod).

Schauenburg, Konrad. "Herakles unter Göttern," *Gymnasium*, 70 (1963), pp.113-133.

Simon, Erika. *Opfernde Götter*. Berlin: Gebr. Mann, 1953. Pp.88-91 (apotheosis).

Willemsen, Franz. "Der delphische Dreifuss," *Jb.*, 70 (1955), pp.85-104.

Zancani Montuoro, P. and U. Zanotti-Bianco. *Heraion alla foce del Sele*, 2. Rome: Libreria dello Stato, 1954. Pp.167-177, 215-221 (Nessos).

CHAPTER 11

Alfieri, Nereo. "Grande kylix del pittore di Pentesilea con ciclo teseico," *Riv. Ist.*, n. s. 8 (1959), pp.68-81, 108-109.

———. "Da Spina: Kelebe del pittore di Cadmo con miti teseici," *Gli archeologi italiani in onore di Amedeo Maiuri*. Cava dei Tirreni: Di Mauro, 1965. Pp.63-78.

———. "Da Spina: un nuovo vaso con il mito di Egeo e Medea," *Mélanges d'archéologie et d'histoire offerts à André Piganiol*. Paris: S.E.V.P.E.N., 1966. Pp.613-619.

Arias, Paolo Enrico. "Cratere con Amazzonomachia nel Museo di Ferrara," *Riv. Ist.*, n. s. 2 (1953), pp.15-28.

———. "La tomba 136 di Valle Pega," *Riv. Ist.*, n. s. 4 (1955), pp.116-128, 169-173 (Thessalian centauromachy).

Baur, Paul V. C. *Centaurs in Ancient Art. The Archaic Period.* Berlin: Karl Curtius, 1912.

Beazley, J. D. "Two Swords: Two Shields," *Bull. Vereen.*, 14 (1939), pp.4-14 (Kaineus).

———. *CB* 3, pp.83-87 (centauromachy).

Beckel, Guntram. *Götterbeistand in der Bildüberlieferung griechischer Heldensagen*. Waldsassen/Bayern: Stiftland-Verlag, 1961. Pp.67-71.

Bielefeld, Erwin. *Amazonomachia*. Halle: Max Niemeyer, 1951.

Bothmer, Dietrich von. *Amazons in Greek Art*. Oxford: Clarendon Press, 1957.

Boucher, Henri. "Kaineus et les Centaures," *RA*, 1922, 2, pp.111-118.

Brommer, Frank. "Attische Könige," *Charites; Studien zur Altertumswissenschaft*. Bonn: Athenäum-Verlag, 1957. Pp.152-164.

Bruckner, Auguste. *Palästradarstellungen auf frührotfigurigen attischen Vasen*. Hanover, 1954. Pp.18-22 (Kerkyon).

Buschor, Ernst. *FR* 3, pp.117-123 (cyclic cups); 288-289 (centauromachy).

Courbin, P. "Un nouveau canthare attique archaïque," *BCH*, 76 (1952), pp. 370-383 (centauromachy).

Curtius, Ludwig. "Lekythos in Tarent," *Jh.*, 38 (1950), pp.1-16 (Ariadne).

Diez, Erna. "Der Kampf des Theseus mit Minotauros auf einem Schalendeckel in Graz," *Jh.*, 38 (1950), pp.55-65.

Dugas, Charles. "L'évolution de la légende de Thésée," *REG*, 56 (1943), pp. 1-24.

——— and R. Flacelière. *Thésée; images et récits*. Paris: E. de Boccard, 1958.

Bibliography

Dumm, Martha. "Schale mit Theseus und Sinis," *Münchner Jahrbuch der bildenden Kunst*, 1971, pp.7-22.

Ely, Talfourd. "Theseus and Skiron," *JHS*, 9 (1888), pp.272-281.

Fittschen, Klaus. *Untersuchungen zum Beginn der Sagendarstellungen bei den Griechen*. Berlin: Bruno Hessling, 1969. Pp.161-168 (Helen, Minotaur).

Friis Johansen, K. *Thésée et la danse à Délos; étude herméneutique*. Copenhagen: Ejnar Munksgaard, 1945.

Furtwängler, A. FR 1, pp.27-30 (Amphitrite); 124-135 (Amazonomachy); 173-179 (Helen); 292-294 (Amazonomachy); FR 2, pp.88-91 (Amazonomachy).

Gentili, Bruno. "Il ditirambo XVII Sn. di Bacchilide e il cratere Tricase da Ruvo," *Archeologia classica*, 6 (1954), pp.121-125 (Poseidon).

Ghali-Kahil, Lilly B. *Les enlèvements et le retour d'Hélène*. École française d'Athènes, Travaux et mémoires, 10 (1955), pp.305-312.

Hafner, German. "Sinis, der Fichtenbeuger," *AA*, 1966, pp.151-157.

Hahland, Walter. "Einige Bemerkungen zur Deutung und Anordnung der Metopenreliefs von Bassae," *Jh.*, 44 (1959), pp.42-47 (Ariadne).

Hampe, Roland. "Neue Funde aus Olympia," *Die Antike*, 15 (1939), pp.39-44 (Kaineus).

Hauser, Friedrich. FR 2, pp.297-325 (Amazonomachy).

Hausmann, Ulrich. *Hellenistische Reliefbecher aus attischen und böotischen Werkstätten*. Stuttgart: W. Kohlhammer, 1959. Pp.69-78 (bull).

Heimberg, Ursula. *Das Bild des Poseidon in der griechischen Vasenmalerei*. Freiburg, 1968. Pp.53-58.

Höfer, O. "Krommyon," Roscher, 2, cols. 1450-1452.

———. "Periphetes," Roscher, 3, cols. 1973-1978.

———. "Phaia," Roscher, 3, col. 2203.

Hofkes-Brukker, Ch. "Die Liebe von Antiope und Theseus," *Bull. Vereen.*, 41 (1966), pp.14-27.

Jacobsthal, Paul. *Theseus auf dem Meeresgrunde*. Leipzig: E. A. Seemann, 1911.

Jahn, Otto. "Theseus Skiron und Sinis," *AZ*, 23 (1865), cols. 21-31.

Kardara, Chrysoula P. "On Theseus and the Tyrannicides," *AJA*, 55 (1951), pp.293-300.

Karouzou, Semni. "Stamnos de Polygnotos au Musée National d'Athènes," *RA*, 1970, 2, pp.229-252 (Helen).

Kluegmann, A. "Combattimento di Amazzoni a cavallo sopra i vasi di stile bello," *Annali*, 39 (1867), pp.211-225.

Kunze, Emil. *Archaische Schildbänder*. Deutsches archäologisches Institut, Olympische Forschungen, 2. Berlin: Walter de Gruyter, 1950. Pp.127-135 (Minotaur, Helen).

La Coste-Messelière, Pierre de. "Thésée à Délos," *RA*, 1947, 2, pp.145-156.

Lehmann, Phyllis Williams. "The Meander Door: a Labyrinthine Symbol," *Studi in onore di Luisa Banti*. Rome: "L'Erma" di Bretschneider, 1965. Pp.215-222.

Marini, Anna Maria. "Il mito di Arianna nella tradizione letteraria e nell'arte figurata," *Atene e Roma*, n. s. 13 (1932), pp.60-97, 121-142.

Metzger, Henri. *Les représentations dans la céramique attique du IVe siècle*. Bibliothèque des Écoles françaises d'Athènes et de Rome, 172 (1951), pp. 110-125 (Ariadne).

Milani, Luigi A. "Tazza di Chachrylion ed alcuni altri vasi con le imprese di Teseo," *Museo Italiano di antichità classica,* 3 (1890), pp.219-266.
Pottier, E. "Pourquoi Thésée fut l'ami d'Hercule," *Revue de l'art ancien et moderne,* 9 (1901), pp.1-18.
Robertson, Martin. "The Hero with Two Swords," *Journal of the Warburg and Courtauld Institutes,* 15 (1952), pp.99-100 (Kaineus).
——. "The Hero with Two Swords, a postcript," ibid., 28 (1965), p.316.
Salis, Arnold von. *Theseus und Ariadne.* Berlin: Walter de Gruyter, 1930.
Schauenburg, Konrad. "Eine neue Sianaschale," *AA,* 1962, cols. 745-765 (Kaineus).
Shefton, Brian B. "Medea at Marathon," *AJA,* 60 (1956), pp.159–163 (bull).
——. "Herakles and Theseus on a Red-Figured Louterion," *Hesperia,* 31 (1962), pp.330-368 (bull, centauromachy).
Simon, Erika. "Zur Lekythos des Panmalers in Tarent," *Jh.,* 41 (1954), pp. 77-90 (Ariadne).
——. "Ein Anthesterien-Skyphos des Polygnotos," *Antike Kunst,* 6 (1963), pp.14-16 (Ariadne).
Smith, A. H. "Illustrations to Bacchylides," *JHS,* 18 (1898), pp.276-280 (Poseidon).
Smith, Cecil. "Kylix with Exploits of Theseus," *JHS,* 2 (1881), pp.57-64.
Sourvinou-Inwood, Christiane. "Theseus Lifting the Rock and a Cup Near the Pithos Painter," *JHS,* 91 (1971), pp.94-109.
Steuben, Hans von. *Frühe Sagendarstellungen in Korinth und Athen.* Berlin: Bruno Hessling, 1968. Pp.33-36.
Steuding, H. "Theseus," Roscher, 5, cols. 678-760.
Stoll, H. W. "Ariadne," Roscher, 1, cols. 540-546.
Tillyard, E. M. W. "Theseus, Sinis, and the Isthmian Games," *JHS,* 33 (1913), pp.296-303.
Touchefeu-Meynier, Odette. "Amphore attique du musée de Nantes: Thésée et le Minotaure," *BCH,* 81 (1957), pp.714-718.
Walter, Hans. "Zu den attischen Amazonenbildern des vierten Jahrhunderts v. Chr.," *Jb.,* 73 (1958), pp.36-47.
Ward, Anne G., W. R. Connor, Ruth B. Edwards, Simon Tidworth. *The Quest for Theseus.* New York: Praeger Publishers, 1970.
Waser, Otto. "Theseus und Prokrustes," *AA,* 1914, cols. 32-38.
——. "Skiron," Roscher, 4, cols. 1004-1013.
Watzinger, Carl. "Ariadne auf Naxos," *Archaiologike Ephemeris,* 1937, 2, pp.449-453.
Webster, T. B. L. "The Myth of Ariadne from Homer to Catullus," *Greece and Rome,* ser. 2, 13 (1966), pp.22-31.
Weill, Nicole. "Un cratère d'Hermonax," *BCH,* 86 (1962), pp.64-77 (Minotaur).
Weizsäcker, P. "Peirithoos," Roscher, 3, cols. 1758-1790.
Wernicke, Konrad. "Kerkyaneus," *Jb.,* 7 (1892), pp.208-214 (Skiron, Kerkyon).
Wörner, E. "Sinis," Roscher, 4, cols. 921-934.

CHAPTER 12

Arias, Paolo Enrico. "Una nuova scena del mito di Perseo e di Andromeda," *Dioniso,* 36 (1962), pp.50-57.

Beazley, J. D. "The Rosi Krater," *JHS*, 67 (1947), pp.7-9 (Graiai).

———. CB 2, pp.11-12 (Danae).

Beckel, Guntram. *Götterbeistand in der Bildüberlieferung griechischer Heldensagen.* Waldsassen/Bayern: Stiftland-Verlag, 1961. Pp.32-40.

Benson, J. L. "The Central Group of the Corfu Pediment," *Gestalt und Geschichte: Festschrift Karl Schefold. Antike Kunst*, Beiheft 4 (1967), pp. 48-60.

Bethe, E. "Der Berliner Andromedakrater," *Jb.*, 11 (1896), pp.292-300.

Boehlau, J. "Perseus und die Graeen," *AM*, 11 (1886), pp.365-371.

Brommer, Frank. "Die Königstochter und das Ungeheuer," *MWP*, 1955.

Clairmont, Christoph. "Studies in Greek Mythology and Vase-Painting. 3. Danae and Perseus in Seriphos," *AJA*, 57 (1953), pp.92-94.

Cook, Arthur Bernard. *Zeus, a Study in Ancient Religion*, 3. Cambridge: University Press, 1940. Pp.455-471 (Danae).

Diepolder, Hans. "Ein neues Werk des Pan-Malers," *Münchner Jahrbuch der bildenden Kunst*, 1958–59, pp.7-14.

Dugas, Charles. "Observations sur la légende de Persée," *REG*, 69 (1956), pp. 1-15.

Engelmann, Richard. "Danae und Verwandtes," *Jh.*, 12 (1909), pp.165-171.

Fittschen, Klaus. *Untersuchungen zum Beginn der Sagendarstellungen bei den Griechen.* Berlin: Bruno Hessling, 1969. Pp.127-128, 152-157.

Freyer-Schauenburg, Brigitte. *Elfenbeine aus dem samischen Heraion.* Universität Hamburg, Abhandlungen aus dem Gebiet der Auslandskunde, 70 (1966), pp.30-39.

Furtwängler, A. "Die Gorgonen in der Kunst," Roscher, 1, cols. 1709-1727.

———. FR 2, pp.94-96 (Andromeda).

Gialouris, Nicolaos. "Πτερόεντα πέδιλα" *BCH*, 77 (1953), pp.293-321.

Hampe, Roland. "Korfugiebel und frühe Perseusbilder," *AM*, 60-61 (1935–36), pp.269-299.

Hersom, Shirley. "A Fragment of an Archaic Vessel with Stamped Decoration," *Hesperia*, 21 (1952), pp.275-278.

Howe, Thalia Phillies. "Illustrations to Aeschylos' Tetralogy on the Perseus Theme," *AJA*, 57 (1953), pp.269-275 (Danae).

Kretschmer, Paul. "Perseus auf Seriphos," *Jb.*, 7 (1892), pp.37-42.

Kuhnert, E. "Perseus," Roscher, 3, cols. 1986-2060.

Kunze, Emil. *Archaische Schildbänder.* Deutsches archäologisches Institut, Olympische Forschungen, 2. Berlin: Walter de Gruyter, 1950. Pp.65-72, 136-139.

———. "Zum Giebel des Artemistempels in Korfu," *AM*, 78 (1963), pp.74-89.

Libertini, Guido. "Grandiosa Pelike col Mito di Perseo," *Bollettino d'Arte*, ser. 3, 3 (1933–34), pp.554-560.

Luschey, H. "Danae auf Seriphos," *Bull. Vereen.*, 24-26 (1949–51), pp.26-28.

Matz, Friedrich. "Ein hellenistisches Bild," *MWP*, 1947, pp.9-12 (Andromeda).

Merlin, A. "Pégase et Chrysaor sur une pyxide attique du Musée du Louvre," *Mélanges Gustave Glotz.* Paris: Les presses universitaires de France, 1932. Pp.599-609.

Metzger, Henri. *Les représentations dans la céramique attique du IVe siècle.* Bibliothèque des Écoles françaises d'Athènes et de Rome, 172 (1951), pp. 335-338 (Danae).

Milne, Marjorie J. "Perseus and Medusa on an Attic Vase," Metropolitan

Museum of Art, *Bulletin*, n. s. 4 (1945–46), pp.126-130.
——. Review of Brommer, "Die Königstochter und das Ungeheuer," *AJA*, 60 (1956), pp. 300-302.
Mylonas, George E. ʽΟ πρωτοαττικὸς ἀμφορεὺς τῆς ᾽Ελευσῖνος. Βιβλιοθήκη τῆς ἐν ᾽Αθήναις ᾽Αρχαιολογικῆς ᾽Εταιρείας, 39 (Athens, 1957).
Papaspyridi-Karouzou, Semni. "Sur un miroir du Musée Britannique," *BCH*, 70 (1946), pp.436-443 (Danae).
Payne, Humfry. "On the Thermon Metopes," *BSA*, 27 (1925–26), pp.124-132.
——. *Necrocorinthia. A Study of Corinthian Art in the Archaic Period.* Oxford: Clarendon Press, 1931. Pp.79-89, 133.
Phillips, Kyle M., Jr. "Perseus and Andromeda," *AJA*, 72 (1968), pp.1-23.
Riccioni, Giuliana. "Origine e sviluppo del Gorgoneion e del mito della Gorgone-Medusa nell'arte greca," *Riv. Ist.*, n. s. 9 (1960), pp.157-206.
Robert, Carl. "Maskengruppen," *AZ*, 36 (1878), pp.13-20 (Andromeda).
Rodenwaldt, Gerhart. *Korkyra, 2. Die Bildwerke des Artemistempels von Korkyra.* Berlin: Gebr. Mann, 1939. Pp.135-139.
Schauenburg, Konrad. *Perseus in der Kunst des Altertums.* Bonn: Rudolf Habelt, 1960.
Séchan, Louis. *Études sur la tragédie grecque dans ses rapports avec la céramique.* Paris: Librairie ancienne Honoré Champion, 1926. Pp.107-113 (Graiai); 148-155, 256-273 (Andromeda).
Sparkes, B. A. "Black Perseus," *Antike Kunst*, 11 (1968), pp.3-16.
Steuben, Hans von. *Frühe Sagendarstellungen in Korinth und Athen.* Berlin: Bruno Hessling, 1968. Pp.13-17.
Webster, T. B. L. "The *Andromeda* of Euripides," *LBICS*, 12 (1965), pp.29-33.
Woodward, Jocelyn M. *Perseus, a Study in Greek Art and Legend.* Cambridge: University Press, 1937.
Zanker, Paul. *Wandel der Hermesgestalt in der attischen Vasenmalerei.* Bonn: Rudolf Habelt, 1965. Pp.5-8.

CHAPTER 13

Amandry, Pierre. "ΠΥΡΠΝΟΟΣ ΧΙΜΑΙΡΑ," *RA*, 1949: *Mélanges Charles Picard*, 1, pp.1-11.
——. "Bellérophon et la Chimère dans la mosaïque antique," *RA*, 1956, 2, pp.155-161.
Brommer, Frank. "Bellerophon," *MWP*, 1952–54.
Dunbabin, T. J. "Bellerophon, Herakles and Chimaera," *Studies Presented to David Moore Robinson*, 2. St. Louis: Washington University, 1953. Pp.1164-1184.
Engelmann, R. "Bellerofonte e Pegaso," *Annali*, 46 (1874), pp.5-37.
Fittschen, Klaus. *Untersuchungen zum Beginn der Sagendarstellungen bei den Griechen.* Berlin: Bruno Hessling, 1969. Pp.157-161.
Gericke, Tobias. "Die Bändigung des Pegasos," *AM*, 71 (1956), pp.193-201.
Hiller, Stefan. *Bellerophon. Ein griechischer Mythos in der römischen Kunst.* Munich: Wilhelm Fink, 1970.
Malten, Ludolf. "Bellerophontes," *Jb.*, 40 (1925), pp.121-160.
Moret, Jean-Marc. "Le départ de Bellérophon sur un cratère campanien de Genève," *Antike Kunst*, 15 (1972), pp.95-106.
Ohly, Dieter. "Die Chimären des Chimäramalers," *AM*, 76 (1961), pp.1-11.

Bibliography

Salviat, François and Nicole Weill. "Un plat du VII^e siècle à Thasos: Bellérophon et la Chimère," *BCH*, 84 (1960), pp.347-386.
Schauenburg, Konrad. "Bellerophon in der unteritalischen Vasenmalerei," *Jb.*, 71 (1956), pp.59-96.
———. "Neue Darstellungen aus der Bellerophonsage," *AA*, 1958, cols. 21-37.
Schmitt, Marilyn Low. "Bellerophon and the Chimaera in Archaic Greek Art," *AJA*, 70 (1966), pp.341-347.
Séchan, Louis. *Études sur la tragédie grecque dans ses rapports avec la céramique*. Paris: Librairie ancienne Honoré Champion, 1926. Pp.494-502.
Shefton, B. B. "Odysseus and Bellerophon Reliefs," *BCH*, 82 (1958), pp.34-45.
Steuben, Hans von. *Frühe Sagendarstellungen in Korinth und Athen*. Berlin: Bruno Hessling, 1968. Pp.11-13.
Will, Édouard. *Korinthiaka*. Paris: E. de Boccard, 1955. Pp.145-168.
Yalouris, Nikolaos. "Athena als Herrin der Pferde," *Museum Helveticum*, 7 (1950), pp.19-30.

CHAPTER 14

Beazley, J. D. *Etruscan Vase-Painting*. Oxford: Clarendon Press, 1947. Pp. 56-60 (Amykos).
———. "Some Inscriptions on Vases: VIII," *AJA*, 64 (1960), pp.221-225 (funeral games for Pelias).
Beckel, Guntram. *Götterbeistand in der Bildüberlieferung griechischer Heldensagen*. Waldsassen/Bayern: Stiftland-Verlag, 1961. Pp.77-79.
Benton, Sylvia. "The Evolution of the Tripod-Lebes," *BSA*, 35 (1934–35), pp.127-128 (Peliads).
Brommer, Frank. "Peliades," *AA*, 1941, cols. 53-56.
Degrassi, Nevio. "Il pittore di Policoro e l'officina di ceramica protoitaliota di Eraclea Lucana," *Bollettino d'Arte*, ser. 5, 50 (1965), pp.8-10 (Medea).
———. "Meisterwerke frühitaliotischer Vasenmalerei aus einem Grabe in Policoro-Herakleia," *RM Ergänzungsheft*, 11 (1967), pp.204-207 (Medea).
Dugas, Charles. "Le premier crime de Médée," *REA*, 46 (1944), pp.5-11.
Flasch, A. "Phineus auf Vasenbildern," *AZ*, 38 (1880), pp.138-145.
Furtwängler, A. *FR* 1, pp.196-201 (Talos); 209-214, 302-305 (Phineus); FR 2, pp.161-166 (Medea).
Götze, Heinz. "Die attischen Dreifigurenreliefs," *RM*, 53 (1938), pp. 200-207, 257-265 (Peliads).
Hartwig, Paul. "Phrixos und eine Kentauromachie auf einer Schale der Mitte des V. Jahrhunderts," *Festschrift für Johannes Overbeck*. Leipzig: Wilhelm Engelmann, 1893. Pp.14-21.
Hauser, Friedrich. *FR* 3, pp.1-12 (funeral games for Pelias).
Heydemann, Heinrich. *Jason in Kolchis*. 11. *HWP* (1886).
Jacobsthal, Paul. *Die melischen Reliefs*. Berlin–Wilmersdorf: Heinrich Keller, 1931. Pp.186-188 (Phrixos).
Jessen, O. "Argonautai," *RE*, 2, cols. 743-787.
La Coste-Messelière, P. de. *Au Musée de Delphes*. Bibliothèque des Écoles françaises d'Athènes et de Rome, 138 (1936), pp.168-176 (Phrixos).
Lesky, A. "Medeia," *RE*, 15, cols. 29-64.
Marchese, L. "Il mito di Àmico nell'arte figurata—Fortuna di un mito greco nell'arte etrusca," *Studi Etruschi*, 18 (1944), pp.45-81.

Massow, Wilhelm von. "Die Kypseloslade," *AM*, 41 (1916), pp.33-44 (funeral games for Pelias), 48-50 (Phineus).
Montanari, Giovanna Bermond. "Il mito di Talos su un frammento di vaso da Valle Trebba," *Riv. Ist.*, n. s. 4 (1955), pp.179-189.
Page, Denys L., ed. *Euripides, Medea.* Oxford: Clarendon Press, 1952. Pp. lvii-lxviii.
Richter, Gisela M. A. "Jason and the Golden Fleece," *AJA*, 39 (1935), pp.182-184.
Robert, Carl. *Archaeologische Hermeneutik.* Berlin: Weidmann, 1919. Pp. 159-167 (Medea); 261-264 (Talos); 333-338 (Phrixos).
Robertson, D. S. "The Flight of Phrixus," *Classical Review*, 54 (1940), pp. 1-8.
Schauenburg, Konrad. "Phrixos," *Rheinisches Museum für Philologie*, 101 (1958), pp.41-50.
Séchan, Louis. *Études sur la tragédie grecque dans ses rapports avec la céramique.* Paris: Librairie ancienne Honoré Champion, 1926. Pp.396-422 (Medea); 467-481 (Peliads).
Seeliger, K. "Iason," Roscher, 2, cols. 63-88.
——. "Medeia," Roscher, 2, cols. 2482-2515.
Simon, Erika. "Die Typen der Medeadarstellung in der antiken Kunst," *Gymnasium*, 61 (1954), pp.203-242.
Stoll, H. W. "Amykos," Roscher, 1, cols. 326-327.
Türk, G. "Phrixos," Roscher, 3, cols. 2458-2467.
Zancani Montuoro, P. and U. Zanotti-Bianco. *Heraion alla foce del Sele*, 2. Rome: Libreria dello Stato, 1954. Pp.350-361 (Peliads).

CHAPTER 15

Albizzati, Carlo. *Due nuovi acquisti del Museo Gregoriano-Etrusco.* Rome, 1929. Pp.16-22.
Beazley, J. D. CB 2, pp.72-76.
Cook, Arthur Bernard. *Zeus, a Study in Ancient Religion*, 3. Cambridge: University Press, 1940. Pp.99-102.
Furtwängler, A. "Orpheus. Attische Vase aus Gela," 50. *BWP* (1890), pp. 154-164.
Gruppe, O. "Orpheus," Roscher, 3, cols. 1172-1202.
Hauser, Friedrich. "Nausikaa," *Jh.*, 8 (1905), pp.35-40 (Thamyras).
——. "Orpheus und Aigisthos," *Jb.*, 29 (1914), pp.26-32.
Heydemann, H. "Tod des Orpheus," *AZ*, 26 (1868), pp.3-5.
Hoffmann, Herbert. "Orpheus unter den Thrakern," *Jahrbuch der Hamburger Kunstsammlungen*, 14-15 (1970), pp.31-44.
Kern, Otto. "Der Kitharode Orpheus," *AM*, 63-64 (1938–39), pp.107-110.
Mylonas, Eunice M. "The Niobid Painter," *Brooklyn Museum Annual*, 1 (1959–60), pp.17-24.
Robert, C. "Das orakelnde Haupt des Orpheus," *Jb.*, 32 (1917), pp.146-147.
Schmidt, Margot. "Ein neues Zeugnis zum Mythos vom Orpheushaupt," *Antike Kunst*, 15 (1972), pp.128-137.
Schoeller, Felix M. *Darstellungen des Orpheus in der Antike.* Freiburg, 1969.
Schröder, B. "Die polygnotische Malerei und die Parthenongiebel," *Jb.*, 30 (1915), pp.113-115 (Thamyras).
Séchan, Louis. *Études sur la tragédie grecque dans ses rapports avec la*

céramique. Paris: Librairie ancienne Honoré Champion, 1926. Pp.193-198 (Thamyras).

Watzinger, Carl. FR 3, pp.355-361.

CHAPTER 16

Blatter, Rolf. "Dinosfragmente mit der kalydonischen Eberjagd," *Antike Kunst*, 5 (1962), pp.45-47.

Bothmer, Dietrich von. "An Attic Black-figured Dinos," *Bulletin of the Museum of Fine Arts*, Boston, 46 (1948), pp.42-48.

Daltrop, Georg. *Die kalydonische Jagd in der Antike.* Hamburg and Berlin: Paul Parey, 1966.

Friis Johansen, K. "Eine neue caeretaner Hydria," *Opuscula Romana*, 4 (1962), pp.65-71.

Kleiner, Fred S. "The Kalydonian Hunt: A Reconstruction of a Painting from the Circle of Polygnotos," *Antike Kunst*, 15 (1972), pp.7-19.

Kuhnert, Ernst. "Meleagros," Roscher, 2, cols. 2591-2622.

La Coste-Messelière, P. de. *Au Musée de Delphes.* Bibliothèque des Écoles françaises d'Athènes et de Rome, 138 (1936), pp.120-152.

Metzger, Henri. *Les représentations dans la céramique attique du IVe siècle.* Bibliothèque des Écoles françaises d'Athènes et de Rome, 172 (1951), pp. 312-318.

Minto, Antonio. *Il Vaso François.* Accademia toscana di scienze e lettere, Studi, 6 (1960), pp.27-41.

Schauenburg, Konrad. "Eine neue Sianaschale," *AA*, 1962, cols. 765-776.

Séchan, Louis. *Études sur la tragédie grecque dans ses rapports avec la céramique.* Paris: Librairie ancienne Honoré Champion, 1926. Pp.423-433.

Steuben, Hans von. *Frühe Sagendarstellungen in Korinth und Athen.* Berlin: Bruno Hessling, 1968. Pp.42-44.

Young, Rodney S. "A Black-Figured Deinos," *Hesperia*, 4 (1935), pp.430-441.

CHAPTER 17

Beazley, J. D. "The Rosi Krater," *JHS*, 67 (1947), pp.1-7 (Seven against Thebes).

———. "Some Inscriptions on Vases: V," *AJA*, 54 (1950), pp.311-315 (Seven against Thebes).

———. CB 2, pp.1-3 (Pentheus).

Beckel, Guntram. *Götterbeistand in der Bildüberlieferung griechischer Heldensagen.* Waldsassen/Bayern: Stiftland-Verlag, 1961. Pp.74-76 (Kadmos).

Cosi, Pasquale. "Sulla datazione dell'Arca di Cipselo," *Archeologia classica*, 10 (1958), pp.81-83 (Amphiaraos).

Curtius, Ludwig. *Pentheus.* 88. BWP (1929).

Dodds, E. R., ed. *Euripides, Bacchae.* Oxford: Clarendon Press, 1944. Pp.xxx-xxxiii (Pentheus).

Furtwängler, A. FR 2, pp.27-28 (Eriphyle).

Goldman, Hetty. "Two Unpublished Oedipus Vases in the Boston Museum of Fine Arts," *AJA*, 15 (1911), pp.378-385.

Hampe, Roland and Erika Simon. *Griechische Sagen in der frühen etruskischen Kunst.* Mainz: Philipp von Zabern, 1964. Pp.18-21 (Amphiaraos).

Hartwig, P. "Der Tod des Pentheus," *Jb.*, 7 (1892), pp.153-164.

Bibliography 215

Hauser, Friedrich. FR 3, pp.1-12 (Amphiaraos).
Heydemann, H. "Kadmos," AZ, 29 (1871), pp.35-37.
Höfer, O. "Oidipus," Roscher, 3, cols. 700-737.
Libertini, Guido. "Una nuova rappresentazione del mito di Penteo," *Annuario*, n. s. 1-2 (1939–40), pp.139-145.
Lullies, Reinhard. "Die lesende Sphinx," *Neue Beiträge zur klassischen Altertumswissenschaft. Festschrift zum 60. Geburtstag von Bernhard Schweitzer*. Stuttgart: W. Kohlhammer, 1954. Pp.140-146.
Massow, Wilhelm von. "Die Kypseloslade," *AM*, 41 (1916), pp.30-33 (Amphiaraos).
Payne, Humfry. *Necrocorinthia. A Study of Corinthian Art in the Archaic Period*. Oxford: Clarendon Press, 1931. Pp.139-141 (Amphiaraos).
Philippart, Hubert. "Iconographie des 'Bacchantes' d'Euripide," *Revue Belge de Philologie et d'Histoire*, 9 (1930), pp.50-72 (Pentheus).
Rapp, A. "Pentheus," Roscher, 3, cols. 1925-1943.
Richter, Gisela M. A. "Newcomers," *AJA*, 74 (1970), pp.331-333 (Seven against Thebes).
Rizzo, Giulio Emanuele. "Vasi greci della Sicilia," *ML*, 14 (1904), cols. 63-74 (Amphiaraos).
Robert, Carl. "La partenza di Anfiarao e le feste funebri a Pelia su vaso ceretano," *Annali*, 46 (1874), pp.82-110.
———. *Oidipus*. Berlin: Weidmann, 1915. I, pp.48-58.
Séchan, Louis. *Études sur la tragédie grecque dans ses rapports avec la céramique*. Paris: Librairie ancienne Honoré Champion, 1926. Pp.102-106, 308-310 (Pentheus).
Simon, Erika. "Kypselos," *Enciclopedia dell'Arte Antica*, 4, pp.427-432 (Amphiaraos).
Steuben, Hans von. *Frühe Sagendarstellungen in Korinth und Athen*. Berlin: Bruno Hessling, 1968. Pp.37-41.
Trendall, A. D. *Paestan Pottery*. London: British School at Rome, 1936. Pp. 23-24 (Kadmos).
Vian, Francis. *Les origines de Thèbes. Cadmos et les Spartes*. Paris: C. Klincksieck, 1963. Pp.35-50.
Walter, Hans. "Sphingen," *Antike und Abendland*, 9 (1960), pp.63-72.
Wrede, Walther. "Kriegers Ausfahrt in der archaisch-griechischen Kunst," *AM*, 41 (1916), pp.221-320, passim (Amphiaraos).

CHAPTER 18

Beazley, J. D. "Achilles and Polyxene: on a Hydria in Petrograd," *Burlington Magazine*, 28 (1915–16), pp.137-138.
———. "Two Swords: Two Shields," *Bull. Vereen.*, 14 (1939), pp.4-6 (Achilles and Chiron).
———. " ΕΛΕΝΗΣ ᾽ΑΠΑΙΤΗΣΙΣ," *Proceedings of the British Academy*, 43 (1957), pp.233-244.
Bloch, L. "Peleus," Roscher, 3, cols. 1833-1839.
Bothmer, Dietrich von. Review of Clairmont, *Das Parisurteil*, *AJA*, 57 (1953), pp.138-140.
Cambitoglou, Alexander and John Wade. "Achilles and Troilos: A Campanian Bell-krater in the Nicholson Museum, Sydney, by the Libation Painter, representing Achilles and Troilos," *Antike Kunst*, 15 (1972), pp.90-94.

Clairmont, Christoph. *Das Parisurteil in der antiken Kunst.* Zurich, 1951.
Dugas, Charles. "Tradition littéraire et tradition graphique dans l'antiquité grecque," *AntCl,* 6 1937), pp. 5-13 (judgment of Paris).
Duhn, F. von. "Parisurtheil auf attischer Amphora," *AZ,* 41 (1883), cols. 307-312.
Fittschen, Klaus. *Untersuchungen zum Beginn der Sagendarstellungen bei den Griechen.* Berlin: Bruno Hessling, 1969. Pp.169-172.
Friis Johansen, K. "Achill bei Chiron," *Dragma Martino P. Nilsson . . . dedicatum.* Lund: H. Ohlsson, 1939. Pp.181-205.
Furtwängler, A. FR 1, pp.1-6 (Peleus and Thetis); 93-97, 141-144 (judgment).
Ghali-Kahil, Lilly B. *Les enlèvements et le retour d'Hélène.* École française d'Athènes, Travaux et mémoires, 10 (1955).
Hampe, Roland. "Rückkehr eines Jünglings," *Corolla Ludwig Curtius.* Stuttgart: W. Kohlhammer, 1937. Pp.142-147 (Paris).
———. Review of Clairmont, *Das Parisurteil, Gnomon,* 26 (1954), pp.545-551.
Harrison, Jane E. "The Judgment of Paris: Two Unpublished Vases in the Graeco-Etruscan Museum at Florence," *JHS,* 7 (1886), pp.202-210.
Haspels, C. H. Émilie. "Deux fragments d'une coupe d'Euphronios," *BCH,* 54 (1930), pp.422-444 (Peleus and Thetis).
Heidenreich, Magda. "Zu den frühen Troilosdarstellungen," *MdaI,* 4 (1951), pp.103-119.
———. "Zur frühen attischen Bildschöpfung der Peleushochzeit," *MdaI,* 5 (1952), pp.134-140.
Himmelmann-Wildschütz, Nikolaus. *Zur Eigenart des klassischen Götterbildes.* Munich: Prestel, 1959 (judgment).
Kunisch, Norbert. "Die Verfolgung des Troilos. Zu einem Vasenfragment," *AA,* 1965, cols. 394-401.
Kunze, Emil. *Archaische Schildbänder.* Deutsches archäologisches Institut, Olympische Forschungen, 2. Berlin: Walter de Gruyter, 1950. Pp. 140-142 (Troilos).
Lesky, Albin. "Troilos," *RE,* ser. 2, 7 A, cols. 602-615.
Lord, Louis E. "The Judgment of Paris on Etruscan Mirrors," *AJA,* 41 (1937), pp.602-606.
Mayer, M. "Troilos," Roscher, 5, cols. 1215-1230.
Metzger, Henri. *Les représentations dans la céramique attique du IVe siècle.* Bibliothèque des Écoles françaises d'Athènes et de Rome, 172 (1951), pp. 267-286.
Minto, Antonio. *Il Vaso François.* Accademia toscana di scienze e lettere, Studi, 6 (1960), pp.87-106 (Peleus and Thetis).
Mota, Charlette. "Sur les représentations figurées de la mort de Troilos et de la mort d'Astyanax," *RA,* 1957, 2, pp.25-44.
Perdrizet, P. "Hypothèse sur la première partie du *Dionysalexandros* de Cratinos," *REA,* 7 (1905), pp.109-115 (judgment).
Pottier, Edmond. "Vases peints grecs à sujets homériques," *MonPiot,* 16 (1909), pp.113-136 (Troilos).
Robertson, Martin. "Ibycus: Polycrates, Troilus, Polyxena," *LBICS,* 17 (1970), pp.11-15.
Rocco, Anna. "Il mito di Troilo su di un'anfora italiota della Biblioteca dei Gerolomini in Napoli," *Archeologia classica,* 3 (1951), pp.168-175.
Schauenburg, Konrad. "Achilleus in der unteritalischen Vasenmalerei," *Bonner Jahrbücher,* 161 (1961), pp.218-221 (Troilos).

Bibliography 217

Schefold, Karl. FR 3, pp.332-336 (Peleus and Thetis).
Séchan, Louis. *Études sur la tragédie grecque dans ses rapports avec la céramique*. Paris: Librairie ancienne Honoré Champion, 1926. Pp.214-218 (Troilos).
Sestieri, Pellegrino Claudio. "Gamikos lebes da Paestum," *Archeologia classica*, 7 (1955), pp.1-5 (judgment).
Severyns, A. "Pomme de discorde et Jugement des déesses," *Phoibos*, 5 (1950–51), pp.145-172.
Sichtermann, Hellmut. "Zur Achill und Chiron-Gruppe," *RM*, 64 (1957), pp.98-110.
Steuben, Hans von. *Frühe Sagendarstellungen in Korinth und Athen*. Berlin: Bruno Hessling, 1968. Pp.54-64.
Stinton, T. C. W. *Euripides and the Judgement of Paris*. London: Society for the Promotion of Hellenic Studies, 1965.
Türk, G. "Paris," Roscher, 3, cols. 1603-1638.
———. "Polyxena," Roscher, 3, cols. 2718-2733.
Umhang-Ernst, Renate. "Vasenfragmente mit Parisurteil," *Antike Kunst*, 10 (1967), pp.60-64.
Wüst, Ernst. "Paris," *RE*, 18, cols. 1513-1536.
Zancani Montuoro, Paola. "L'agguato a Troilo nella ceramica laconica," *Bollettino d'Arte*, ser. 4, 39 (1954), pp.289-295.
——— and U. Zanotti-Bianco. *Heraion alla foce del Sele*, 2. Rome: Libreria dello Stato, 1954. Pp.222-229 (Troilos).
Zanker, Paul. *Wandel der Hermesgestalt in der attischen Vasenmalerei*. Bonn: Rudolf Habelt, 1965. Pp.19-24 (judgment).

CHAPTER 19

Arias, Paolo Enrico. "Morte di un eroe," *Archeologia classica*, 21 (1969), pp.190-209 (death of Patroklos?).
Beazley, J. D. "A Cup by Hieron and Makron," *Bull. Vereen.*, 29 (1954), pp.12-15 (ransom of Hektor).
Bernhard, M.–L. "Une scene inconnue de l'Iliade," *RA*, 1970, 1, pp.49-54.
Bothmer, Dietrich von. "The Arming of Achilles," *Bulletin of the Museum of Fine Arts*, Boston, 47 (1949), pp.84-90.
Bulas, Kazimierz. *Les illustrations antiques de l'Iliade*. Lwów: Société polon. de philologie, Université, 1929.
———. "La colère d'Achille," *Eos*, 34 (1932–33), pp.241-250.
———. "New Illustrations to the Iliad," *AJA*, 54 (1950), pp.112-118.
Döhle, Bernhard. "Die 'Achilleis' des Aischylos in ihrer Auswirkung auf die attische Vasenmalerei des 5. Jahrhunderts," *Klio*, 49 (1967), pp.63-149.
Fittschen, Klaus. *Untersuchungen zum Beginn der Sagendarstellungen bei den Griechen*. Berlin: Bruno Hessling, 1969. Pp.172-177.
Friis Johansen, K. *The Iliad in Early Greek Art*. Copenhagen: Munksgaard, 1967.
Furtwängler, A. FR 2, pp.117-124 (ransom).
Graham, J. Walter. "The Ransom of Hektor on a New Melian Relief," *AJA*, 62 (1958), pp.313-319.
Heydemann, Heinrich. "Heroisierte Genrebilder auf bemalten Vasen," *Commentationes philologae in honorem Theodori Mommseni*. Berlin: Weidmann, 1877. Pp.163-179.

Hofkes-Brukker, Charline. "Die Umformung des homerischen Bildstoffes in den archaischen Darstellungen," *Bull. Vereen.*, 15 (1940), pp.2-31.
Jacobsthal, Paul. *Die melischen Reliefs*. Berlin-Wilmersdorf: Heinrich Keller, 1931. Pp.182-184 (Nereids on dolphins).
Kunze, Emil. *Archaische Schildbänder*. Deutsches archäologisches Institut, Olympische Forschungen, 2. Berlin: Walter de Gruyter, 1950. Pp.145-148 (ransom).
Laurent, Marcel. "L'Achille voilé dans les peintures de vases grecs," *RA*, 1898, 2, pp.153-186.
Lullies, Reinhard. "Eine Amphora aus dem Kreis des Exekias," *Antike Kunst*, 7 (1964), pp.82-89 (ransom).
Metzger, Henri. *Les représentations dans la céramique attique du IV^e siècle*. Bibliothèque des Écoles françaises d'Athènes et de Rome, 172 (1951), pp. 290-293 (Nereids on dolphins).
Robert, Carl. *Archaeologische Hermeneutik*. Berlin: Weidmann, 1919. Pp. 167-173 (ransom); 178-180 (mission to Achilles).
Schauenburg, Konrad. "Achilleus in der unteritalischen Vasenmalerei," *Bonner Jahrbücher*, 161 (1961), pp.221-226.
Séchan, Louis. *Études sur la tragédie grecque dans ses rapports avec la céramique*. Paris: Librairie ancienne Honoré Champion, 1926. Pp.114-120 (ransom).
Stähler, Klaus P. *Grab und Psyche des Patroklos. Ein schwarzfiguriges Vasenbild*. Münster i. W., 1967.
Steuben, Hans von. *Frühe Sagendarstellungen in Korinth und Athen*. Berlin: Bruno Hessling, 1968. Pp.44-50.
Vermeule, Emily T. "The Vengeance of Achilles: The Dragging of Hektor at Troy," *Bulletin of the Museum of Fine Arts*, Boston, 63 (1965), pp.35-52.

CHAPTER 20

Beazley, J. D. CB 2, pp.13-19; CB 3, pp.44-46 (Memnon).
Bothmer, Dietrich von. *Amazons in Greek Art*. Oxford: Clarendon Press, 1957.
Fittschen, Klaus. *Untersuchungen zum Beginn der Sagendarstellungen bei den Griechen*. Berlin: Bruno Hessling, 1969. Pp.177-181.
Furtwängler, A. FR 1, pp. 31-34, 282-283; FR 2, pp.90-91 (Penthesileia).
Hampe, Roland. *Die Gleichnisse Homers und die Bildkunst seiner Zeit*. Tübingen: Max Niemeyer, 1952. Pp.38-39 (Penthesileia).
Hofkes-Brukker, Ch. "Die Liebe von Antiope und Theseus," *Bull. Vereen.*, 41 (1966), pp.17-18 (Penthesileia).
Körte, G. "Tazza di Corneto con rappresentanza riferibile al mito di Meleagro," *Annali*, 53 (1881), pp.168-173 (Memnon).
Kunze, Emil. *Archaische Schildbänder*. Deutsches archäologisches Institut, Olympische Forschungen, 2. Berlin: Walter de Gruyter, 1950. Pp.148-154 (Penthesileia, Aias with the body of Achilles).
Lung, Gustav Erich. *Memnon. Archäologische Studien zur Aithiopis*. Bonn: Heinrich Ludwig, 1912.
Ricci, G. "Una hydria ionica da Caere," *Annuario*, n. s. 8-10 (1946–48), pp. 47-57 (Memnon).
Robert, Carl. *Thanatos*. 39. BWP (1879), pp.3-27 (Memnon).
———. *Scenen der Ilias und Aithiopis auf einer Vase der Sammlung des Grafen Michael Tyskiewicz*. 15. HWP (1891).

Schefold, Karl. "Gestaltungen des Unsichtbaren auf frühklassischen Vasen," *AM*, 77 (1962), pp.130-132 (Penthesileia).
Steuben, Hans von. *Frühe Sagendarstellungen in Korinth und Athen.* Berlin: Bruno Hessling, 1968. Pp.64-67.
Walter, Hans. "Zu den attischen Amazonenbildern des vierten Jahrhunderts v. Chr.," *Jb.*, 73 (1958), pp.36-38.
Wüst, Ernst. "Psychostasie," *RE*, 23, cols. 1441-1448 (Memnon).

CHAPTER 21

Beazley, J. D. *Etruscan Vase-Painting.* Oxford: Clarendon Press, 1947. Pp. 137-141 (suicide of Aias).
———. CB 3, pp.1-7 (Achilles and Aias gaming).
Chase, George H. "Two Sixth-Century Attic Vases," *Bulletin of the Museum of Fine Arts*, Boston, 44 (1946), pp.45-50 (Achilles and Aias gaming).
Davies, Mark I. "The Suicide of Ajax: A Bronze Etruscan Statuette from the Käppeli Collection," *Antike Kunst*, 14 (1971), pp.148-157.
Ervin, Miriam. "A Relief Pithos from Mykonos," *Archaiologikon Deltion*, 18 (1963), pp.37-75 (wooden horse).
Fröhner, W. "Troianische Vasenbilder," *Jb.*, 7 (1892), pp.28-31 (wooden horse).
Furtwängler, A. FR 1, pp.272-274 (arms of Achilles).
Hauser, Friedrich. FR 3, pp.65-71 (Achilles and Aias gaming).
Kunze, Emil. *Archaische Schildbänder.* Deutsches archäologisches Institut, Olympische Forschungen, 2. Berlin: Walter de Gruyter, 1950. Pp.142-144 (Achilles and Aias gaming); 154-157 (suicide of Aias).
Robert, Carl. *Bild und Lied.* Berlin: Weidmann, 1881. Pp.213-221 (arms of Achilles).
Schefold, Karl. "Statuen auf Vasenbildern," *Jb.*, 52 (1937), pp.30-33, 68-70 (Achilles and Aias gaming).
Séchan, Louis. *Études sur la tragédie grecque dans ses rapports avec la céramique.* Paris: Librairie ancienne Honoré Champion, 1926. Pp.128-131 (suicide of Aias).
Sparkes, B. A. "The Trojan Horse in Classical Art," *Greece and Rome*, ser. 2, 18 (1971), pp.54-70.
Walter, Hans. "Amazonen oder Achäer?" *AM*, 77 (1962), pp.193-196 (wooden horse).
Yalouris, Nikolaos. "Athena als Herrin der Pferde," *Museum Helveticum*, 7 (1950), pp.65-73 (wooden horse).
Zancani Montuoro, Paola. "Heraion alla foce del Sele. I. Altre metope del 'Primo Thesauros,'" *Atti e memorie della Società Magna Grecia*, n. s. 5 (1964), pp.70-76 (suicide of Aias).

CHAPTER 22

Amandry, Pierre. Review of Ghali-Kahil, *Les enlèvements et le retour d'Hélène*, *AJA*, 62 (1958), pp.335-339.
Arias, Paolo Enrico. "Dalle necropoli di Spina. La tomba 136 di Valle Pega," *Riv. Ist.*, n. s. 4 (1955), pp.95-116 (murder of Priam, Aias and Kassandra).
Beazley, J. D. "A Cup by Hieron and Makron," *Bull. Vereen.*, 29 (1954), pp. 12-15 (sacrifice of Polyxena).
———. CB 3, pp.32-39 (Helen); 61-65 (Iliupersis).

Bibliography

Bielefeld, Erwin. "Eine Iliupersis-Schale des Telephos-Malers," *Würzburger Jahrbücher für die Altertumswissenschaft*, 2 (1947), pp.358-360.

Bothmer, Dietrich von. "New Vases by the Amasis Painter," *Antike Kunst*, 3 (1960), pp.75-76 (recovery of Helen).

Brann, Eva T. H. "A Figured Geometric Fragment from the Athenian Agora," *Antike Kunst*, 2 (1959), pp.35-37 (murder of Astyanax?)

Clement, Paul A. "The Recovery of Helen," *Hesperia*, 27 (1958), pp.47-73.

Davreux, Juliette. *La légende de la prophétesse Cassandre d'après les textes et les monuments*. Bibliothèque de la Faculté de Philosophie et Lettres de l'Université de Liége, 94 (1942).

Dugas, Charles. "Du style sévère au style libre," *REA*, 39 (1937), pp. 193-196 (recovery of Helen).

——. "Tradition littéraire et tradition graphique dans l'antiquité grecque," *AntCl*, 6 (1937), pp.14-26 (murder of Priam).

Duhn, F. von. "Zur Deutung des klazomenischen Sarkophags in Leiden," *Jb.*, 28 (1913), pp.272-273 (sacrifice of Polyxena).

Engelmann, R. "Kassandra," Roscher, 2, cols. 979-985.

Ervin, Miriam. "A Relief Pithos from Mykonos," *Archaiologikon Deltion*, 18 (1963), pp.56-65.

Fittschen, Klaus. *Untersuchungen zum Beginn der Sagendarstellungen bei den Griechen*. Berlin: Bruno Hessling, 1969. Pp.182-185.

Furtwängler, A. *La collection Sabouroff*. Berlin: A. Asher & Co., 1883-87. Text to pl. 49, 3 (murder of Priam).

——. FR 1, pp.116-122, 182-186 (Iliupersis); FR 2, pp.125-131 (Helen).

Gabrici, Ettore. "Vasi greci arcaici della necropoli di Cuma," *RM*, 27 (1912), pp.124-133 (murder of Astyanax).

——. "Cuma. Parte seconda," *ML*, 22 (1914), cols. 477-484 (murder of Astyanax).

Gardner, E. A. "A Lecythus from Eretria with the Death of Priam," *JHS*, 14 (1894), pp.170-177.

Ghali-Kahil, Lilly B. *Les enlèvements et le retour d'Hélène*. École française d'Athènes, Travaux et mémoires, 10 (1955).

Hampe, Roland. *Frühe griechische Sagenbilder in Böotien*. Athens: Deutsches archäologisches Institut, 1936. Pp.82-86 (murder of Priam).

Kunze, Emil. *Archaische Schildbänder*. Deutsches archäologisches Institut, Olympische Forschungen, 2. Berlin: Walter de Gruyter, 1950. Pp.157-167.

Mota, Charlette. "Sur les représentations figurées de la mort de Troilos et de la mort d'Astyanax," *RA*, 1957, 2, pp.25-44.

Robert, Carl. *Bild und Lied*. Berlin: Weidmann, 1881. Pp.59-79.

——. "Aias und Kassandra auf einer tarentinischen Vase," *RM*, 33 (1918), pp.31-44.

Schauenburg, Konrad. "Äneas und Rom," *Gymnasium*, 67 (1960), pp. 176-191.

——. "Iliupersis auf einer Hydria des Priamosmalers," *RM*, 71 (1964), pp. 60-64.

Schefold, Karl. "Statuen auf Vasenbildern," *Jb.*, 52 (1937), pp.41-46 (Aias and Kassandra, recovery of Helen).

Simon, Erika. "Die Wiedergewinnung der Helena," *Antike Kunst*, 7 (1964), pp.91-95.

Steuben, Hans von. *Frühe Sagendarstellungen in Korinth und Athen*. Berlin: Bruno Hessling, 1968. Pp.67-72.

Bibliography 221

Tosi, T. "Nuove rappresentanze dell'Iliupersis," *Studi e materiali di archeologia e numismatica*, 3 (Florence, 1905), pp.159-181.
Türk, G. "Polyxena," Roscher, 3, cols. 2733-2739.
Wiencke, Matthew I. "An Epic Theme in Greek Art," *AJA*, 58 (1954), pp. 285-306 (murder of Priam).

CHAPTER 23

Amandry, P. "Eschyle et la purification d'Oreste," *RA*, 1938, 1, pp.19-27.
Bock, Martin. "Orestes in Delphoi auf einer vergessenen unteritalischen Amphora," *AA*, 1935, cols. 493-511.
Brommer, Frank. "Eine kampanische Kanne in Schloss Fasanerie," *MWP*, 1956, pp.13-20 (murder of Aigisthos).
Clairmont, Christoph W. "Zum Oresteia-Krater in Boston," *Antike Kunst*, 9 (1966), pp.125-127.
Ducati, Pericle. "Il cratere bolognese della morte di Egisto," *Dedalo*, 9 (1928–29), pp.451-462.
Dyer, R. R. "The Evidence for Apolline Purification Rituals at Delphi and Athens," *JHS*, 89 (1969), pp.38-56.
Fittschen, Klaus. *Untersuchungen zum Beginn der Sagendarstellungen bei den Griechen*. Berlin: Bruno Hessling, 1969. Pp.186-191.
Furtwängler, A. FR 2, pp.75-80 (murder of Aigisthos).
Goldman, Hetty. "The *Oresteia* of Aeschylus as Illustrated by Greek Vase-Painting," *Harvard Studies in Classical Philology*, 21 (1910), pp.111-159.
Hauser, Friedrich. FR 2, pp.330-333 (Orestes in Delphi).
——. "Orpheus und Aigisthos," *Jb.*, 29 (1914), pp.30-32.
Höfer, O. "Orestes," Roscher, 3, cols. 979-985.
Huddilston, John H. *Greek Tragedy in the Light of Vase Paintings*. London and New York: Macmillan and Co., Limited, 1898. Pp.43-73.
Jacobsthal, Paul. *Die melischen Reliefs*. Berlin-Wilmersdorf: Heinrich Keller, 1931. Pp.11-16, 80-85, 168-170, 181-182, 192-198 (Orestes and Elektra at the tomb of Agamemnon).
Kunze, Emil. *Archaische Schildbänder*. Deutsches archäologisches Institut, Olympische Forschungen, 2. Berlin: Walter de Gruyter, 1950. Pp.167-169 (murder of Agamemnon, murder of Aigisthos).
Lacroix, L. "A propos des monnaies de Cyzique et de la légende d'Oreste," *AntCl*, 15 (1946), pp.209-216 (Orestes in Delphi).
Laviosa, Clelia. "Su alcuni vasi etruschi sovradipinti," *Bollettino d'Arte*, ser. 4, 43 (1958), pp.293-298 (murder of Aigisthos).
Lesky, Albin. "Orestes," *RE*, 18, cols. 991-997.
Metzger, Henri. *Les représentations dans la céramique attique du IV^e siècle*. Bibliothèque des Écoles françaises d'Athènes et de Rome, 172 (1951), pp. 295-297 (Orestes in Delphi).
Robert, Carl. *Bild und Lied*. Berlin: Weidmann, 1881. Pp.149-191 (murder of Aigisthos).
Séchan, Louis. *Études sur la tragédie grecque dans ses rapports avec la céramique*. Paris: Librairie ancienne Honoré Champion, 1926. Pp.86-101.
Sestieri, P. C. "Riflessi di drammi eschilei nella ceramica pestana," *Dioniso*, n. s. 22 (1959), pp.40-51.
Tillyard, E. M. W. *The Hope Vases*. Cambridge: University Press, 1923. Pp. 137-140 (Orestes in Delphi).
Trendall, A. D. "The Choephoroi Painter," *Studies Presented to David*

222 Bibliography

Moore Robinson, 2. St. Louis: Washington University, 1953. Pp.120-122 (Orestes and Elektra at the tomb).

Vermeule, Emily. "The Boston Oresteia Krater," *AJA*, 70 (1966), pp.1-22.

Watzinger, Carl. FR 3, pp.362-369 (Orestes in Delphi).

Wernicke, Konrad. "Orestes in Delphi," *AZ*, 42 (1884), cols. 199-208.

Zancani Montuoro, P. and U. Zanotti-Bianco. *Heraion alla foce del Sele*, 2. Rome: Libreria dello Stato, 1954. Pp.269-300.

CHAPTER 24

Bieber, Margarete. "The Statue of a Ram in Toledo," *AJA*, 47 (1943), pp.378-382 (escape from Polyphemos).

Brommer, Frank. "Odysseus als Bettler," *AA*, 1965, cols. 115-119.

Bulle, Heinrich. "Odysseus und die Sirenen," *Strena Helbigiana*. Leipzig: B. G. Teubner, 1900. Pp.31-37.

Buschor, Ernst. FR 3, pp.124-131 (homecoming of Odysseus).

Caskey, L. D. "Odysseus and Elpenor in the Lower World," *Bulletin of the Museum of Fine Arts*, Boston, 32 (1934), pp.40-44.

Courbin, Paul. "Un fragment de cratère protoargien," *BCH*, 79 (1955), pp.1-49 (blinding of Polyphemos).

Fittschen, Klaus. *Untersuchungen zum Beginn der Sagendarstellungen bei den Griechen*. Berlin: Bruno Hessling, 1969. Pp.192-194.

Furtwängler, A. FR 1, pp.300-301 (Odysseus in the underworld).

Gresseth, Gerald K. "The Homeric Sirens," *Transactions and Proceedings of the American Philological Association*, 101 (1970), pp.203-218.

Hauser, Friedrich. "Nausikaa," *Jh.*, 8 (1905), pp.18-41.

———. FR 3, pp.23-27, 57-60 (sirens); 99-106 (Nausikaa, slaying of the suitors).

Hofkes-Brukker, Charline. "Die Umformung des homerischen Bildstoffes in den archaischen Darstellungen," *Bull. Vereen.*, 15 (1940), pp.2-31.

Jacobsthal, Paul. *Die melischen Reliefs*. Berlin-Wilmersdorf: Heinrich Keller, 1931. Pp.54-56, 188-190 (Skylla); 67-74, 192-198 (homecoming).

Jucker, Ines. "Eine neue Odysseedarstellung," *MdaI*, 3 (1950), pp.135-138 (landing in Ithaka).

Kunze, Emil. "Sirenen," *AM*, 57 (1932), pp.124-134.

Luce, Stephen Bleecker, Jr. "A Polyphemus Cylix in the Museum of Fine Arts in Boston," *AJA*, 17 (1913), pp.1-13.

Müller, Franz. *Die antiken Odyssee-Illustrationen in ihrer kunsthistorischen Entwicklung*. Berlin: Weidmann, 1913.

Mylonas, George E. Ὁ πρωτοαττικὸς ἀμφορεὺς τῆς Ἐλευσῖνος. Βιβλιοθήκη τῆς ἐν Ἀθήναις Ἀρχαιολογικῆς Ἑταιρείας, 39 (Athens, 1957).

Payne Humfry. *Necrocorinthia. A Study of Corinthian Art in the Archaic Period*. Oxford: Clarendon Press, 1931. Pp.137-139 (Polyphemos, sirens).

Perdrizet, Paul. "Polyphème," *RA*, 1897, 2, pp.28-37.

Pollard, J. R. T. "The Boston Siren Aryballos," *AJA*, 53 (1949), pp.357-359.

Scherling, Karl. "Polyphemos," *RE*, 21, cols. 1815-1820.

Schweitzer, Bernhard. "Zum Krater des Aristonothos," *RM*, 62 (1955), pp.78-106 (blinding of Polyphemos).

Séchan, Louis. *Études sur la tragédie grecque dans ses rapports avec la céramique*. Paris: Librairie ancienne Honoré Champion, 1926. Pp.173-180 (homecoming).

Seeliger, K. "Kirke," Roscher, 2, cols. 1193-1199.

Bibliography 223

Shefton, B. B. "Odysseus and Bellerophon Reliefs," *BCH*, 82 (1958), pp.27-34 (homecoming).

Steuben, Hans von. *Frühe Sagendarstellungen in Korinth und Athen.* Berlin: Bruno Hessling, 1968. Pp.50-53.

Touchefeu-Meynier, Odette. "Ulysse et Circé: notes sur le chant X de l'*Odyssée*," *REA*, 63 (1961), pp.264-270.

——. *Thèmes odysséens dans l'art antique.* Paris: E. de Boccard, 1968.

Trendall, A. D. and Alexander Cambitoglou. "The Slaying of the Suitors —A Fragmentary Calyx-krater by the Hearst Painter," *Antike Kunst*, 13 (1970), pp.101-102.

Weickert, Carl. "Eine geometrische Darstellung aus der Odyssee?" *RM*, 60-61 (1953–54), pp.56-61 (Circe?).

Winter, Franz. "Polyphem," *Jb.*, 6 (1891), pp.271-274.

Wolters, Paul. "Kirke," *AM*, 55 (1930), pp.209-236.

Index of Types
(with Sources)

Acheloos. *See* Herakles

Achilles and Aias gaming, 142
(Gerhard, *AV*, pl.219, 3)

Achilles, armor for, 136
(*JHS*, 34 [1914], p.217, fig.28)

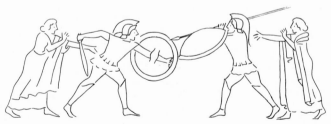

Achilles and Memnon: duel, 141
(*Mon.*, 11, pl.33)

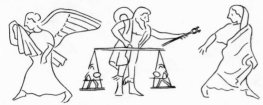

Achilles and Memnon: psychostasia, 141
(*Mon.*, 6-7, pl.5, a)

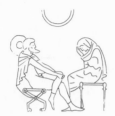

Achilles, mission to, 134
(*Mon.*, 6-7, pl.21)

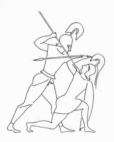

Achilles and Penthesileia, 139
(*WV*, 1888, pl.6, 2)

Achilles. *See also* Aias, Hektor, Peleus, Troilos

Aeneas and Anchises, 154
(Gerhard, *EKV*, pl.25)

Index of Types

Aias and Odysseus: quarrel over arms of Achilles, the vote, 142
 (FR, pl.54)

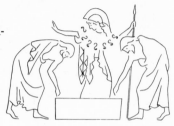

Aias rescues body of Achilles, 141
 (FR, pls.1-2)

Aias, suicide of, 144
 (*Mon.*, 6-7, pl.33, c)

Aias. *See also* Achilles

Aias the Less. *See* Kassandra

Aigisthos, murder of, 158
 (Gerhard, *EKV*, pl.24)

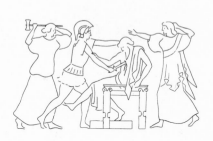

Aithra, rescued by sons of Theseus, 153
 (*Mon.*, 11, pl.15)

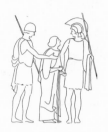

Index of Types 227

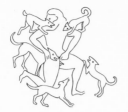

Aktaion, death of, 41
(Ch. Lenormant and J. de Witte, *Élite des monuments céramographiques*, 2 [Paris: Leleux, 1857], pl.103, c)

Alkyoneus. *See* Herakles

Amazonomachy. *See* Herakles, Theseus

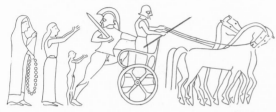

Amphiaraos, departure of, 123
(FR, pl.121)

Anchises. *See* Aeneas

Antaios. *See* Herakles

Antiope. *See* Theseus

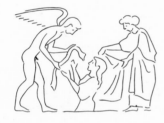

Aphrodite, birth of, 33
(*CVA*, Genoa, III I c, pl.6, 2)

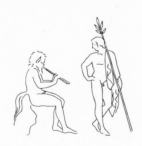

Apollo and Marsyas, 39
(Inghirami, pl.327)

Apollo and Tityos, 36
 (Richter and Hall, pl.136)
Argos. *See* Io

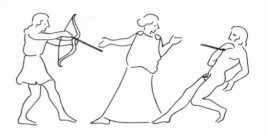

Ariadne, sleeping, abandoned by Theseus, 85
 (*Mon.*, 11, pl.20)
Astyanax. *See* Priam

Athena, birth of, 31
 (Gerhard, *AV*, pl.1)

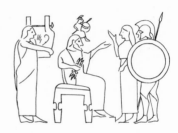

Bellerophon and the chimaera, 100
 (*Mon.*, 9, pl.52)
Busiris. *See* Herakles
Chiron. *See* Peleus
Circe. *See* Odysseus
Danae. *See* Perseus
Deianeira. *See* Herakles and Nessos

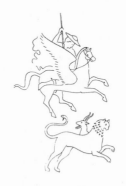

Index of Types

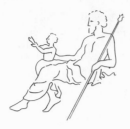

Dionysos, birth of, 32
(*JHS*, 54 [1934], pl.9)

Elektra. *See* Aigisthos, Orestes

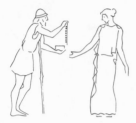

Eriphyle, bribing of, 122
(FR, pl.66, 2)

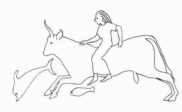

Europa and the bull, 28
(Otto Jahn, *Die Entführung der Europa auf antiken Kunstwerken* [Vienna: Gerold, 1870], pl.5, a)

Eurystheus. *See* Herakles

Ganymede. *See* Zeus

Geras. *See* Herakles

Geryon. *See* Herakles

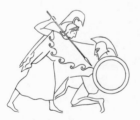

Gigantomachy, 4, 47
(Gerhard, *AV*, pl.6)

Gorgons. *See* Perseus

Index of Types

Hektor, body dragged by Achilles, 136

Hektor, ransom of, 137
(FR, pl.84)

Helen, birth of, 34
Helen. *See also* Menelaos, Theseus

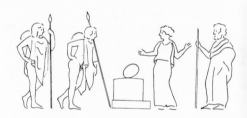

Hephaistos, return of, 46
(FR, pl.7)

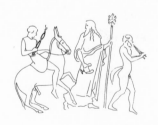

Herakles and Acheloos, 75
(Gerhard, *EKV*, pls.15-16, 1)

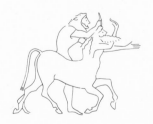

Index of Types

231

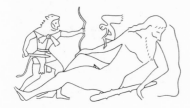

Herakles and Alkyoneus, 72

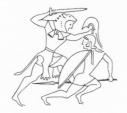

Herakles and the Amazons, 64
(Gerhard, *EKV*,pl.17, 3)

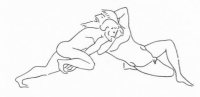

Herakles and Antaios, 69
(FR, pl.92)

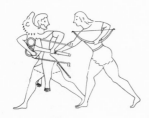

Herakles and Apollo: theft of the tripod, 76
(FR, pl.133)

Herakles and the birds, 63
(*Gazette archéologique*, 2 [1876], pl.3)

Index of Types

Herakles in the bowl of Helios, 65
(Gerhard, *AV*, pl.109)

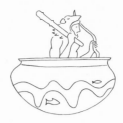

Herakles and the bull, 63

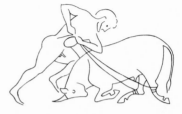

Herakles and Busiris, 70
(FR, pl.73, 1)

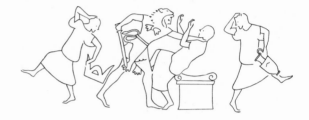

Herakles and Eurystheus, 61
(Theodor Panofka, *Antiques du Cabinet du Comte de Pourtalès-Gorgier* [Paris: Firmin Didot Frères, 1834], pl.12)

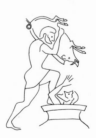

Index of Types

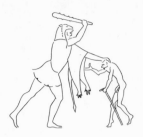

Herakles and Geras, 58
(*Philologus*, 50 [1891], pl.1)

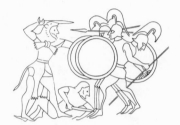

Herakles and Geryon, 65
(*WV*, 1888, pl.5, 1 b)

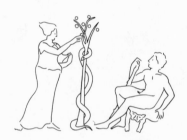

Herakles and the Hesperides, 70
(FR, pl.8)

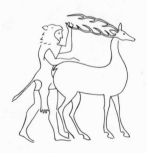

Herakles and the hind, 62
(Gerhard, *AV*, pl.100)

Index of Types

Herakles and the hydra, 61
(Gerhard, *AV*, pls.95-96)

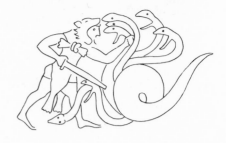

Herakles and Kerberos, 67
(Gerhard, *AV*, pl.130)

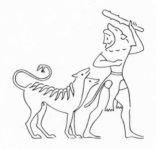

Herakles and the Kerkopes, 72
(Percy Gardner, *Catalogue of the Greek Vases in the Ashmolean Museum* [Oxford: Clarendon Press, 1893], pl.8)

Herakles and Kyknos, 73

Index of Types

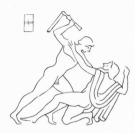

Herakles and Linos, 73
(FR, pl.105)

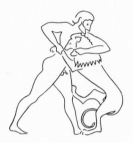

Herakles and the lion, 58
(WV, 1888, pl.6, 3 b)

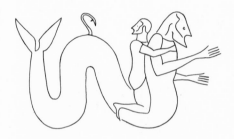

Herakles and Nereus, 68
(AM, 62 [1937], pls.50, 2 and 55)

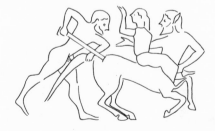

Herakles and Nessos, 75
(Mon., 6-7, pl.56, 4)

Index of Types

Herakles entering Olympos, 77
(*AZ*, 28 [1870], pl.33)

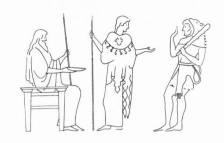

Herakles and Pholos, 61
(O. M. von Stackelberg, *Die Graeber der
Hellenen* [Berlin: G. Reimer, 1837], pl.41)

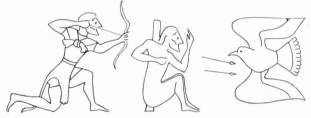

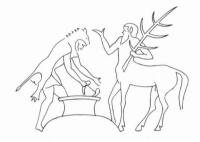

Herakles and Prometheus, 74
(*Studi e materiali di archeologia e
numismatica*, 3 [Florence, 1905], pl.2)

Herakles and Syleus, 74
(*AZ*, 19 [1861], pl.149, 1)

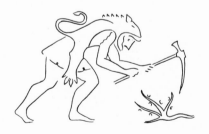

Index of Types

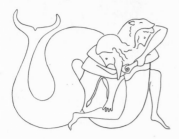

Herakles and Triton, 69
(Gerhard, *EKV*, pl.16)

Hesperides. *See* Herakles

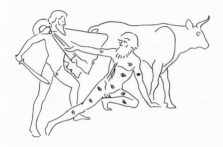

Io and Argos, 27
(*ML*, 22 [1914], pl.85)

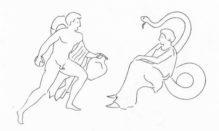

Kadmos and the serpent, 119
(Raoul-Rochette, pl.4, 2)

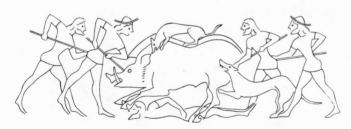

Kalydonian boar, hunt of the, 116
(Gerhard, *EKV*, pl.10, 4)

Kassandra and Aias, 151
(Gerhard, *EKV*, pl.22)

Kerberos. *See* Herakles

Kerkopes. *See* Herakles

Kerkyon. *See* Theseus

Klytaimnestra. *See* Aigisthos

Kyknos. *See* Herakles

Leto. *See* Apollo and Tityos

Linos. *See* Herakles

Marsyas. *See* Apollo

Medea. *See* Pelias

Medusa. *See* Perseus

Meleager. *See* Kalydonian boar

Memnon, death of, 141
(James Millingen, *Ancient Unedited Monuments. Painted Greek Vases* [London, 1822], pl.5)

Memnon. *See also* Achilles

Menelaos and Helen: the meeting, 152
(Gerhard, *EKV*, pl.21)

Menelaos and Helen: the pursuit, 153
(Gerhard, *AV*, pl.169, 4)

Minotaur. *See* Theseus

Neoptolemos. *See* Priam

Nereus. *See* Herakles

Nessos. *See* Herakles

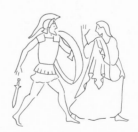

Index of Types

239

Niobids, death of, 39
(FR, pl.165)

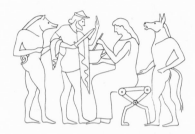

Odysseus and Circe, 165
(*AZ*, 34 [1876], pl.15)

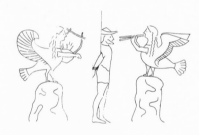

Odysseus and sirens, 166
(*JHS*, 13 [1892], pl.1)

Odysseus. *See also* Aias, Polyphemos

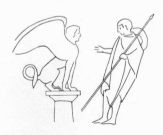

Oidipus and the sphinx, 121
(CB 1, pl.23)

Index of Types

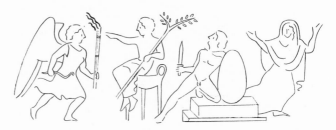

Orestes at Delphi, 159
(Raoul-Rochette, pl.35)

Orestes and Elektra at the tomb of
Agamemnon, 167
(Inghirami, pl.137)

Orestes. *See also* Aigisthos

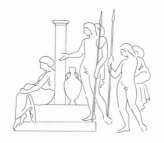

Orpheus, death of, 113
(*Mon.,* 9, pl.30)

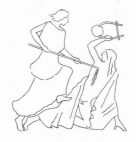

Paris, judgment of, 128
(Gerhard, *EKV,* pl.14)

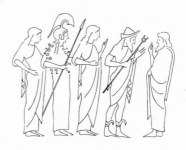

Index of Types

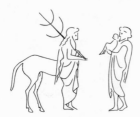

Peleus brings Achilles to Chiron, 126
(*JHS*, 1 [1880], pl.2)

Peleus and Thetis, 125
(FR, pl.24)

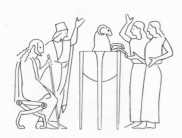

Pelias and daughters, 109
 (Gerhard, *AV*, pl.157, 1)
Penthesileia. *See* Achilles

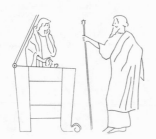

Perseus and Danae, 87
 (Richter and Hall, pl.86)

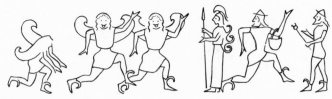

Perseus and the gorgons, 92
(*Annali*, 23 [1851], pl.P)

Perseus and Medusa, 90
(*WV*, 1889, pl.4, 1)

Pholos. *See* Herakles

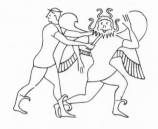

Phrixos and the ram, 103
(Paul Hartwig, "Phrixos und eine
Kentauromachie auf einer Schale der Mitte
des V. Jahrhunderts," *Festschrift für
Johannes Overbeck* [Leipzig: Wilhelm
Engelmann, 1893], p.17, fig.1)

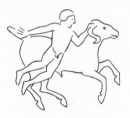

Polyphemos, blinding of, 162
(*Mon.*, 10, pl.53, 2)

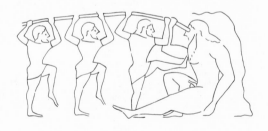

Polyphemos, escape from, 164
(Inghirami, pl.335)

Polyxena. *See* Troilos

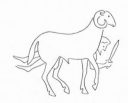

Index of Types

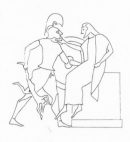

Priam, murder of, 146
 (Gerhard, *EKV*, pl.21)
Priam. *See also* ransom of Hektor
Prokrustes. *See* Theseus
Prometheus. *See* Herakles
Sinis. *See* Theseus
Skiron. *See* Theseus
Syleus. *See* Herakles

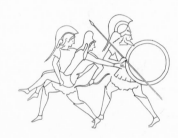

Theseus and the Amazons, 86
 (*Mon.*, 8, pl.44)

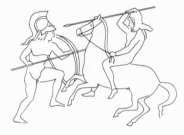

Theseus and Antiope, 85
 (FR, pl.113)

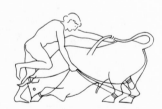

Theseus and the bull, 82
 (*Museo Italiano di antichità classica*, 3
 [1890], pl.3)

Index of Types

Theseus and Helen, 85
 (*Jb.*, 17 [1902], p.54, fig.1)

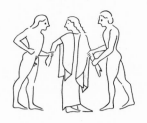

Theseus and Kerkyon, 82
 (FR, pl.141)

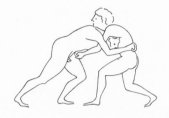

Theseus and the Minotaur, 83
 (Gerhard, *EKV*, pl.23)

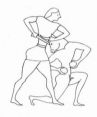

Theseus and Poseidon, 84
 (*Mon.*, 1, pl.52)

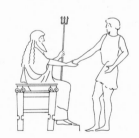

Index of Types

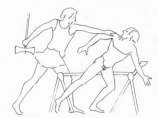

Theseus and Prokrustes, 82
(J. V. Millingen, *Peintures antiques et inédites de vases grecs* [Rome: de Romanis, 1813], pl.9)

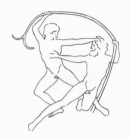

Theseus and Sinis, 80
(*CVA*, Madrid, III I d, pl.4)

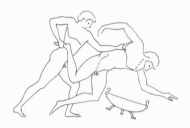

Theseus and Skiron, 82
(*Museo Italiano*, 3 [1890], pl.4)

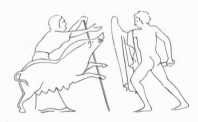

Theseus and the sow, 80
(*JHS*, 2 [1881], pl.10)
Theseus. *See also* Ariadne
Thetis. *See* Peleus
Tityos. *See* Apollo
Triton. *See* Herakles

Index of Types

Troilos and Achilles: the pursuit, 132
(Gerhard, *EKV*, pl.20)

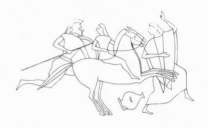

Troilos and Polyxena at the fountain, 131
(Gerhard, *EKV*, pl.11)

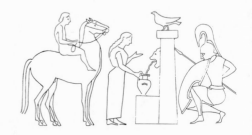

Zeus and Ganymede, 30
(CB 2, pl.50, 95)

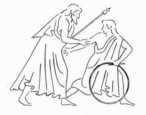